the COLOR REVOLUTION

color lithography in France
1890-1900

the COLOR REVOLUTION

color Lithography in France 1890-1900

Phillip Dennis Cate
Director
Rutgers University Art Gallery

and

Sinclair Hamilton Hitchings
Keeper of Prints
Boston Public Library

with a translation by Margaret Needham of

André Mellerio's 1898 Essay *La Lithographie originale en couleurs*

➜

Peregrine Smith, Inc.
SANTA BARBARA AND SALT LAKE CITY
1978

This book is the result of an exhibition and catalogue which were organized and published by the Rutgers University Art Gallery, Rutgers, The State University of New Jersey, in cooperation with The Boston Public Library and with support from the National Endowment for the Arts, a Federal Agency in Washington, D.C.

Exhibition Schedule:
 Rutgers University Art Gallery September 10–October 29, 1978
 The Baltimore Museum of Art November 10–December 31, 1978
 The Boston Public Library May 2–July 1, 1979
 (smaller exhibition)

ISBN: 0-87905-032-2

Library of Congress Catalog Card Number 78-13809

Manufactured in the United States of America
by Hoffman Printing

Contents

v

Introduction

For a period of approximately ten years—1890 to 1900—color lithography flourished in France as the favored printmaking medium of avant-garde artists. The intensity of artistic production in the medium caused André Mellerio, editor of the journal *L'Estampe et l'affiche,* to write and publish a small book entitled *La Lithographie originale en couleurs* in 1898. Its cover and fronticepiece were color lithographs designed by Pierre Bonnard. In it Mellerio observed that the general artistic use of the medium of color lithography was a phenomenon unique to his time. He also realized that the medium was the one creative common denominator among the variety of radical, experimental aesthetic movements in French art. Indeed, Mellerio was among the first to see the growing use of color lithography in the 1890s as a valid artistic movement in itself—a movement which he also saw as having social repercussions and aesthetic implications in the future.

Mellerio's book was printed in an edition of one thousand. Among collectors, it has attracted interest largely for the two small color prints contributed by Bonnard, yet it remains the best description of one artistic phenomenon in a time and place that are well-remembered. It comes from the man who made himself, for the Nabis, their resident critic and commentator, analyzing, gently reproving, encouraging. They knew him as an advocate of their work, and they were lucky to have him, just as they were fortunate to have Vollard as entrepreneur. The alliance was of benefit to all concerned. Of the two, we remember Vollard today as a titan among art dealers and as creator of his own unique and memorable chapter of the patronage of art; we remember his love of what the portfolio-series of prints and the illustrated book can become in the hands of great artists. Mellerio's life, by contrast, has long been in the shadows. He deserves an honored place in the history of art criticism.

His essay of 1898 gives detailed consideration to nineteen artists and their color lithographs. Twenty-one more he mentions briefly, and another dozen are mentioned in passing. He also discusses the editors and dealers Sagot, Kleinmann, Pellet and Vollard and the printers Duchatel, Stern and Clot, and he comments on a number of publications devoted to the commissioning and issuing of original color lithographs. Of the attention being given to color lithography in Paris in the nineties he writes, "Even older artists with glorious careers are interested. As for the young, this method is a veritable instrument of battle which they use abundantly and happily. Some have given their hearts to the work Day by day they improve and perfect the technique, each in the aspect fitted to his temperament."

La Lithographie originale en couleurs, with its review of the short history of color lithography as an artistic medium and its astute critical appraisals of artists' works, serves as the basis for the present publication and the exhibition which has coincided with it. Mellerio's book is such as important document of nineteenth century art criticism (one which has never been available in English) that we sought, first of all, a careful translation to be printed in its entirety.

Hindsight, however, allows one to appreciate the full implications of the designing, printing, publishing and distributing of color lithographs in the medium's first and greatest decade and to understand better its sources. The perspective of time suggests that this activity was more than just an artistic movement but indeed was a "revolution"— social, commercial and artistic.

It was an artistic revolution stimulated not only by early efforts in color lithography of the 1870s and 1880s but also by the development of new commercial color printing processes used in illustrating journals and books. Through the design of

large, colorful commercial posters, theatre programs and book covers by artists absorbed in experiments and new concepts, it altered irrevocably the concept of advertising—from illustration and description of a product to sales through the sensual appeal of color and design. The element of social revolution was present by implication, for many of the artist-designers were strong supporters of socialist and anarchist activities. Steinlen, Luce, Ibels and others illustrated radical journals often in color (though not in lithography), and their numerous color lithographs bespoke their political and social sympathies. Mellerio stated that Chéret's posters and Rivière's prints were "the frescoes, if not of the poor, at least of the crowd."

Since the publication of Mellerio's essay, relatively little has been written specifically on the theme of late nineteenth century color lithography. There are, however, two studies which together encompass the two main divisions of the medium in the nineties: the commercial poster and the individual print. Robert Goldwater's 1942 *Gazette des Beaux-Arts* article "L'Affiche moderne, a revival of poster art after 1880," summarized the development of the color lithographic poster; in the same journal, Gustave von Groschwitz's 1954 article "The Significance of XIX Century color lithography" added further analysis and detailed information on the history of nineteenth century color lithographic prints. Also in 1954, Von Groschwitz mounted a major exhibition at the Cincinnati Art Museum of the Albert P. Strietmann Collection of Color Lithographs, and issued a concise catalogue. Daryl Rubenstein's *The Avant-Garde in Theatre and Art: French Playbills of the 1890s,* although not specifically oriented toward color lithography, has collated valuable information on the role of theatre programs as a vehicle for color lithography. The writings of Alan Fern, Eleanor Garvey, Philip Hofer, Una Johnson, Philippe Julian and Peter Wick contain extensive and valuable information; these and other

scholars are helpful in the effort to piece together the full story of artists' color lithography in the 1890s.

Two authorities whose work deserves separate mention are Claude Roger-Marx and Una Johnson. Roger-Marx's comments on color lithography in the introductions to his catalogues of the lithographs of Bonnard and Vuillard and in his other writings are of particular value. So is the meticulously detailed knowledge of Vollard's publishing ventures which Una Johnson has presented in her *Ambroise Vollard, Editeur.* The medium of color lithography and Vollard's role in bringing artists to it are substantial parts of her story, and the information she gives on prints and projects is indispensable.

The Color Revolution endeavors to complete that story in the following ways: by documenting the early history of the medium as well as the events in commercial and noncommercial color printing which led up to the 1890s and which helped to set the atmosphere which was favorable to color printing; by revealing the vehicles of support which began to emerge in the mid-eighties—the print and poster dealers, color lithographic printers, independent exhibitions, print albums and journals; by indicating the conflicting printmaking aesthetics of the period, and by discussing the variety of stylistic approaches to the medium.

Finally, as an epilogue to the color revolution, achievements in color lithography by twentieth-century artists in Europe and the United States are discussed. Though original work in color lithography slowed at the turn of the century, the medium has remained an important means of expression for many artists throughout the last seventy-eight years.

The choice of prints to be reproduced in color in this publication was based on several criteria. First, an effort has been made to indicate the broad range of style in color, from the subtle pastels of Charpentier and Denis to the bold fiery effects of Hermann-Paul and from the composition in three primary

colors of Lautrec's *Moulin Rouge* to the startling intermediate color design of Guilloux's *L'Inondation*. We also felt it important to reproduce as many works as possible which had not been illustrated in color elsewhere but which still represent well the color revolution. More specifically seminal works for the color revolution, including those by Grasset, Signac, Chéret and Lautrec, were selected, and work was chosen which Mellerio referred to in his essay—Realier-Dumas' *Napoléon,* for instance, and prints from Lautrec's *Elles* and Lunois' bullfight series. In order to re-emphasize the great importance of Lautrec, Bonnard and Vuillard as color lithographers, each of these artists has been represented with two or more color reproductions.

We have received much valuable assistance in the organization of this publication. We are most grateful to Margaret Needham for her sensitive translation of Mellerio's book and her substantial editorial suggestions. Thanks are due to J. Carl Cook, Rutgers University Extension Division, and Richard Firmage of Peregrine Smith, Inc., for their editorial comments and suggestions and their partnership in the design of the book. We greatly appreciate the assistance of members of the Rutgers University Art Gallery staff, Sadie Zainy, Nancy Kusek, and Marilyn Pruce, and a student volunteer, Delores Ross; the help, as well, of Paul Swenson and Eugene Zepp of the Boston Public Library Print Department. We would also like to thank the following individuals and institutions for allowing us the opportunity to study their collections and research materials pertaining to nineteenth century French color lithography: Ripley Albright, Print Department, The Brooklyn Museum; Colles Baxter, Print Department, Smith College Museum of Art; Victor Carlson and Jay Fisher, Print Department, The Baltimore Museum of Art; Ruth Fine, Alverthorpe Gallery, National Gallery of Art; Eleanor Garvey and David Becker, Harvard College Department of Printing & Graphic Arts; Lucien Goldschmidt, Lucien Goldschmidt, Inc.; Colta Ives, Department of Prints, The Metropolitan Museum of Art; Stewart Johnson, Department of Architecture and Design, Museum of Modern Art; Kneeland McNulty, Print Department, Philadelphia Museum of Art; François Meyer, Paris; Robert Nikirk, Grolier Club, New York City; Elizabeth Roth, Print Division, New York Public Library; Eleanor Sayre and Barbara Shapiro, Print Department, Boston Museum of Fine Arts; Mr. and Mrs. Herbert D. Schimmel, New York City; Kristin Spangenberg, Print Department, Cincinnati Art Museum; the Print Department of the National Gallery of Art, London; and in Paris, the Cabinet des estampes, Bibliothèque Nationale; Jean-Claude Romand, Sagot-Le Garrec Gallery, and Paule Cailac, Paule Cailac Gallery. Finally, special thanks must go to Allan Maitlin and the Rutgers Class of 1958 for designating their twentieth reunion class gift specifically for the university's purchase of art work included in this project.

The subject of the present book is a special interest of the authors, an interest going back a decade, expressed in exhibitions and in collecting by the Rutgers University Art Gallery and by the Print Room of the Boston Public Library. Both of these public collections have exceptional holdings of French color lithographs of the 1890s. Complementary interest and enterprises led to partnership in the present book and the exhibition which has been part of its creation.

A National Endowment for the Arts Museum professional travel grant in 1976 made it possible for Phillip Dennis Cate to perform research essential to this undertaking. N.E.A. has also supported in part the present book. We are, therefore, most grateful to this Federal agency for its backing, bringing to fruition *The Color Revolution: Color Lithography in France, 1890-1900.*

Phillip Dennis Cate
Sinclair Hamilton Hitchings

the 1880s: the prelude

By its essential principles, its origins and its traditions, the art of the print is unquestionably the art of Black and White. This is the traditional classification to which it is attributed.

Henri Lefort, 1898

But the right of the color print to exist comes directly from the principle which we consider an axiom: any method or process which an artist develops to express himself is for that very reason legitimate.

André Mellerio, 1898

I N 1898 the perennial battle between the French academicians and more radical, innovative artists came to a head with the outcry against the continued exclusion of color prints in the annual Salon of the Society of French Artists. The Committee of Ninety, the official body responsible for the Salon, requested on December 21, 1897 that the print section of the Society review its 1891 statute which succinctly read: "No work in color will be admitted."

The following January Henri Lefort, president of the section of engraving and lithography, presented a statement, the essence of which is quoted above, defending the 1891 statute. Lefort's defense was published in the March issue of *La Lithographie*. Once made public, negative reactions were spontaneous. That same month a letter of rebuttal from color printmaker Charles Maurin was printed in the *Journal des artistes*. It represented the most volatile protestations of those who thought very little of the opinions of leaders of the Salon, but who also felt it to be the moment to voice their objections to the tired and often inaccurate aesthetic rationales of the establishment.

It is perhaps important to protest against Mr. Lefort's claims. In doing so, we are sure that we represent numerous printmakers who, for the last ten years, have given a new scope to the original French print which the new president classes under the disdainful and childish heading: 'color pictures'. . . .

As there are faggots and faggots, there are printmakers and printmakers. The original printmaker and the reproductive printmaker. The former, if we are not deceiving ourselves are the artists, the latter can only be technicians. . . .

The public is no longer fooled; they admire and buy essentially original prints. Is it our fault if the color print is in demand and the black and white abandoned? The future is with the artists, the creators. Let's work, comrades! And for God's sake let's not be used as a photograph.

The voice of moderation arrived in a letter from Löys Delteil who supported the goals of both the original and reproductive printmakers working in either black and white or in color. Delteil corrected Lefort's assertion that color prints were the domain of industry not of the Salon by indicating that since the eighteenth century color prints, such as those by Debucourt, played a part of the Salon and were supported by the state. Consequently, he recommended that "our representation of the Committee of Ninety finally accept our amiable sister, the color print, into the Salon beginning in 1899." And so it was. Paragraph 6, article 2 of the section of engraving and lithography of the Statutes for the Salon of 1899 read as follows: "Works in color will be admitted."

The confrontation between the printmaking representatives of the Salon and their radical adversaries is of interest in so far as it epitomizes the struggle of the entire modern movement in French

1

1. Alöys Senefelder, illuminated letter "B" from *L'Art de la lithographie*, French edition, 1819. Museum of Fine Arts, Boston, Sylvester R. Koehler Collection.

art during the second half of the nineteenth century. The victory won by the color print advocates was, however, a symbolic one. The reluctant but none the less official acceptance of the color print by the reactionary Society of French Artists was anticlimatic to the general success of color printmaking within the previous ten years.

The color movement of the 1890s was built upon a series of events occurring in the 1880s, among which were the general renewal of interest in printmaking and in lithography per se, technological developments in commercial printing, the achievements of a few isolated color lithographic poster artists, and specific publications and exhibitions. Beginning at the end of the decade, this background generated a chain reaction of artistic activity in color printmaking and was sustained and intensified in the 1890s by a proliferation of printers, dealers, independent salons, print organizations, publishers and critics. The subsequent supremacy of color lithography as the dominant creative force within all this activity was nothing less than a revolution, and by 1898 the "Color Revolution" was a *fait accompli*.

The history of color lithography dates back to 1817 with the early attempts by Alöys Senefelder, the inventor of lithography, to print one impression in several colors from several stones (Fig. 1). That year Senefelder is said to have published *The Fair of Bulgaria*, a print in eleven colors with the enormous dimensions for that time of 1½ x 1 meter. To obtain a print of this large format Lorilleux states that

Senefelder drew upon three stones (side by side) which necessitated thirty-three separate printings for each copy.

The main obstacle in the early development of a practical system of producing color lithographs was the absence of an easy and accurate technique of color registration. In 1837 Godefroy Engelmann, an Alsacian, overcame many of the problems of registration with his invention of a registration frame for his new process of color printing called "chromolithography." Englemann based his procedure on the three color system devised for intaglio color printing by J. C. LeBlon in the 1720s. Like LeBlon, Englemann used separate plates or stones for each of the three primary colors — red, blue, and yellow. When printed in juxaposition or superimposition it was possible to produce any or all of the intermediate tints in the color spectrum. Both inventors also incorporated a black plate for added tone or contour differentiation.

In 1839 the English lithographer and printer Charles Joseph Hullmandel used his own system of color printing based on color tints rather than LeBlon's three primary colors for Thomas Shotter Boys' *Picturesque Architecture in Paris, Ghent, Antwerp, Rouen* (Fig. 2). Boys' lithographs for this publication are the first significant artistic achievements using a fully evolved system of color lithography.

The subsequent technical improvements in registration and mass printing in the 1840s and 1850s remained in the domain of industry; the medium was not readily available to artists on an individual

2. Thomas Shotter Boys, *St. Lauren, Rouen,* 1839, four color lithograph, 16¼ x 12″. Rutgers University Fine Arts Collection.

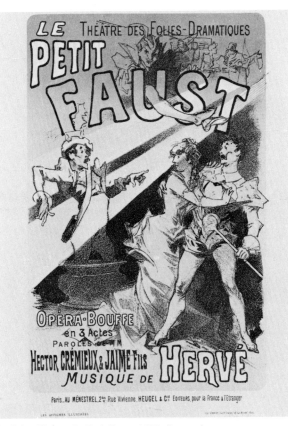

3. Jules Chéret, *Le Petit Faust,* 1869, four color lithographic poster, reproduced from Ernest Maindron's *Les Affiches illustrées,* 1886.

basis. Hullmandel also called his process "chromolithography." The commercial use of the chromolithographic systems, specifically in the service of rendering art reproductions, imparted a derogatory meaning to this purely descriptive term which prevails even today. Therefore, not only were the technical complexities a hindrance to the use of color lithography by artists, but so too was its reputation as a medium unsuitable for original art production. To reinstate color lithography as a creative artistic medium would take twenty-five years of effort by one man, a Frenchman, Jules Chéret.

Chéret was both a technician and an artist, an essential combination for the aesthetic development of the medium. Little is known of his early training, and even less of the influences upon his work. At the age of thirteen Chéret is said to have become apprenticed for three years to a commercial lithographer specializing in funeral announcements, headlines, and prospectuses. His technical experience was later broadened at the lithographic shop of Bouasse-Lebel, popularly known for its production of pious images. During these years, frequent Sunday visits to the Louvre, where he was particularly impressed by the eighteenth century colorist Antoine Watteau, inspired him to study drawing under Lecoque de Boisbaubran, mentor of Auguste Rodin and Puvis de Chavannes.

Orpheé aux enfers of 1858, a design for an operetta by Jacques Offenbach, is the first documented color poster by Chéret. Printed at the shop of Joseph and Alfred Lemercier in three colors (red-brown, green and black), it proved to be a false start in his Parisian career as a postermaker. Unable to find other commissions in Paris, he left that same year for London where, for the following eight years he designed advertisements for the products of a perfume manufacturer named Remmel. It was this same manufacturer who in 1866 financially backed Chéret's return to Paris and establishment of a lithographic print shop.

In 1869 Chéret introduced a rather creative system of three color lithographic printing from three stones with such works as *Le Petit Faust* (Fig. 3). This processs, which was the basis of his work throughout the 1870s and early 1880s, was described by Henri Beraldi in 1886 in volume one of *Les Graveurs du XIX siècle:*

> In principle, the posters of Chéret are made by three superimposed impressions. One, in black, establishes the drawing, strongly indicated and skillfully composed in order to receive in certain places the energetic red coloration, which is the most violent color to attract the eye. Another impression gives this "red touch." The third harmonizes the brutal note of the red by means of a gradated background [*fond gradué*]: the cool tones, blues or greens, placed at the top half of the poster; the warm tones, yellow or orange, placed at the bottom.
> The gradated background was already employed for drawing-papers; but it is Chéret, I believe, who first had the idea of applying it to posters. This triple impression became the normal, classic process for Chéret's posters. In exceptional

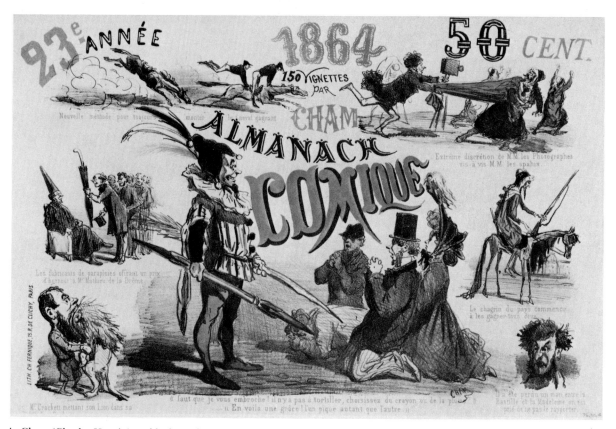

4. Cham (Charles Henri Amedée de Noé), *Almanach comique*, 1864, three color lithographic poster, 12 x 18½". Rutgers University Fine Arts Collection.

cases, he added a fourth impression for yellow. Even sometimes, but very rarely, a fifth.

Prior to the development of Chéret's integrated color printing system, lithographic posters were either black and white or, as in the case of Cham's (pseudonym for Amedée de Noé) *Almanach comique* of 1864 (Fig. 4), simply printed in three colors—black, red, and blue—on a white background with the colors incidental to the composition and serving only as highlights to an essentially black and white poster. Generally, however, when posters printed either by woodblock or lithography were in color, the colors were applied by stencils as in *Bonne Double Bierre* of c.1830 (Fig. 5) or the folk images of Epinal.

Alan Fern offers a most provocative suggestion for the influences upon Chéret's early poster style. He proposes that Chéret came under the influence of the large American color woodcut circus posters which accompanied the troupes which toured England in the 1850s and 1860s. This certainly accounts for the bold compositions of figures and words in Chéret's work. Add to this his fondness for Tiepolo and Watteau, plus Beraldi's suggestion of tinted drawing papers as the source for Chéret's *"fond gradué,"* and one has the eclectic development of a unique system of color lithography.

With Chéret, in 1869, one finds an artist-printer thinking more thoroughly in terms of color than ever before. It is amazing that the fervor of the 1870s caused by the explorations in color by Manet, Whistler, and the Impressionist group produced only one color print. In 1874 Manet created *Le*

Polichinelle, a color lithograph from seven stones (Fig. 6). Yet this was his only effort in color print-making and, until the 1890s, the only one by any artist associated with the Impressionists. Edgar Degas, Félix Bracquemond, Camille Pissarro, and Mary Cassatt were all making prints in the 1870s in Paris, some of which were lithographs, but none in any medium was in color. In fact, until the time of Chéret, there is no history of original color print-making in France.

Obviously color was on the minds of most innovative French painters of the 1870s. However, in addition to the continual production of color posters by Chéret, it would take a variety of printing and print-related activities in the 1880s to stimulate French artists to begin thinking in terms of color in the creation of original prints.

The 1880s was the decade for the take-over of photo-mechanical processes for illustrating journals and books. Until 1878, all French publications were illustrated by the traditional techniques of etching, wood or metal engraving, lithography, or by the relatively new process, *gillotage*. Named after its inventor, Firmin Gillot, gillotage is a method of transferring an intaglio (etched) or planographic (lithographic) image into a relief image on a zinc plate for printing on a typographic press. By 1875 Charles Gillot, son of Firmin, had adapted his father's system to photography, and the next year Charles set up the first photo-relief print shop in Paris. By the end of that decade the book *Dans les nuages* (1878) by Sarah Bernhardt and the journal

4

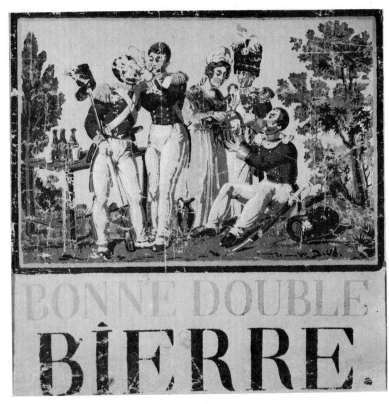

5. Anonymous French artist, Bonne Double
Bierre, c. 1830, stencil colored woodcut,
10¾ x 16″. Sinclair Hitchings.

6. Edouard Manet, *Le Polichenelle,* 1874, six color
lithograph, 16⅜ x 12½″. The Baltimore Museum
of Art, George A. Lucas collection, on indefinite
loan from the Maryland Institute, College of Art.

L'Illustration (1879) inaugurated the era of relief
photographic printing with their photo-mechanical
illustrations after black line drawings.

The 1881 Christmas issue of *L'Illustration* in-
cluded photo-mechanical color illustrations for the
first time in journalistic history. This issue was also
the first French journal to be illustrated in color.
Chromotypogravure or photo color relief printing
was at this period a tedious and complicated task
requiring the efforts of two sensitive technicians, a
photographer and an engraver. The latter was
responsible for producing the various color plates
(one for each color). Color separation could only be
achieved by the sharp eye and the controlled hand
of the engraver. Photo mechanical color separation
was purely experimental throughout the 1880s and
1890s in the United States and France and had no
practical application until the turn of the century.

The simplest photo color relief printing process
required that a photo glass positive of a black line
drawing be placed over a zinc plate previously
prepared with a ground of photosensitive bitumin.
All the areas of the drawing except those to be
printed from that particular color plate were stop-
ped out on the glass positive by an opaque pigment.
The bitumin corresponding to the remaining draw-
ing became hardened and acid resistant upon ex-
posure to light. The unexposed bitumin, corres-
ponding to the stopped out areas of the drawing,
was washed away, allowing acid to eat away the
naked areas of the plate and placing the protected
areas in relief, ready for printing on a letter press.

The result of this process was a printing of flat
colors. More complicated printings were obtained
by mixing a granulated resin with the bitumin; the
printed color areas took on a speckled, aquatint
quality which accommodated an intermixing of
color and, since the white of the paper could show
through, a lighter over-all effect was produced.
After all the complexities of the photo work were
completed, it was still necessary for each plate to be
touched up by hand before a successful color print-
ing was possible. In the production of color illustra-
tions with any degree of creative artistic intent the
engraver and the artist must have worked closely
together in order to achieve their aesthetic goal.
The title pages designed by Paul Avril for Octave
Uzanne's *Evantail* (1882) and *L'Ombrelle* (1883) are
two of the earliest examples of book illustrations
printed in the aquatint grain photo color relief
process. The most notable incunabulum of photo
color relief printing is the extraordinary book of
1883, *L'Histoire des quatre fils Aymon,* illustrated by
Eugène Grasset (Fig. 48).

It is a startling example of a successful collabora-
tion between artist and printer. Charles Gillot trans-
lated, with much input by the artist, the watercolor
designs of Grasset into richly grained, subtle and
refreshing color illustrations innovatingly inte-
grated with the text. The amount of work Grasset
actually performed on the plates must have been
substantial. The work is of major importance in the
history of creative book illustration as well as in the
development of the color movement. Grasset and

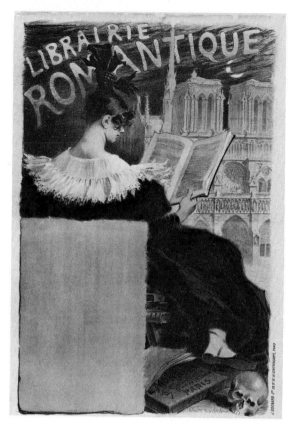

7. Eugène Grasset, *Librarie romantique*,
1887, four color lithographic poster, 39 x 32½″.
Rutgers University Fine Arts Collection,
"Friends" purchase.

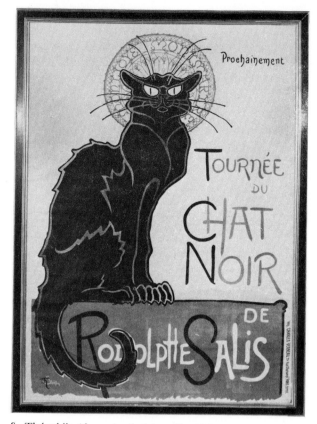

8. Théophile Alexandre Steinlen, *Chat Noir*,
1896, two color lithographic poster, 54⅜ x 38″.
Rutgers University Fine Arts Collection.
Gift of Susan Schimmel.

Gillot used the white of the paper to infuse and enliven the printed color, much as the Impressionists used their canvas to intensify the quality of light. The paper itself, complementing the printed color, functioned for Grasset as it would for the color printmakers of the 1890s. Since there is no half-tone screen—no obvious signs of photographic involvement—the chromotypogravures of Grasset are in texture and concept closely allied with original color prints of the end of the century. It was precisely this print-like, non-reproductive characteristic which later attracted so many young artists to the medium. Théophile Alexandre Steinlen, Henri de Toulouse-Lautrec, Félix Vallotton and others would produce photo color relief illustrations for the journal *Le Rire* at the end of the century. Grasset, however, antedated their efforts and introduced to the general French public quality color "prints" with his photo illustrations for the journal *Paris Illustré* (1886).

As we will see, Grasset became an important figure in the color lithographic movement of the 1890s. In the 1880s he ranked beside Chéret as an early producer of artistic color lithographic posters, not in quantity but rather in quality, specifically with his *Librairie romantique* of 1887 (Fig. 7). Nevertheless, Grasset was essentially a decorative artist who created designs for furniture, tapestries, stained glass windows, textile fabrics and typographical printing, all of which were highly influenced by the romantic and exotic aesthetics of Japan, Persia and Egypt. He was an artist-craftsman

who, like Owen Jones and William Morris in England, sought to imbue everyday utensils with a sense of design and art. It is no wonder then that Grasset relished the concept of artfully illustrating a book in the newly developed mass process of photo color relief printing.

Grasset probably came in contact with Steinlen and Toulouse-Lautrec at the Chat Noir cabaret, the lively and arty nightclub founded by Rodolphe Salis in December, 1881 in the heart of Montmartre, the artists' quarter of Paris (Fig. 8). Its early habitués included not only many young artists such as the three just mentioned, but also such famous figures as Emile Zola, Louis Pasteur, Puvis de Chavannes, Edgar Degas, Félix Nadar, Jules Verne, J. K. Huysmans, John Singer Sargent and Anatole France. In January of 1882, Salis published the first issue of the *Chat Noir* journal which was to exist under his direction until 1895. Its literary and artistic contributors were drawn from the sophisticated clientele and young associates of the cabaret. Henri Rivière, the inventor of the Chat Noir shadow theater, was the journal's artistic director; Georges Auriol, writer, illustrator, and later designer of Art Nouveau type faces, was its secretary; Adolphe Willette, Caran d'Ache and Steinlen were its able young artist-illustrators. Of these five collaborators all but Caran d'Ache would play a part in the color movement.

The early 1880s coincided with the official rebirth of the socialist movement in France, banned since the Commune of 1871. Anarchist and anti-

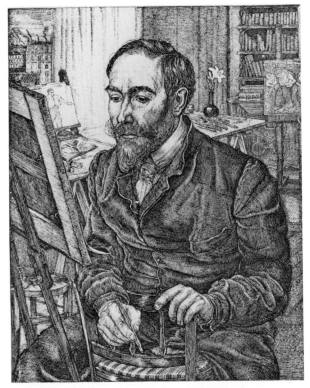

9. P. Dupont, *Steinlen in His Studio*, c. 1900, Wood engraving, 6⅛ x 5″. Rutgers University Fine Arts Collection.

10. Théophile Alexandre Steinlen, *Bruant in His Cafe*, cover for *Le Mirliton*, January 20, 1893, stencil colored photo relief process, 6½ x 5¾″. Rutgers University, Archibald S. Alexander Library, Department of Special Collections.

capitalist ideas were widespread among intellectuals, writers, and artists, many of whom frequented the Chat Noir. For Steinlen (Fig. 9), this philosophical ferment, reinforced by his own experiences of destitution, was to set the tone for his life work. In 1883 Steinlen met the singer and song writer Aristide Bruant, with whom he would collaborate for almost two decades, providing a pictorial complement to Bruant's earthy and descriptive songs of Parisian low life (Fig. 10). For two years, beginning in 1883, Bruant regularly entertained at the Chat Noir, developing an abrasive, aggressive style which brought him great popularity among left bank sophisticates who were drawn to the café for the pleasure of Bruant's insults and gutsy recitals. His songs were of the street people — the prostitute, the assassin, the petty thief, the tramp—sung in the argot of the street. They circulated among the bistros and the unsavory parts of the city, so that he was soon dubbed the "Chansonnier populaire."

Steinlen's first collaborative effort with Bruant occurred in the August 9, 1884 issue of the *Chat Noir* in which Steinlen illustrated Bruant's song *Le Chat Noir ballade*, dedicated to Salis. When Salis moved the Chat Noir to larger quarters in June 1885, Bruant took over the old building and established his own café-concert, Le Mirliton, where for twelve years he continued to throw abuse at his customers. After the example of Salis, Bruant began to publish his cabaret's journal, *Le Mirliton*, in the fall of 1885. For ten and one-half years it was irregularly issued, sometimes monthly, sometimes

bi-weekly, and existed primarily to publicize Bruant's songs, although later, in 1892, it developed into an organ for all Parisian cafés-concerts. The illustrators included Henri Pille and Heidbrinck as well as Steinlen and Toulouse-Lautrec, using their pseudonyms, Jean Caillou and Tréclau. For the last two artists especially, their careers in color printing began with *Le Mirliton*. Unlike the *Chat Noir*, printed in black and white, and *Paris Illustré*, printed in color by a photo relief process, *Le Mirliton's* photo black line illustrations were colored by stencils or *pochoir*.

From its inception, Steinlen's illustrations dominated *Le Mirliton*. He effectively developed the economical system of coloring by stencil—in the cover for November 1888, for instance, he used pink and blue plus the black ink of the press and the stark white of the paper to produce a dramatic moonlit view of "la rue" that sympathetically but humorously deals with the alcoholic (Fig. 11). Toulouse-Lautrec's 1887 cover for the journal also simply but effectively stencil colors his dynamic composition of a worker observing a funeral procession (Fig. 12). In addition to their work for *Le Mirliton* Steinlen (in the late 1880s and early 1890s) and Lautrec (in the early 1890s) had their black and white lithographic cover illustrations for song sheets colored by stencils. Steinlen produced a great number of these lithographic covers for Bruant as well as for the journal *La Semaine artistique et musicale*, extending the use of stencils into ever greater complexity, sometimes using subtly overlaid colors to produce intermediary tints.

7

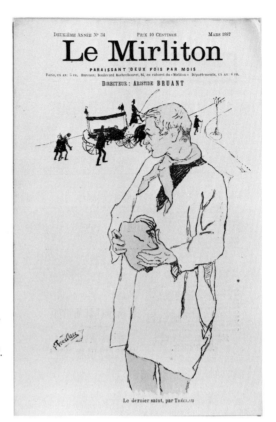

11. Théophile Alexandre Steinlen (signed Jean Caillou), "Soulauds" cover for *Le Mirliton,* November, 1888, photo relief process with two color stencils, 11 x 6⅞". Rutgers University Archibald Alexander Library, Department of Special Collections.

12. Henri de Toulouse-Lautrec (signed Tréclau), "Le Dernier Salut" cover for *Le Mirliton,* March, 1887, photo relief process with three color stencils, 11 x 6⅞". Rutgers University, Archibald Alexander Library, Department of Special Collections.

In terms of public visibility Steinlen was the Norman Rockwell of the late 1880s and 1890s. From 1883 through 1900, he produced illustrations for over 100 books, approximately 2000 illustrations for fifty journals, close to 200 lithographic music sheet covers, more than 300 individual lithographs and etchings and thirty-six large lithographic posters plus a miscellany of other work. Between 1891 and 1900 his thousand cover and back-page photo color relief illustrations for *Gil Blas illustré,* the weekly literary magazine of the daily newspaper *Gil Blas,* reached an average weekly audience of 200,000. In 1893-94, simultaneously with his work in *Gil Blas illustré,* Steinlen produced thirty-two full-page covers in color for the socialist journal *Le Chambard,* which had a weekly circulation of 50,000. The humanity of the street—the working class, the uneducated, the exploited—was the pervasive subject of Steinlen's art. His popular sympathies found an economical and popular vehicle of expression in the photo and stencil printing processes. Color, either by relief process, stencil, or lithography was, for Steinlen, a dramatic and effective means of communicating his social messages.

The application of photo-mechanical or stencil colored illustrations in journals and books in the 1880s played an important role in sensitizing the public to the use of color in printing. The activities of Grasset, Steinlen and Lautrec in the genesis of these processes paved the way for other artists to attempt work in these media. Notable among them were Edouard Vuillard in his first 1890 program for the Théâtre Libre and Pierre Bonnard with his illustrations for the 1893 music book *Petit Solfège illustré* by Claude Terrasse (Fig. 13). While photo processes were generally frowned upon by the established and older generation of artists and critics, they were often treated by the young with the same respect given to traditional print techniques. One finds, for instance, proofs of Lautrec's photo color relief illustrations for *Le Rire* printed on china without the text, signed and numbered by the artist and impressed with the publisher's (Kleinmann) stamp.

Repercussions of the involvement of artists with the new color processes in the 1880s and of the obvious economic benefits of the processes were felt throughout the 1890s, and a large body of such work was produced. This is most apparent in the numerous artistic posters for the Salon des cent exhibitions printed in a photo relief process and colored by stencils, and also with the inclusion of many photographic prints (collotypes) colored by stencils and listed as original prints in the 1897-99 portfolios of *L'Estampe moderne.*

The democratization of color printing brought about by the new photo processes in the 1880s was, therefore, one highly available force inducing the artist-printmakers to begin thinking in terms of color. Another powerful force was the Japanese color woodblock print.

Beginning with its discovery in 1856 by Félix Bracquemond, the Japanese print served as a major source of inspiration to many traditional and

13. Pierre Bonnard, illustration from *Petit Solfege illustré* by Claude Terrasse, Paris, 1893, two color photo relief process, 7½ x 10⅛". Rutgers University Fine Arts Collection.

avant-garde French artists throughout the century. By 1890 the Japanese print had been documented and legitimized by scholarly publications and had been made readily visible to artists through a series of exhibitions and publications. In 1883 *L'Art japonais,* a two volume history of Japanese art, was written and published by Louis Gonse, director of the *Gazette des Beaux-Arts.* This coincided with the first major retrospective exhibition of Japanese art in the Western world at the Gallery of Georges Petit. In 1887 Vincent and Théo Van Gogh organized an exhibition of Japanese prints from the collection of Samuel Bing at the Cafe Tambourin in Montmartre. The next year Bing exhibited an even more extensive display of Japanese prints in his shop at 22 rue de Provence, and in May of 1888 he began publishing the journal, *Le Japon artistique,* which for three years presented fully illustrated articles in color and black and white on all aspects of Japanese art. The 1889 Universal Exposition in Paris presented a major display of the art of Japan and was followed in 1890 by a comprehensive and monumental exhibition of Japanese prints at the École Nationale des Beaux-Arts.

In 1889 Auguste Lepère and Henri Rivière created their first color prints. *La Convalescente* by Lepère and the *Chantier de la tour Eiffel* (Fig. 14) by Rivière are in the color woodblock medium and were directly inspired by the Japanese in technique, style and subject matter. This becomes evident with Rivière's print which was one of eventually three woodcuts made for what in 1902 became the series of color lithographs entitled *Les Trente-Six Vues de la tour Eiffel.* The title, the theme and much of the style and format were inspired by Hokusai's *Thirty-Six Views of Mount Fuji.*

The Japanese print, with its humble status and function in its homeland, reinforced the democratic concept of printmaking promoted by the color photo processes. However, unlike the latter, the Japanese print offered the artists in France the precedent of the use of color in original printmaking and in the creation of individual prints or a series of prints unrelated to a text. An obvious example of the appeal of the Japanese woodblock in France is Mary Cassatt's remarkable attempt to duplicate the Japanese system of color printing in her well-known 1891 series of ten color etchings. The Japanese print proved to be a fundamental and sustaining influence on the color revolution. Throughout the 1890s it would be an essential aesthetic source for many of the color lithographs of Toulouse-Lautrec, Bonnard, Vuillard, Denis, Grasset and others.

Today when one tours Paris, one finds the exterior walls of building after building blatantly stamped with the phrase "Défense d'afficher Loi de 29 juillet, 1881." This almost comic situation of the official desecration of walls in order that they not be desecrated by posters is relevant to the development of poster art in France at the end of the century and, thus, indirectly to the color movement. The phrase itself refers to the 1881 law on freedom of the press which lifted many of the restrictions and

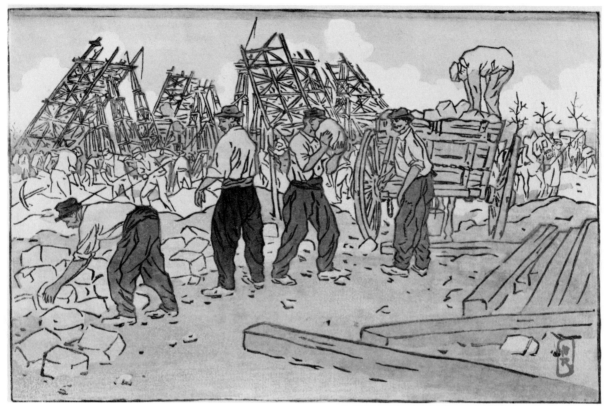

14. Benjamin Jean Pierre Henri Rivière, *Chantier de la tour Eiffel*, 1888-89, seven color woodcut, 8½ x 13½". Rutgers University Fine Arts Collection.

censorships on printed matter established between 1830-1880.

The law affects the poster in various ways. Prior to July 29, 1881 the *afficheurs* or individuals who actually pasted posters to walls had two legal obligations: to obtain official authorization for their work and to show each poster to the prefect of police. After enactment of the new law, both of these requirements were dropped, and the number of afficheurs rapidly increased.

The 1881 law allows the placement of posters (appropriately taxed) everywhere except on churches, voting rooms and areas designated by the mayor of each community for the posting of official notices. The latter are indicated by the printing of the above quoted phrase. One aspect of the law which has had aesthetic ramifications is the qualification that only white paper be used for the printing of official notices. All other posters for public display must be printed on tinted papers. Also, anyone found removing or destroying posters may be fined, imprisoned or both. The law at one fell swoop liberated the production of posters and facilitated the growth in the 1880s of a vast new industry —*"Les compagnies d'affichage"*—comprised of designers, printers and pasters (Fig. 15).

It is possibly only a coincidence, but that same July (1881) Jules Chéret transferred the responsibility of his print shop to Chaix and company, although he maintained artistic control. The freedom gained for Chéret with this merger enabled him to concentrate more fully on the design of posters and

to lead the way in the production of the artistic poster. Simultaneously, in November of 1884, Gustave Fustier and Ernest Maindron published in separate journals the first historic and critical studies of the French poster. While there were other poster designers working at this time (Fustier lists nine, all out of the shop of Emile Levy, with the Choubrac brothers Léon and Alfred (Fig. 16) the most notable), Chéret is designated by both critics as the master of the illustrated poster. By 1884 he was said to have produced close to 1,000 posters and annually was printing nearly 200,000 impressions. At the same time, Maindron names eight printers (Appel, A. Chaix, Clarey, Danel, de Lille, Duprey, Franc and Laas) who specialized in posters.

The first poster exhibition in France occurred that same year in the Passage Vivienne, Paris. It was small and included American as well as French posters with specific representation of the work of Chéret and the two Choubracs. By the summer of 1885 the artistic qualities of Chéret's posters were beginning to be widely recognized: "Today the color lithographs which are posted on the walls are veritable signs which appear like gouaches or watercolors. . . . At the present, the bragging electoral bills which cover our walls have not yet borrowed the talent of Chéret." However, it was the inclusion of Maindron's article in the richly illustrated book *Les Affiches illustrées* (Fig. 17) and the publication that same year (1886) of the section on Chéret in Henri Beraldi's *Les Graveurs du XIXe siècle* that brought to the fore the immensity and brilliance of Chéret's

15. Eugène Atget, *rue de L'Abbaye*, 1898, Photograph. Cabinet des estampes, Bibliothèque National, Paris.

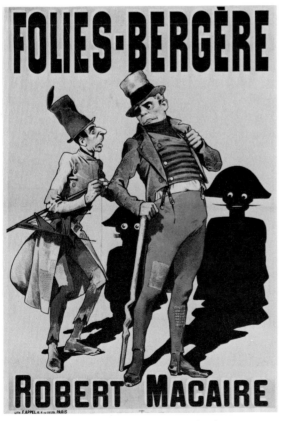

16. Alfred Choubrac, *Robert Macaire*, 1880s, six color lithographic poster, 44½ x 30¼". Rutgers University Fine Arts Collection.

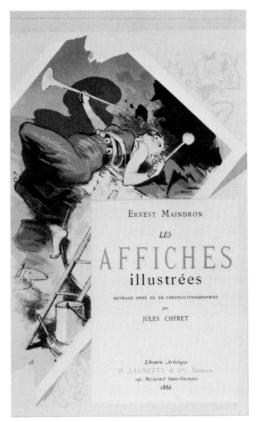

17. Cover by Jules Chéret for the book *Les Affiches illustrées* by Ernest Maindron, 1886. Rutgers University Fine Art Collection.

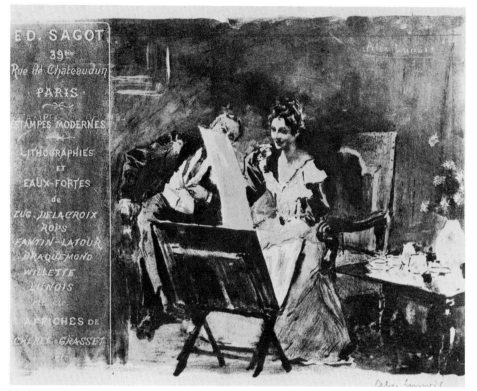

18. Alexandre Lunois, *Ed. Sagot,* 1894, four color lithograph, 6½ x 8⁹/₁₆″. Rutgers University Fine Arts Collection.

career and, with that, the broader recognition of the color lithographic poster as a developing art form in France. This was an important step for the poster and the color movement, per se.

The reaction to the two publications was almost spontaneous: there rapidly developed a general interest in the poster among art collectors and, correspondingly, the active involvement of book and print dealers in the retail trade of illustrated posters. It was no idle boast when Maindron later stated in reference to the two 1886 publications that "there did not yet exist any book or print dealer who would dream of acquiring or cataloging posters. . . . We, the two of us, opened the way for dealers."

Edmond Sagot was the first to add illustrated posters to his inventory and enthusiastically to support the "new art" (Fig. 18). Sagot established his Librairie de nouveautés et librairie artistique on the right bank at 53 rue d'Argout in 1881. Dealing in rare and contemporary prints and books, Sagot began publishing a sale catalogue in December, 1884 and continued to do so every two to three months until 1901. In Catalogue no. 8 for September-October, 1886, Sagot included such items as Maindron's *Les Affiches illustrées* and the 1884 *Le Livre* with Fustier's article on posters. Most significant, however, were two entries, one which itemized a collection of sixty-two theatre posters, all anonymous except six by Chéret, and another which listed a collection of fifty-four Chéret posters ranging in price from twenty-five centimes to

ten francs. Three other dealers, L. Sapin, Georges Brunox, and Vanier were soon to follow Sagot's lead.

By 1888 poster mania was in full swing and even the law of 1881 could not protect those on walls from the prowling passionate collector. Nor could it control where posters were placed:

> The law which regulates the poster is no longer observed to the letter. One easily forgets that the placards cannot be placed indiscriminately throughout and the local authorities, in the province, do not sufficiently protect the historic monuments against the untimely invasion of electoral posters and others.
>
> Where is not the poster today? It is everywhere, not only in the street but behind the shop windows of merchants, and that of the smallest pub where it proclaims the benefits of the latest bitter.

In 1889 Ernest Maindron organized the first large scale exhibition serving as a historical resumé of the French poster at the Paris Universal Exposition in the Palais des arts libéraux; that year in Nantes Gustave Bourcard organized an exhibition of 310 posters at the Galerie Préaubert; and, beginning in December, Chéret's first one man exhibition of paintings, pastels and posters, accompanied by a catalogue by the critic Roger Marx, was installed at the Théâtre d'Application, Paris. The style of Chéret's poster designs changed perceptively during the decade of the 1880s. As early as 1877 one finds a greater use of lithographic crayon, developing a freer sketch-like quality of drawing and an opening up of the composition. By the end of the 1880s the gradated color background disappears

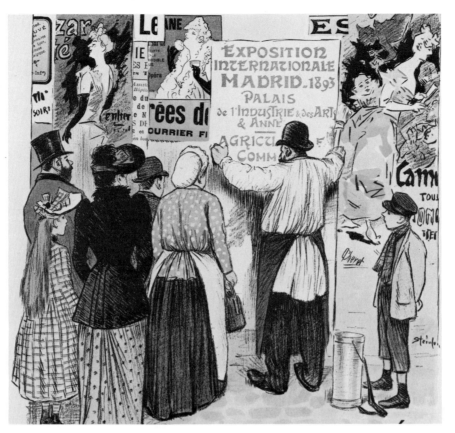

19. Théophile Alexandre Steinlen, advertisement for the Madrid International Exhibition of 1893, three color photo relief process, 8 x 9″. Rutgers University Fine Arts Collection. Chéret's posters crowd the wall.

from his work, black becomes negligible and the use of *crachis*, a light rain of spattered ink, dominates the light, atmospheric compositions of five and six colors. As the following notice reveals, Chéret's work was universally appreciated by the eve of the 1890s: "Chéret has arrived at his hour of popularity. His posters are the joy of Paris, and amateurs and artists class them with reason among the delicate and original works of this time" (Fig. 19).

Not only had Chéret's reputation grown, but so too had the size of his posters (Fig. 20). It is difficult to determine precisely the evolution of the various poster sizes and formats. Fustier stated in 1884 that "the discovery of lithographic machines of a large format permitted Chéret to execute some colossal posters several meters tall." However, Maindron's 1896 catalogue of Chéret's posters gave 2½ meters as the largest measurement. Obviously, large posters could and were made by the registration and pasting together of two or more printed sheets. It was only in 1888 that a press was built large enough to receive a stone measuring 1 meter 56 x 1 meter 13, making the poster of grand format more easily obtainable.

However, as early as 1818, Senefelder had experimented with the zinc plate as a replacement for the bulky lithographic limestone. By 1874 the production of zinc plates had reached such a state of perfection that the printer Monrocq replaced all his stones with zinc. Zinc was lighter, generally eight times cheaper, and its pliability allowed it to be used in large sheets on a cylinder press. According to Lorilleux, zinc gave superior results to stone when printing crayon images transferred from a grained paper; and Lemercier praised the metal as a highly successful material for the planographic printing of posters. Zinc was used by Toulouse-Lautrec for the 1896 poster *The Ault & Wiborg Co.;* while, in 1889, Gauguin used zinc for his series of eleven planographic prints depicting scenes of Brittany, Arles and Martinique. Stone was preferred by most artists, probably because of zinc's connection with industrial printing. Nevertheless, for practical reasons, zinc often replaced stone in the creation of large color lithographic posters. The concern for large posters continued into the 1890s—gigantic color lithographic posters such as Steinlen's *La Rue* (Fig. 60) measuring 2 meters 38 x 3 meters 04 and Herbert Dys' *Imre Kyvalfy's superbe creation,* mentioned by Maindron, 2 meters 85 x 5 meters 85 are exceptional examples of the grandiosity of the color revolution.

While the color lithographic poster began to emerge in the second half of the 1880s as an independent aesthetic force in French art, the color lithographic print was almost non-existent. In fact, during the entire decade less than a dozen—and all by one artist—were created, in contrast to the thousands of posters. This in spite of a genuine renewal of the medium of lithography promoted by the founding of the Société des artistes lithographes français in 1884. Discouraged with the general lack of lithographic work on the part of artists and with the preference for engraving of the Salon's jury,

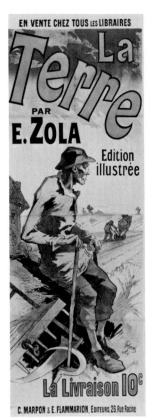

20. Jules Chéret, *La Terre,* 1889, five color lithographic poster, 97 x 34″. Rutgers University Fine Arts Collection.

Paul Maurou, a conservative, reproductive, but competent lithographic artist, initiated the new organization in the summer of 1884 in order "to perpetuate the art of lithography." Chéret, Edouard Duchatel, Hermann-Paul, Odilon Redon and Alexandre Lunois, all future participants in the color revolution, became members of the Society of French Lithographic Artists in the 1880s; yet, except for Chéret's commercial work, their contributions to the color movement awaited the next decade. Only one member, John Lewis Brown, broke with the artists' traditional prejudice against color lithography and produced eleven prints, each with three to five colors between 1883 and 1890. Brown's subtle color lithographs (e.g. his first, *Eventail du cirque Molier,* and his last, *Amazone* (Fig. 21)) deal primarily with the theme of horses and are reminiscent of paintings by Degas. His color work comprised half of his total lithographic output which began in 1849. In 1890 Brown joined the dissidents of the Society of French Artists in organizing their own Salon. His untimely death that year robbed him of possible notoriety in the color revolution. Nevertheless, he is an important, independent precursor of the activities of the 1890s.

Indeed, there was not an abundance of creative printmaking in any medium during the 1870s and 1880s in France. The "painter-printmakers" so necessary to the Romantic lithographic movement in the 1820s and 1830s and to the renaissance of original etching in the 1850s and 1860s were far less visible in the 1880s. The prints by Degas and Pissarro, for instance, were private efforts rarely made available to the public until later. Rather, the works most visible and touted by the Salon were reproductive prints, while the photo intaglio reproductions of paintings and old master prints published by Goupil and Co. and the company Armand-Durand were a great commercial success. This arid, controlled climate caused some artists and critics to reflect upon the past glories of printmaking by artists such as Rembrandt, Tiepolo, Goya and Charles Meryon and to react positively and aggressively. This is certainly the case with the founders of the Society of French Lithographic artists who hoped for the return of quality lithography on a par with that produced by Charlet, Delacroix, Daumier and Gavarni earlier in the century.

In 1888 and 1889, respectively, it became the purpose of the Société de l'estampe originale and the exhibition Peintres-Graveurs to rejuvenate French printmaking by stimulating painters to create original prints and to offer an alternative for innovative artists to the closed doors of the Salon. The Society of the Original Print, directed by J. D. Maillard, had planned to produce a biannual publication starting May 1, 1888 consisting of original prints in all media and limited to 150 impressions printed under the supervision of the artist. Unfortunately, very little is known of the publications and only ten prints by six artists resulted from the project. However, in his preface to the 1889 catalogue of the first *Exposition des peintres-graveurs*

14

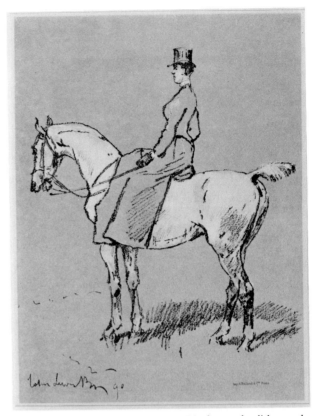

21. John Lewis Brown, *L'Amazone*, 1890, three color lithograph, 12¼ x 9¼". The Metropolitan Museum of Art, Gift of Durand-Ruel, 1924.

Philippe Burty indicates the common ground for these two ventures:

> Several months ago, I received the first issue of a newly born publication, *L'Estampe original.* Mr. Roger Marx in the forward puts forth a program full of sense and of confidence in the future. The thought which presides at the exhibition of Painter-Printmakers is therefore at this moment on everyone's mind. It is necessary to give more importance than ever to the personality of the original print. Any reproduction of another work by whatever process is not admitted to this exhibition.

As Burty further explains, the exhibition also served to expose the "knowledgeable public" to graphic works not seen at the Salon and to cultivate an elite group of collectors committed to the original print. The exhibition held at the Durand-Ruel Gallery consisted of 353 objects, mostly prints, by thirty-nine French, American and Dutch artists including John Lewis Brown, Mary Cassatt, Chéret, Degas, Camille and Lucien Pissarro, Rodin, Redon, Félix Bracquemond and Henri Guérard.

The results of the exhibition were gratifying to Burty. In the preface of the catalogue of the second annual Exhibition of Painter-Printmakers he states:

> Today, almost all the printmakers are beginning to print their own studies, to vary the effects of impressions. All possess some convenient presses in their studios. I owe it to myself for my friends going first class.

Thus, at the end of the decade, the seed was planted for a renaissance of original printmaking which was to blossom fully in the 1890s with color lithography as its major element. As we have seen, the greatest influences on artists to begin thinking in terms of printing in color were the color photo printing processes, the Japanese print, and the development of the poster as a legitimate art form. Out of all of the activities in the 1880s relevant to color printing, however, the renewal of interest on the part of many artists in creative printmaking was the last and most essential ingredient for the birth of the color revolution.

P.D.C.

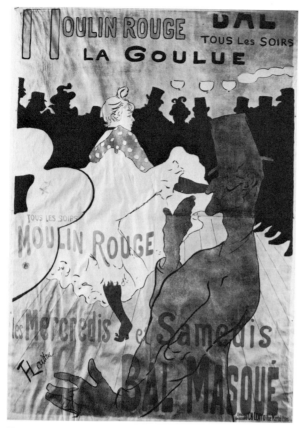

22. Henri de Toulouse-Lautrec, *La Goulue au Moulin Rouge,* 1891, four color lithographic poster, 67¾ x 48". Mr. and Mrs. Herbert D. Schimmel.

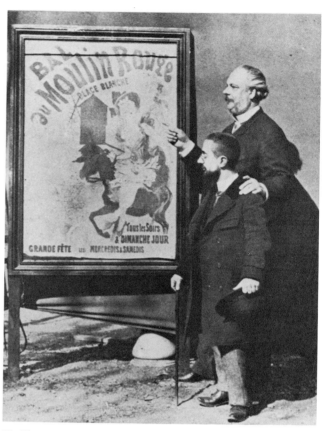

23. Photograph of Henri de Toulouse-Lautrec and Zidler, owner of the Moulin Rouge, standing in front of Chéret's poster, c. 1891.

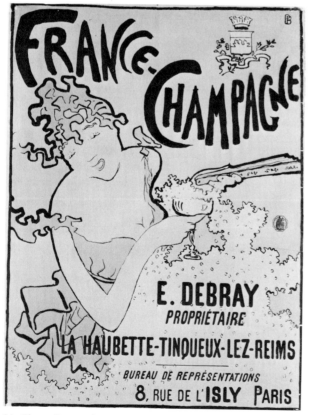

24. Pierre Bonnard, *France Champagne,* 1889, three color lithograph, 30⅛ x 23". Collection, The Museum of Modern Art, New York, Purchase.

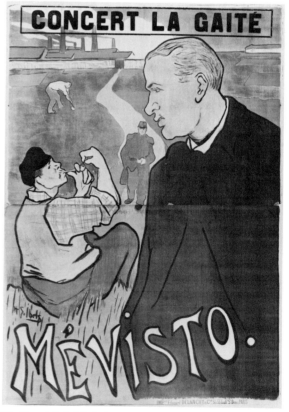

25. Henri-Gabriel Ibels, *Mévisto,* 1892, three color lithographic poster with black stencil, 67 x 47". Rutgers University Fine Arts Collection.

the 1890s: the revolution

I F it were possible to name one work as the start of the color revolution, that distinction would undoubtably go to Henri Toulouse-Lautrec's 1891 color lithographic poster *La Goulue au Moulin Rouge* (Figs. 22, 50). Stylistically its dramatic break with past work in color (including that by the much admired Chéret) indicates not only a new phase in the development of French poster art but also in color lithography per se. In 1889 Chéret had produced the first poster for Zidler's Montmartre dance hall, the Moulin Rouge (Fig. 49). It is a composition of gay, slightly modelled figures placed within a bright and colorful three-dimensional environment with illusionistically projecting letters superimposed. The photograph of Lautrec and Zidler in front of Chéret's poster is suggestive of Lautrec's respect for the work of the older lithographer (Fig. 23). However, the young artist, using the same colors as Chéret (yellow, red, blue plus black) introduces the dominant color aesthetics of 1890s graphic art. The bold yellow globes of light pasted against the stark white of La Goulue's undergarments, the black cut-out like figures of the audience in the back similar to the silhouette images projected on the screen of a Chat Noir shadow theatre, the large simple red and black letters, and the foreshortened profile figure of the dancer Valentin create a dynamic pattern of flat colored shapes emphasizing the two dimensional picture plane. As André Mellerio states, "This is no longer just a poster, and it is not yet quite a print, it is a work of a hybrid pungency deriving from the two or rather, yes . . . it is the modern print." Pierre Bonnard's subtle pink, orange and black poster, *France-Champagne* (Fig. 24), predates that of Lautrec by two years. Indeed, as Roger-Marx suggests, it may have been Bonnard who introduced the other to color lithography. Nevertheless, it is Lautrec's fully developed use of the three primary color system and his bold approach which made his *Moulin Rouge* the most significant color work to that date.

The following year, 1892, he created five major lithographic works in four to six colors: two prints, *Au Moulin Rouge la Goulue et mome Frome* and *L'Anglais Warner au Moulin Rouge* (Fig. 53) plus three posters. These were complemented by posters by Grasset and by Henri Ibels (Fig. 25), as well as the latter's color lithographs for *L'Amour s'amuse*. No matter how important or seminal a role Lautrec played, it is too simplistic to set aside one artist or one work as the initiator of the color revolution. Rather, it is the accumulation of a body of work by young avant-garde artists, beginning hesitantly in 1888 and coming to a head in 1893 with the publication of *L'Estampe originale*, which makes it apparent that the medium of color lithography was the prime vehicle for innovative printmaking of the 1890s.

In the Spring of 1887 André Antoine opened the Théâtre Libre in Montmartre. This experimental theatre—which introduced realism to the French stage with productions by Zola, Ibsen and Strind-

Le blanc Pierrot, assassiné,
N'est-il pas l'Idéal sans tache
Que la Réalité s'attache
À frapper d'un poing obstiné?

Qu'importe! Pierrot vit encore,
Et du plus pur sang de son coeur
Jaillit toujours l'Espoir vainqueur
Fleur de pourpre qui le décore!

Rodolphe Darzens

1re 1888 -

26. Adolphe Willette, Théâtre Libre program, 1888, five color lithograph, 9⁷/₁₆ x 6⅜". Rutgers University Fine Arts Collection.

berg—used the talents of equally radical young artists to illustrate its programs. Thirty-five illustrated programs in black and white and in color were issued by the theatre during its nine years of existence. For many of the artists, the Théâtre Libre offered the first opportunity (outside of painting) to work in color and specifically in color lithography.

From 1888 to 1894, the theatre's most active and influential period, it commissioned programs in color by Willette, Signac, Vuillard, Ibels, Charpentier, Auriol, Rivière and Lautrec. Willette began the series with his five color lithograph of October 1888 (Fig. 26); it was followed in December by the nine color litho by Paul Signac, his first (Fig. 51). Signac's design serves as a dual advertisement for the Théâtre Libre and Charles Henry's recent publication *The Chromatic Circle*. In the announcement the bold initials, T-L, are divided into Henry's harmonious color scale, while the circular scene in a pointillist style is the first application in lithography of the divisionist color theory. The color lithographic programs of Charpentier and Rivière for the 1890-91 season carry their distinctive trademarks — Charpentier added four colors to his characteristically embossed impression while Rivière imitated the subtle coloration and format of Japanese woodcut albums. That same year Vuillard produced his first color work, a photo relief and stencil colored program. The 1892-93 season was dominated by a spectacular series of eight color lithographs by Ibels (Fig. 52). In reference to this series Antoine remarked the next year: "I have

succeeded in continuing a series of programs and it will be unique. . . . I have even had the pleasure of furnishing a newcomer with an opportunity to show himself in an original way by setting aside eight programs for H. G. Ibels last year." During Antoine's final year (1893-94) as director of the Théâtre Libre, Toulouse-Lautrec designed three programs in this medium.

The use of color lithography to illustrate theatre programs was not introduced by the Théâtre Libre. John Lewis Brown had, in fact, produced one in 1883; and, of course, Chéret had designed many over the previous years. But the combination of color lithography and the theatre program became just the right vehicle for young artists to gain exposure of their work and realization of their aesthetic goals. The collaboration of artists with the theatre created a dialogue between the new movements in the visual and the performing arts, in effect allowing empathetic artists to express on paper, often in color, the concepts of the realist or (beginning in 1893) the symbolist theatre.

By 1893 realism had run its course as a movement in the theatre. In its place the symbolist theatre began to emerge with Lugné-Poe and his Théâtre de l'Oeuvre. Lugné-Poe continued Antoine's practice of commissioning young artists to illustrate programs. The theories of Paul Gauguin in which he emphasized the symbolic functions of flat pure colors and sensuous line were officially established as the aesthetic doctrine of the Nabis— the group organized by Paul Sérusier in 1889. It was

18

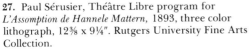

27. Paul Sérusier, Théâtre Libre program for *L'Assomption de Hannele Mattern,* 1893, three color lithograph, 12⅜ x 9¼". Rutgers University Fine Arts Collection.

natural, then, that the bulk of the programs for the Théâtre de l'Oeuvre be produced by members of the Nabis such as Bonnard, Vuillard, Denis, as well as Serusier who had already produced a rather symbolistic color design for an 1893 Théâtre Libre performance (Fig. 27). Ironically, very few programs for the Théâtre de l'Oeuvre were made in color. Those for its realist predecessor, however, excelled in color and established color lithography as an expressive medium for numerous artists recently acquainted with printmaking.

In April 1890 the dealer, Edmond Sagot, activated his role as middle-man by collaborating with Chéret in the publication of a series of twelve color lithographic posters printed in an edition of fifty proofs, signed and numbered by the artist. According to Sagot, the posters would be printed on a paper "which assured the conservation of it for an unlimited time; they permit the artist or the man of the world to decorate the family 'home' and bring to it by their brightness and gaiety a note of exquisite art." By this time the collector had become an influential force in French poster art. Sagot's publications directly catered to the collectors' quest for the rare, the unique, and the esoteric in color printing. An example from his 1891 catalogue is quoted below:

> We have had printed and put on sale four collections of proofs separated from our poster, *La Jolie Jardinière;* these collections are thus composed: yellow, red, blue, backgrounds in two tones, yellow and red, yellow-red, blue and a proof pulled in black from the blue stone (which gives

the contours); the reunion of these proofs gives the genesis of our poster; it interests the artist, the curious and all those who are fond of the processes of color impressions.

That year Sagot continued to go all out in his promotion of posters; in November he published as sale catalogue no. 30 the *Catalogue d'affiches illustrées anciennes et modernes,* the first dealer's catalogue exclusively dedicated to posters. Limited to a printing of 550 copies, each catalogue included an actual poster by Chéret, while the cover was a five color lithograph by the same artist. Inside were over one hundred pages abundantly illustrated, describing 2,200 posters with, for the first time in a Sagot catalogue, Steinlen and Rivière listed among the moderns. The following year, 1892, Sagot organized an exhibition based on the same theme at the Théâtre d'Application which was accompanied by a historical survey of the poster written by Germain Hédiard.

His contemporaries appreciated Sagot's unique role as a dealer:

> It is on the left bank at 18 rue Guénégaud at Mr. Edmond Sagot's that the passion of illustrated placards has found its general quarter or rather its central foyer. . . . Sagot becomes the poster-man of the bookshop; he draws to him all the lithographs not on walls and all the curious amateurs of the capital; he monopolizes the poster, the collectors of posters, and in his tiny tiny shop, scarcely a space of twelve square meters, he has found the means of placing thousands of rare pieces including some curious surveys of ancient and modern illustrated placards.

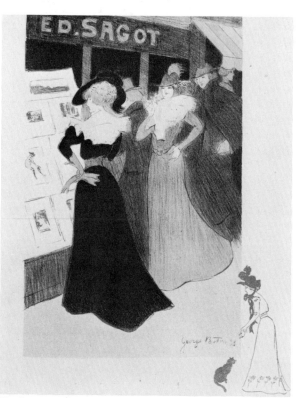

28. George Alfred Bottini, *Sagot's Gallery,* 1898, four color lithograph, 12⅝ x 9¼″. The Grolier Club, New York.

As Chéret was the father of the modern poster, Sagot was certainly the father of the modern print dealer — selecting and promoting individual artists, publishing their posters, prints and illustrated books while maintaining an extensive selection of items to sell (Fig. 28). As one reviews his sale catalogues it appears that as soon as a print was produced by any young artist of worth it immediately found its way into the Sagot catalogue. Sagot was constantly on top of the current print, poster and print album scene; his catalogues serve as a record of the massive printmaking activity of the decade.

By 1893 other dealers began to participate in the printmaking renaissance. Eventually four were to emerge to play major supportive roles in the color revolution: Gustave Pellet, Edouard Kleinmann, A. Arnould and Ambroise Vollard. From 1888 to 1895 Pellet was listed in the Paris Bottin as a bookdealer; in 1894, in addition to selling prints, he began publishing color lithographs by Paul Signac, and in 1896 he published Lautrec's *Elles* series (Figs. 63, 64). The following year he published a large quantity of color lithographs by Maximilien Luce, Alexandre Lunois (Fig. 67), Georges Jeanniot as well as prints in other media by Félicien Rops, Louis Legrand, Charles Maurin and Odilon Redon.

As early as 1893 Kleinmann had produced his first sale catalogue which lists prints by Steinlen, Ibels, Toulouse-Lautrec, Willette, Chéret, Forain and others. The next year prints and posters by Grasset, Maurin, Rivière, Vallotton, Luce and de

Feure were included among his holdings.

A. Arnould was listed in the 1891 Paris Bottin as a bookbinder; however, by 1896 his activities had expanded greatly as suggested by his important *Catalogue d'affiches artistiques* which lists 451 French and foreign prints and posters, many of which are illustrated. A color lithograph by Toulouse-Lautrec serves as the cover for the *Catalogue* (Fig. 29).

Ambroise Vollard, first a dealer in Impressionist paintings, commissioned his first print portfolio in 1895, the series of twelve color lithographs by Bonnard entitled *Quelques Aspects de la vie de Paris* (Figs. 72, 73, 74). This was followed by two group portfolios, *L'Album des peintres-graveurs* (1896) and *L'Album d'estampes originales de la Galeries Vollard* (1897). By the end of the century he had become the most prolific publisher of avant-garde prints, with individual portfolios by Redon, Vuillard and Denis. Vollard's contribution will be discussed further. In the 1880s there were only four shops in Paris which dealt in contemporary posters and prints; by the end of the 1890s there were at least twenty-three dealers, printers or journals selling and/or publishing contemporary work (Fig. 30). There were also numerous printers available to produce this massive artistic output. The principal shops were those of Edward Ancourt, Chaix and Company, Alfred Lemercier, Bougerie and company, Eugène and Charles Verneau, and the independent master, August Clot. Clot was friend and technical adviser to many artists including Bonnard, Vuillard and Luce, and was responsible for printing

29. Henri de Toulouse-Lautrec, cover for Arnould's *Catalogue d' affiches artistique*, 1896, three color lithograph, 9⅜ x 5⅞". Boston Public Library.

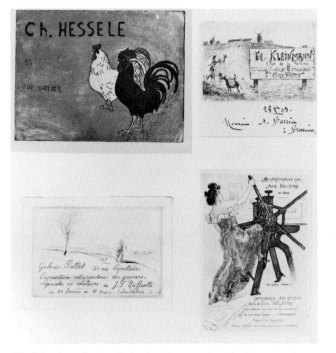

30. Selection of print dealers' address cards etched by Francis Jourdain, Henri Boutet, J. F. Raffaelli and Richard Ranft. The Grolier Club, New York.

many of the major color lithographs of the decade.

The artists, dealers, and printers became mutually supportive of one another: as more artists practiced printmaking, there was more need for printers and dealers; and as more dealers ventured into the area of publishing prints and portfolios of prints, more artists attempted printmaking, until in the mid-1890s the system became self-generating for a while.

At the end of 1892 Octave Uzanne was able to assert: "I believe that I can without any compromising, advance this opinion, that lithography is on the verge of entering into a superb blossoming of a renaissance." By then the signs were right for such an observation, and it was not a new one. In April and May of 1891, due to the efforts of the Société des artistes lithographes Français, a large scale exhibition on the history of French lithography was held at the Ecole des Beaux-Arts. It was comprised of over 1,000 lithographs, including in color: Manet's *Polichinelle,* nineteen by Chéret and one by Brown. The exhibition also coincided with the third annual Exposition des peintres-graveurs at the Durand-Ruel Gallery.

As Beraldi stated in the preface of the lithography exhibition catalogue, it was organized "because the renaissance of lithography seems to be in the air. . . . If it puts lithography in the minds of the public, if it puts the lithographic crayon into the hand of the painter . . . this exhibition will have been truly useful."

The show had little public success; however, in

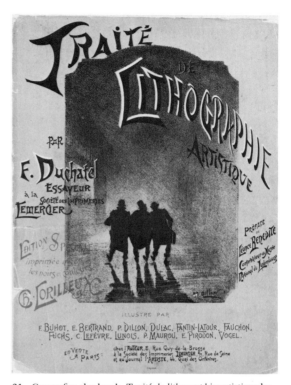

31. Cover for the book, *Traité de lithographie artistique* by Edouard Duchatel, 1893. Rutgers University Fine Arts Collection.

order to help "put the lithographic crayon into the hand of the painter," in 1892 Léonce Bénédite, curator of the Luxembourge museum in Paris, Henri-Patrice Dillon, painter and lithographer, and Jean Alboise, director of the journal *L'Artiste* began publishing *Les Peintres-Lithographes,* an album of original lithographs which eventually involved over sixty artists in the production of seventy prints.

The next year E. Duchatel published the first instructional manual on artistic lithography since Engelmann's treatise of 1835 (Fig. 31). The manual is illustrated with lithographs by twelve artists, including one in color by Alexandre Lunois. One section is reserved entirely for color lithography, describing the process in detail and illustrating it step by step with color proofs. Although the lithographs in both *Les Peintres-Lithographes* and Duchatel's manual stylistically lack avant-garde tendencies, the publications themselves are the first two to include color lithographic prints and, as such, are indications of the coming flood.

By 1893 if there were any doubts that there was a printmaking renaissance and that lithography dominated this general print revival, those doubts were quieted forever by a new publication entitled *L'Estampe original* (Fig. 32). André Marty, director of the *Journal des artistes,* acquired the rights to the title from the 1888 publication. From March 1893 to early 1895, in collaboration with Roger Marx, Marty published *L'Estampe originale,* a series of quarterly albums of ten prints each (except for the last which contained fourteen prints) in the media of etching,

drypoint, mezzotint, woodcut, wood engraving, gypsography and lithography. In all, the publication encompassed ninety-five prints by seventy-four artists representing the young avant-garde such as Lautrec and the Nabis, as well as their established mentors including Gauguin, Puvis de Chavannes, Redon, Chéret, Whistler, Bracquemond and Lepère. *L'Estampe originale* offers a remarkable cross-section of the most advanced aesthetic attitudes in *fin de siècle* French art. As Donna Stein has stated, it "may very well be the greatest print collaborative to date." With it color lithography proved itself as an art independent of commercial rationalizations (Figs. 54, 55, 56).

Of the forty prints published in 1893, twenty-eight were lithographs and sixteen of these were in color (Fig. 33). The next year's forty included twenty-two lithographs with ten in color, while the last album, comprised of fourteen prints, had ten lithographs with two in color. *L'Estampe originale's* twenty-eight color lithographs by twenty-six artists coinciding with the massive production of color lithographic posters and programs by Steinlen, Lautrec, Grasset, Chéret and many others were an astonishing success for the medium and signaled the realization of the color revolution.

Prints in the medium by many artists rapidly multiplied, and by 1895 avant-garde printmaking and color lithography were synonymous. Much of this was prompted by the proliferation of print publications. Already in 1894 *L'Estampe originale* had published *En Zélande* (Fig. 57), a series of six

32. Henri de Toulouse-Lautrec, cover for *L'Estampe originale,* 1893, eight color lithograph, 22¼ x 25⅛". Princeton University Library, Graphic Arts Collection.

33. Pierre Bonnard, *Family Scene* from *L'Estampe originale,* 1893, four color lithograph, 12¼ x 7". The Baltimore Museum of Art, Museum Purchase.

34. Eugène Belville, cover for *Le Cantique des créatures*, 1894, three color lithograph, 25¾ x 19¾". Rutgers University Fine Arts Collection.

embossed color lithographs by Alexandre Charpentier; later, in 1896 it published *Etudes de femmes,* a series of four separate issues each with three lithographs, some in color, by twelve artists. Also in 1894 Pellet began publishing color lithographs by Signac, and Charles Dulac created his important symbolist series *Le Cantique des créatures* (Figs. 34, 35). The next year Vollard commissioned Bonnard to produce the twelve color lithographs for *Quelques Aspects de la vie de Paris* (Figs. 72, 73, 74).

Some publications, however, were collaborations between artists and writers. One such advertised itself thusly:

> *L'Epreuve* is a collaboration of young artists and poets who wish to offer to a knowledgeable public works of *Art,* not works of commerce or servile pastiches of traditional works. They want their subscribers to feel the new thrill, the new art. The famous artist's proof *(épreuve d'artiste)* will be produced.

Beginning in December 1894 *L'Epreuve* issued twelve monthly portfolios of ten prints in an edition of 215 by numerous artists in various media. Lithography again dominates, but multi-color lithographs are conspicuously absent. This may have been due to limitations in printing facilities. The director of *L'Epreuve* was the twenty-four year old artist, Maurice Dumont, and the printing work was done by Paul Lemaire at the studio of the young director.

The publication lasted only one year. However, in the ninth issue plans for the next year were announced. The five deluxe issues proposed for the second year were to be devoted to prints in color with special emphasis on a new process invented by Dumont. His process, called glyptotype, involves printing from a relief plate in such a manner that the inked areas press deeply into the paper leaving the unprinted white portions of the paper in relief. Dumont envisioned this process as a new inexpensive means of producing artistic color prints.

The first three issues of *L'Epreuve* were a combination of literary works and prints. In March 1895 it was transformed into *L'Epreuve album d'art* with *L'Epreuve littéraire* as a separate supplement. The latter also served as a supplement to *Pan,* an international revue of art and literature founded that spring in Berlin. *Pan* had an office in Paris and soon became another vehicle for original French color lithography by commissioning Toulouse-Lautrec, Luce (Fig. 68), Signac (Fig. 69), Hippolyte Petitjean, Henri Edmund Cross (Fig. 36) and Henri Héran to create work for five of its issues.

Another essentially literary effort supportive of original printmaking was *Le Centaure,* a two volume collection of contemporary writing published in 1896 under the supervision of various writers including André Gide. Of its nine original prints, three, by Jacques Emile Blanche, Henri Héran and Paul Ranson, are color lithographs—the last two being printed by Auguste Clot.

Clot was also responsible for printing the thirty-one etchings, wood engravings and lithographs published by Loys Delteil's short-lived journal

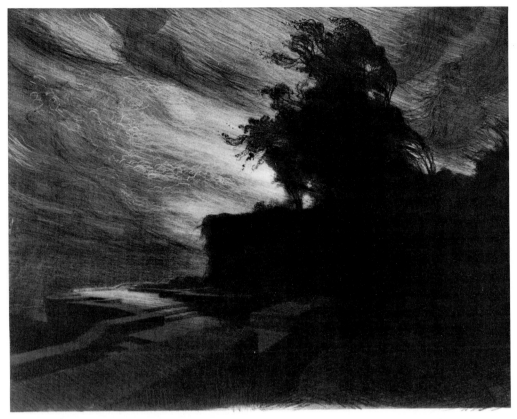

35. Charles Dulac, no. 6 from the album *Le Cantique des créatures*, 1894, three color lithograph, 14⅜ x 21¼. Rutgers University Fine Arts Collection.

36. Henri-Edmund Cross, *Champs Elysée*, from *Pan*, 1898, five color lithograph, 7⅘ x 10⅕".
The Baltimore Museum of Art, Blanche Adler Fund.

37. Edouard Vuillard, *L'Avenue*, 1899, six color lithograph, 12 x 16″. The Baltimore Museum of Art, Museum Purchase Fund.

L'Estampe moderne. It was issued monthly from November 1895 through March 1896. The journal was geared toward presenting historical information on nineteenth century printmaking and offered with each of its five issues a supplement of six prints in an edition of one hundred. Billed as an affirmation of the vitality of the contemporary print, in reality the publication was quite conservative. It contained only one print in color—a color lithograph by Lunois—while Steinlen, Dillon, Blanche and Fantin-Latour were represented by lithographic work in black and white. The majority of the prints were by academicians such as Delteil and François Courboin; two works, in fact, were purely reproductive. The publication was hardly indicative of avant-garde printmaking.

Clot was to redeem himself, however, as the foremost lithographic printer of the color revolution with his collaboration in the print publications of Ambroise Vollard. However, as Mellerio and Gustave von Groschwitz have shown, Clot's involvement sometimes went to extremes. For instance, Sisley's *Les Bords de rivière* in reality is a lithographic facsimile by Clot of a Sisley pastel; the black stone of the color lithographs by Cézanne, Renoir and Rodin were created by the artists but the color areas were simply indicated in watercolor on a proof, and it was left to Clot to produce the separate color plates (Fig. 65). The print department of the Bibliothèque Nationale, Paris, possesses a small oil by Luce close in size to and with virtually no variation in composition from his 1898 color

lithograph, *Usines de Charleroi* (Fig. 68), published in *Pan.* Inscribed on the lower right of the oil are the incriminating words "à Clot Luce 98." This suggests an additional example of Clot's more than peripheral handiwork in the execution of an artist's color lithograph.

It is useful to compare Delteil's *L'Estampe moderne* with Vollard's print publications—they are as different as night and day. The overall mediocrity of Delteil's project is in sharp contrast to the richly innovative work in Vollard's albums of 1896 and 1897. As we have seen, Delteil was sympathetic to the changing print aesthetics of the 1890s. Unlike Vollard, however, he was not a grand impressario sharply attuned to the aesthetic mood of the period who through judicious selection and boldness supported the avant-garde and facilitated the color revolution.

Vollard's print albums continued the kind of sensitive selection and quality publishing of prints by painter-printmakers initiated by André Marty with *L'Estampe originale.* From June 15 to July 20, 1896 the Galerie Vollard held an exhibition entitled Les Peintres-Graveurs; it was the debut of Vollard's *L'Album des peintres-graveurs*, comprised of twenty-two prints by twenty-two artists; and the show also included 176 prints by those and other artists. Confusion, however, with the intermittent exhibitions of the Société des peintres-graveurs and with the Society itself, must have been the reason in 1897 for the more precise title of Vollard's second group publication, *L'Album d'estampes originales de la Galerie Vollard.*

38. Henri Patrice Dillon, *Le Polichinelle* from *L'Estampe moderne,* 1897, five color lithograph, 15⅓ x 11⅓". The Baltimore Museum of Art, The George A. Lucas Collection on indefinite loan from the Maryland Institute.

39. Henri Jacques Evenepoel, *Au Square* from *L'Estampe moderne,* 1897, five color lithograph, 13 x 9". Rutgers University Fine Arts Collection.

The 1896 album contains eleven color prints, nine in lithography by Auriol, Blanche, Bonnard, Denis, Guillaumin, Hermann-Paul, Lunois, Ripple-Ronai and Vuillard. Twenty-seven of the thirty-two prints in the second album are in color and twenty-four of these are lithographs by Aman-Jean, Auriol, Bonnard, Cottet, Cross, Cézanne, Denis, Maurice Eliot, de Feure, Grasset (Fig. 66), Guillaumin, Lewisohn, Lunois, Henri Martin, Redon, Roussel, C. H. Shannon, L. Simon, Sisley, Toulouse-Lautrec, Vuillard, Wagner and Whistler.

Further enumeration of color lithographs published by Vollard in the late 1890s reinforces the already obvious contributions he made to the color revolution: single prints by Auriol, Denis and Renoir; the albums of twelve prints each, *Paysages et interieurs* by Vuillard (Figs. 37, 75, 76), *Amour* by Denis (Fig. 77) and *Paysages* by Roussel; and color lithographs by Blanche, Bonnard, Renoir, Signac, Cézanne (Fig. 65) and Vuillard produced for the proposed but never published third group album of 1898. Una Johnson's book on Vollard of 1944 and its recent second edition accompanying the Vollard exhibition at the Museum of Modern Art well documents his important role as a publisher of prints, bronzes and deluxe illustrated books by the vanguard of late nineteenth and early twentieth century French artists.

In addition to the works published by Vollard, in 1897 Pellet commissioned seven color lithographs by Luce, Redon's *Tete d'enfant avec fleurs* and *La Corrida* (Fig. 67), a suite of eight color lithographs by

Lunois. In the light of all this activity the position against color prints by the paranoid members of the official Salon is certainly understandable no matter how ludicrous.

The last two group print publications of the 1890s, *L'Estampe moderne* (May 1897-April 1899) and *Germinal* (1899), are disappointing after the impressive accomplishments of Marty and Vollard. The albums of the latter two were financially unsuccessful. In an attempt to avoid a similar occurrence *L'Estampe moderne,* a publication entirely unrelated to Delteil's defunct journal, catered to a larger, less sophisticated clientele with its twenty-four monthly portfolios of four "original prints," the majority of which are color lithographs. While the edition of the prints in *L'Estampe originale* and Vollard's albums were limited to one hundred, one hundred fifty copies were printed of each work in *L'Estampe moderne.* Cheaper paper was used, and generally the work is more illustrative than those of its predecessors. Its greatest weakness as an album of "original prints" lies in its use of many collotypes or photolithographs after drawings by artists such as Puvis de Chavannes, Fantin-Latour, Steinlen and others. It has some saving graces, however, with the color lithographs of Alphonse Mucha, Louis John Rhead, Georges Meunier, Dillon (Fig. 38), de Feure and Henri Evenepoel (Fig. 39) maintaining the artistic standards of Marty and Vollard; yet these are exceptions and not the rule.

Germinal, the last group album of the color revolution, contains twenty prints, nine in color

40. Théo van Rysselberghe, *By the Sea* from *Geriminal,* 1899, five color lithograph, 9½ x 16⅜". Rutgers University Fine Arts Collection. Gift of Mr. and Mrs. Allan Maitlin.

lithography by artists including Bonnard, Frank Brangwyn, Denis, Vuillard, Rodin, and Van Rysselberghe (Fig. 40). The publication endeavored to present an outline of a movement of European art. What specific movement it presents is unclear. Degas is represented by a Clot color lithographic facsimile of one of his works; another color lithograph is in the style of a Van Gogh painting; Carrière, Jan Toorop and Toulouse-Lautrec produced black and white lithos for the album; a woodcut by Vallotton and an etching attributed to Gauguin but in reality by Armand Seguin are suggestive of other aesthetics of the decade. The prints are in large format, printed on *chine collé* and limited to an edition of one hundred. It is a quality presentation, but an awkward, indecisive summation of the period. While *L'Estampe moderne* may be a blatant commercial effort with a marked decline in quality, *Germinal* even more sadly represents the disintegration of purpose for group portfolios which seems to have overwhelmed the color revolution by 1900.

One of the most interesting phenomena of the color revolution was the development of the interior "wall print" (l'estampe murale). Prints were generally collected and kept in portfolios and much less often hung on walls. In 1891 Chéret designed four decorative posters (placards décoratifs) entitled *La Musique, La Danse, La Pantomine* and *La Comédie.* (Fig. 41) In the format of large vertical posters, these color lithographs were void of lettering and were to be framed and hung indoors. The Chat

41. Jules Chéret, *Comédie,* 1891, five color lithographic panel, reproduced from Ernest Maindron's *Les Affiches illustrées,* 1895.

42. Benjamin Jean Pierre Henri Rivière, Calender/poster for *Aspects de la nature*, 1898, twelve color lithograph, 15¾ x 20½". Rutgers University Fine Arts Collection.

Noir cabaret, for instance, hung the four high up on its walls on either side of its shadow theatre screen.

In 1894 the printer Charles Verneau requested nineteen artists including Grasset, Lunois, Steinlen, Moreau-Nélaton and Willette to design interior wall prints, smaller than posters but larger than the average print. Champenois commissioned Alphonse Mucha to design "panneaux décoratifs." Beginning in 1896 with the *Quatre Saisons*, by 1903 Mucha had produced fifty such color lithographic panels. In 1896-97 Grasset designed a series of ten interior "estampes décoratives" printed, however, photomechanically and colored by stencil. During the same year Molines published Bonnard's four panel color lithographic screen. Eugène Verneau published numerous series of "l'estampes murales" by Henri Rivière such as the twelve compositions in twelve colors entitled *Les Aspects de la nature* (Fig. 42) of 1897 to be hung in vestibules, dining rooms or children's bedrooms. *L'Hiver* (Fig. 61), annotated on its lower left margin as "Images pour l'école no. 1," was specifically produced to be installed in schools for the aesthetic benefit of children.

Mellerio states that "one might almost say of Chéret's posters and Rivière's prints, that they are the frescoes, if not of the poor, at least of the crowd." Thus, while one segment of the color revolution, the limited edition print, was elitist, the interior wall print, like the poster, was democratic.

Journals played more than a peripheral part in the color revolution. *L'Artiste* and the *Journal des artistes* initiated the publication of the albums of *Les Peintres-Lithographes* and *L'Estampe originale*, respectively. Others such as *Le Courrier français* published supplemental color lithographic posters for their subscribers; and some, with *Le Figaro*, held print exhibitions in their galleries. Three journals in particular, *La Revue blanche*, *La Plume* and *L'Estampe et l'affiche* (Fig. 70) were directly involved on a regular basis with the color revolution.

Perhaps best known today is the art and literary review *La Revue blanche*. Founded in Belgium in 1889, it was relocated in Paris by the brothers Alfred, Alexandre and Thadée Natanson in 1891. Strongly supportive of the Nabis and early to recognize the talent of Toulouse-Lautrec, from July 1893 through December 1894 the journal published one print each month by one of the following: Vuillard, Cottet, Roussel, Denis, Ranson, Bonnard, Vallotton, Redon, Ibels, Toulouse-Lautrec, Serusier and Rippl-Ronai. A collection of twelve prints—mostly color lithographs by some of the same artists—was published at the end of 1894 as *L'Album de la Revue blanche*. The journal generated two promotional posters by Bonnard (Fig. 43) and Toulouse-Lautrec in 1894 and 1896 and numerous prints by other artists in the journal's clique. Much has been written on the important support of *La Revue blanche* and the Natansons to the diverse aesthetic movements emerging in French art and literature in the early 1890s. One journal less documented but just as supportive of the avant-garde and even more so of the print and poster

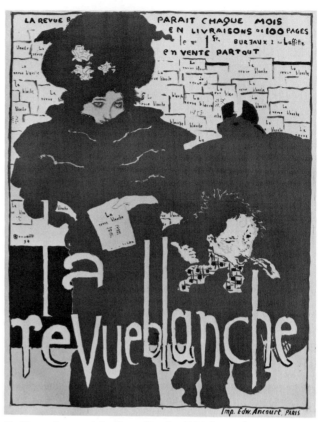

43. Pierre Bonnard, *La Revue blanche,* 1894, four color lithographic poster, 20 x 23″. Rutgers University Fine Arts Collection, Gift of the Class of 1958, twentieth reunion.

movement is *La Plume.* Its development as a vehicle for the color revolution is worth a brief study.

The first issue of *La Plume* was published on April 15, 1889 by a young poet and writer, Léon Deschamps. His goal was to create an independent review, not aligned with any one school of literature, philosophy or art—offering, instead, a vehicle of expression to all. It particularly supported young writers and artists. It also regularly published recognized literary figures such as Paul Verlaine, Jean Moréas, Emile Zola, Stéphane Mallarmé and François Coppée. Deschamps' art, drama and literary critics were Léon Maillard, Marcel Boillot and Paul Rédonnel, respectively. Within the first year of publication Deschamps introduced *La Plume's* monthly banquets and weekly Saturday literary soirées of which the latter convened at the Café Fleurus and eventually at the Café Soleil. The soirée acted as a verbal complement to the journal, allowing the published and unpublished to gather and recite their work. In addition Deschamps organized a Bibliothèque artistique et littéraire which published such works as Verlaine's *Dédicaces.* The journal, the soireés and the Bibliothèque became in this early period, as Deschamps proudly stated, his "triple action."

During its first two years the emphasis of *La Plume* was strongly in the area of literature, poetry and philosophy with the visual arts decidedly a peripheral interest. Finally, in the winter of 1893-94, *La Plume's* commitment to contemporary art and to the graphic arts, in particular, became

much more substantial. The issue of November 15, 1893 is dedicated exclusively to the history of the French illustrated poster. It is an exuberant celebration of the modern chromolithographic posters of Chéret, Willette, Grasset, Ibels, Toulouse-Lautrec, et. al. After an introduction by Ernest Maindron, various critics and writers (Maillard, Francis Jourdain, Huysmans and Anatole France) poetically praised the virtues of the poster.

The poster appealed to Deschamps' aesthetic and business senses. That winter the activities of his organization expanded into the areas of publishing and selling prints and posters in large quantities. Commencing with the January 1 issue of 1894, *La Plume* offered with each issue a deluxe edition of twenty copies on Japan paper accompanied by an original print, photogravure or watercolor. By March it had already published an album of prints by Hermann-Paul; it was offering an edition of six with the *La Plume* stamp of an album of six lithographs by Maurice Dumont entitled *Inexorable Lady;* it was selling prints and albums by Chéret, Gauguin, Grasset, Ibels, Luce, Rops, and Lautrec, and it began its most important publication, "an album which will comprise fifty posters by masters of genre. One each month." Terminating in 1900, this series included the forty-three posters by forty artists for the Salon des cent.

All of the Salon des cent posters are in color; of the twenty-three printed lithographically, those most notable are by Ibels, F. A. Cazals (Fig. 44), Hermann-Paul (Fig. 58), Toulouse-Lautrec, Bon-

44. F. A. Cazals, *Salon des cent,* 1894, color lithograph, 24 x 15¼". The Museum of Modern Art, New York. Gift of Ludwig Charell.

nard, Mucha (Fig. 62), Henry Detouche, Rhead and James Ensor's stencil-colored lithograph. The Salon des cent was a series of monthly exhibitions of paintings, sculpture, prints and crafts in the newly renovated 120 square meter ground floor gallery at 31 rue Bonaparte. Group shows would alternate with one-man shows or exhibitions of particular crafts such as bookbinding, ceramics, etc. The first exhibition, a group show, opened on February 1, 1894. Henri Ibels designed the inaugural poster. Officially only one hundred artists were allowed membership in the society of the Salon des cent. Established artists such as Rops, Puvis de Chavannes, Henri Boutet, Grasset, Chéret, Desboutin and others were invited to become members while the remaining memberships were open to any artists requesting them.

The journal constantly publicized and reviewed the series of Salon des cent exhibitions. The special issues which complemented the one-man shows were often quite large—the June 1896 Rops print issue was comprised of seven installments with a total of 144 pages of critique and catalogue and 155 illustrations. This dual effort of exhibition and special issue occurred as early as the second Salon, the 1894 Eugène Grasset exhibition, and continued through 1899 with the exhibitions of Henri Boutet, André des Gachons, Félicien Rops, Mucha, Jules Baric and James Ensor. In the case of Grasset, for instance, it became the first important exhibition of and publication on the artist. Grasset and Mucha were favorites of Deschamps. The former figured

in most of the group exhibitions, designed the title page vignette for the journal and had a second issue dedicated to him in 1900. In addition to designing two Salon des cent posters, Mucha also created the poster for the 1896 Sarah Bernhardt issue, the *La Plume* calendar, and the cover of the journal for 1900.

Each year the interest in prints and posters on the part of Deschamps and his journal multiplied. Léon Maillard called the fifth Salon a "review of prints." For six months, starting in October 1895 and coinciding with the fourteenth through the twentieth Salons des cent, *La Plume* sponsored at its gallery the Exposition internationale d'affiche illustrée, a major changing display and sale of international posters. Lautrec designed the lithographic poster for the event. The October 1 issue included one hundred reproductions of posters and was dedicated to that theme. The twentieth Salon, a group exhibition for which Mucha designed the poster (Fig. 62), introduced to the public Lautrec's *Elles* series (Figs. 63, 64). To promote the series Lautrec converted its title page into a poster announcing the display of *Elles* at *La Plume.* By 1899 the journal published an illustrated quarterly sale catalogue, *Album d'affiches et d'estampes modernes,* which listed hundreds of items on sale at its office. In addition to stimulating an interest in and market for prints and posters, *La Plume* became great competition for dealers such as Sagot, Kleinmann and Arnould who, however, consistently advertised in the journal.

31

45. Prospective for *Les Maitres de l'affiche* albums, 1895, with examples of posters by Jules Chéret and Georges Meunier, multi-color lithograph 17⁹/₁₆ x 25⁷/₈". Rutgers University Fine Arts Collection.

The journals *L'Estampe, L'Image* and *La Lithographie* served almost exclusively as forums for printmaking activities of the 1890s. In 1896 Roger Marx organized *Les Maîtres de l'affiche* (Fig. 45) to act as a poster chronicle. Published and printed monthly by Chaix and Company, it reproduced current posters as well as major works of the previous decade with miniature color lithographic copies. Similar kinds of copies are found in Maindron's 1896 *Les Affiches illustrées*, 1897 *Les Affiches etrangères* and Leon Maillard's *Les Menus et programmes illustré* published by G. Boudet in 1898.

These color publications created a visual catalogue for collectors of the posters and programs produced in their time and have left to posterity a record of an essentially ephemeral art. However, it was André Mellerio's *L'Estampe et l'affiche* which set as its policy the ever growing opinion that the print and the poster were comparable art forms. In the early issues of the journal, Mellerio also formulated his view that color lithography was the special artistic form of his time. Although never printed in color, the journal offers ample proof of this conclusion.

Published biweekly from March 1897 through December 1899 it documents in detail—indicating edition size, measurements, and cost—the prints and posters published by specific dealers, printers or individual artists. It discusses current print exhibitions and presents feature articles on particular artists and printing techniques. It also acted as a catalyst for public discussion on such matters as "a

poster museum" and "a salon for prints." Also, it printed for its subscribers posters by Bonnard and Jean Peské (Fig. 70) as well as prints by Redon, Fantin-Latour, Villon, Denis and others. Most importantly, the journal published Mellerio's *La Lithographie originale en couleurs. L'Estampe et l'affiche* more than any other journal allows one to realize the great quantity of artistic color lithographic work rolling off the presses by the end of the decade. This information combined with that gleaned from the sale catalogues of Sagot and of *La Plume* clearly reveals the great extent and variety of the color revolution.

This phenomenon of immense artistic color lithographic activity was not destined to last beyond the turn of the century. In all revolutions the intense period of ferment and upheaval cannot endure forever. So it was with the color revolution and the printmaking renaissance in general. By 1900 Vollard ceased publishing print portfolios and would not resume such endeavors until 1913; *La Lithographie, Les Maîtres de l'affiche* and *L'Estampe et L'affiche* had stopped publication; *La Plume* no longer promoted prints and posters; the next year Toulouse-Lautrec died, and Bonnard and Vuillard stopped making prints almost entirely until well into the second decade of the twentieth century. These were all signs of a slowdown in the energetic printmaking activity which symbolizes the 1890s in France. The color revolution was over at the turn of the century.

The social and aesthetic changes effected by it,

46. Théophile Alexandre Steinlen, *À la Bodinière,* 1894, three color lithographic poster 23¾ x 32⅛″. Rutgers University Fine Arts Collection. Gift of Mr. and Mrs. Herbert D. Schimmel.

however, were dramatic. It had brought inexpensive quality art to the streets, to the classroom and to the middle class living room. It had decisively influenced the art of poster advertisement and had made color printing in general reputable and an expected element on the part of the public, especially in the production of journals and books. Once color lithography was accepted as a legitimate art form a slowdown in interest and publicity naturally ensued. New causes beckoned the adventurous while others now treated color lithography as just one part of the larger world of art.

In July 1899 the etcher J. F. Raffaelli announced in *L'Estampe et l'affiche* that the "Société de l'estampe originale en couleurs" had recently been founded with him as president. Therefore, precisely ten years after the first exhibition of peintres-graveurs, in which color printmaking was negligible, a new organization was formed. This time it was based entirely on the color print. But color etching—not lithography—was to be the dominant medium. Nevertheless, the color lithographic activity in France of the 1890s had established the medium as a major art form and had left a rich and an influential legacy to lithographic artists of the twentieth century. Although color lithography would never again attain such a brilliant creative outpouring, in the years to follow artists continued (and continue today) to employ it as one of the honored media of artistic expression.

P.D.C.

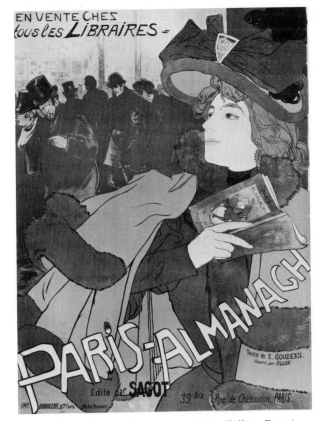

47. Georges de Feure (Georges Joseph Van Sluijters Feure) *Paris almanach,* 1895, seven color lithographic poster, 31 x 23⅜″. Rutgers University Fine Arts Collection. Gift of the Class of 1958, twentieth reunion.

Notes

Page. 1

The Society of French Artists (Société des artistes français) was established as the official organizing body of the French Salon in 1881 and, for the first time in its 208 year history, the Salon became a non-governmental entity. A schism occurred in 1890; members disenchanted with the conservative tendencies of the Society of French Artists organized, under the leadership of Ernest Meissonier and Puvis de Chavannes, the National Society of Fine Arts (Société nationale des beaux-arts) which held its own annual Salon in the Palais des Machines in the Champs de Mars in competition with the official Salon at the Palais des Champs-Elysées. The new Salon did not offer the young avant-garde a very real alternative to that of the Society of French Artists, however.

For a history of the Salon up to 1888 see A. Geoffray, "Le Salon," *La Curiosité universelle,* no. 84, August 27, 1888, pp. 1-2.

The 1891 phrase excluding color prints from the Salon reads in: "Nul ouvrage en couleur ne sera admis," and is found in the catalogue: *Société des artistes français exposition, 109,* Palais des Champs-Elysées, 1891 règlements; section de gravure et de lithographie, p. CCVIII.

Henri Lefort defended the continued exclusion of color prints from the Salon in the article, "Rapport motivant la non admissibilité des gravures en couleur, au Salon, presenté au comité des 90, le 24 janvier," *La Lithographie,* no. 10, March, 1898, pp. 1-3.

Charles Maurin (1856-1914) created numerous color etchings in the 1890s. He was a close friend of Henri de Toulouse-Lautrec; exhibiting with him at the Gallery Boussod and Valadon in 1893. He depicted Lautrec in the 1893 Album of *L'Estampe originale* and had a one-man show at the Edmond Sagot Gallery in 1898. Maurin's rebuttal to Lefort's statement is the article: "De la Gravure en couleurs," *Journal des artistes,* no. 12, March 20, 1898, p. 2217.

Delteil (1869-1927) is best known for his twenty-nine volume catalogue raisonné of the work of the major nineteenth century French printmakers and for his two volume history of nineteenth and early twentieth century French prints: *Manuel de l'amateur d'estampes des XIX et XX siècles,* Librairie Dorbon-Ainé, Paris, 1925. His moderating letter is found in *Journal des artistes,* no. 19, May 6, 1898, pp. 2273-74.

The amendment to the statutes allowing color prints in the Salon reads in: "Les ouvrages en couleur pourront être admis," and is found in the catalogue: *Société des artistes français Exposition 117,* Palais des Champs-Elysées, 1899 Règlements: Section de gravure et de lithographie Article 2, 6th paragraph. Out of 522 prints in the Salon that year only ten were in color.

Page 2

It is generally agreed today that 1798 is the date of Senefelder's (1771-1834) invention of lithography. See Michael Twyman, *Lithography 1800-1850,* Oxford University Press, London, 1970, p. 11, note 3. The confusion occurs with Senefelder's own vague and conflicting statements in his 1818 German edition, 1819 English and French editions of his treatise: *A Complete Course of Lithography* It is interesting to note that Paris celebrated the centennial of lithography in 1895 with a retrospective exhibition at the Palais des Beaux-Arts. *Le Centenaire de la lithographie,* catalogue officiel de l'exposition, 1795-1895, Paris, 1895.

For a discussion on *The Fair of Bulgaria* see Charles Lorilleux, *Traité de lithographie,* Paris, 1889, p. 117.

Englemann's color lithographic system is discussed by Lorilleux, p. 18. Lemercier states that soon after Engelmann's (1788-1839) invention of a practical color registration frame, the machinist Brisset adapted it to his hand lithographic press. Brisset's press proved so popular that it became the most utilized hand color lithographic press in the world up through the 1890s. See Alfred Lemercier, *La Lithographie française de 1796 à 1896 et les arts qui s'y rattachent, manual pratique s'adressant aux artistes et aux imprimeurs,* Paris, 1896, p. 46.

Two French artists, Auguste Bouquet and Emile Lessore, created in 1837 what appears to be an unique impression of a four color original lithograph; it is an anomaly of French printing of the time. See Gustave Von Groswitz, "The significance of XIX century color lithography," *Gazette des Beaux-Arts,* XLIV, November, 1954, pp. 247-48.

In the 1830s another English artist, James Duffield Harding (1796-1863), added one or two tint stones to the background of his essentially black and white lithographs. Often he would apply watercolor to his print for further coloration. Harding's works, however, unlike Boys' (1803-1874) series, were created with tonal values in mind rather than color. For the aesthetic development of the tint stone see Twyman, p. 158-60.

See Lorilleux, pp. 355-359, for a list of patents on improved lithographic presses in the 1840s and 1850s. In the 1850s England had made the greatest advancements in lithographic presses. By 1860,

however, P. Alouzet in France had developed the first mechanical lithographic press. See Robert Goldwater, "L'Affiche moderne: A Revival of Poster Art After 1880," *Gazette des Beaux-Arts,* December, 1942, p. 176 and Alfred Lemercier, p. 315.

Page 3

For the early career of Chéret see Camile Mauclair's *Jules Chéret,* Maurice Le Garrec, Paris, 1930, p. 6.

Chéret's first color lithographs are discussed by Ernest Maindron in *Les Affiches illustrées, 1886-1895,* G. Boudet, Paris, 1896, p. 189.

Mauclair, p. 8, states that Chéret was in London from 1858 to 1866: Beraldi gives 1856-66 as Chéret's dates in London and states that he produced some lithographic posters and music sheet covers. Henri Beraldi, *Les Graveurs du XIX siècle,* volume 4, Paris, 1886, p. 170.

In July 1866 Chéret set up shop on the right bank at 16 rue de La Tour des Dames; he moved to 18 rue Brunel in 1868 where his business remained until 1890 when it moved to 20 rue Bergère and became fully merged with the printshop of Alban Chaix. Chaix had taken over the business end of Chéret's shop in 1881, leaving Chéret with artistic control and more time to devote to his art which included painting as well as postermaking. See Maindron, p. 189-90.

Page 4

The quotation is from Beraldi, v.1, p. 171.

For Alan Fern's views on the early influence upon Chéret's posters see *Word and Image,* Museum of Modern Art, New York, 1968, p. 12.

For a detailed description of the Gillot process see Jules Adeline, *Les Arts de reproduction vulgarisés,* May and Motteroz, Paris, 1894, pp. 126-136 or Alfred de Lostalot, *Les Procédés de la gravure,* A. Quantin, Paris, 1882, pp. 130-141. Gillot (1820-1872) patented his invention on March 21, 1850, and established a printshop in Paris in 1852 for the use of his process. The process was originally called paniconography; later it took on the name gillotage or zincography. Gillotage is a non-photographic process and should not be confused with relief photo-engraving developed by Charles Gillot in the mid 1870s.

In 1864 and 1865 the journal *Le Charivari* printed two of Daumier's lithographs from a relief plate using the Gillot transfer process. By 1871 *Le Charivari* had changed over completely from lithography to the Gillot process for the printing of illustrations.

Page 5

Sarah Bernhardt's *Dans les Nuages* (Paris, 1878, illustrations by Georges Clairin produced photo-mechanically by Charles Gillot) is the earliest book the author has located completely illustrated by a relief photomechanical process. For a discussion on *L'Illustration* see E. Courmont, *Histoire et technique de la photogravure,* Gauthier-Villars, Paris, 1947, p. 67, and R. M. Burch, *Colour Printing and colour printers,* Baker & Taylor, New York, 1911, p. 234. *L'Illustration* was not the first color illustrated journal; since 1855 the *Illustrated London News* had its wood engravings colored by etched tone plates.

For a contemporary view of the problems of color separation see A. Villon, *Manuel du dessinateur et de L'imprimeur lithographe,* Paris, 1891, v. II, p. 259.

For descriptions of various photoprinting processes see the *Reproductive Arts from the XV century to the Present time, with Special Reference to the Photo Mechanical Processes,* Exhibition Catalogue, Museum of Fine Arts, Boston, 1892.

For a description of chromotypogravure and its influence on Seurat see: Norma Broude, "New Light on Seurat's 'Dot': Its Relation to photomechanical color printing in France in the 1880s," *The Art Bulletin,* LVI, no. 4, December, 1974, pp. 581-89.

The text illustrations of Octave Uzanne's *L'Eventail* (1882) and *L'Ombrelle* (1883) are produced by an intaglio photo engraving process and printed in a variety of monochromes; both books were printed in Paris by the publisher A. Quantin.

Retouched color proofs of pages from *L'Histoire des quatre fils Aymon* are itemized and on sale in the journal *La Plume,* no. 122, May 15, 1894, p. 56. Mr. Stuart Berkowitz of Microtone, Inc. lends his professional support as a printer to my view that Grasset must have performed a great deal of work on each of the color plates supplementing substantially the photo process.

Page 6

Mellerio describes the true color print as: "a piece of paper decorated with colors and lines which are part of it without hiding it or weighing it down." It is "a personal conception, something realized for its own sake. An artistic inspiration joined in advance with a technique expressed itself directly in the chosen process of execution."

Grasset's color relief illustrations are found in *Paris illustré,* no. 47, June 1, 1886, A. Lahure and L. Baschet, editors, Charles Gillot, Director.

An early discussion of Grasset's art and life was written by Octave Uzanne in "Eugène Grasset," *The*

Studio, IV, no. 20, November, 1894, pp. 37-47.

For a history of the *Chat Noir* see Mariel Frèrebeau, "What is Montmartre? Nothing! What should it be? Everything!," *Artnews,* v. 73, no. 3, March, 1977, pp. 60-62. Also for further discussion on Steinlen see: Phillip Dennis Cate, "Empathy with the Humanity of the Streets," *Artnews,* v. 73, no. 3, March, 1977, pp. 56-59.

The *Chat Noir guide* (Paris, n.d.) gives a tongue-in-cheek description of the Chat Noir at its second location on rue Victor Massé. Nevertheless, the guide's list of habitués and objects d'art seems reliable and many specifics have been documented elsewhere.

Page 7

For an early account of Bruant (1851-1925) see Oscar Méténier, *Aristide Bruant,* Paris, 1893.

The word *caillou,* pebble, is the French equivalent for the German word *stein.* Tréclau is the transposition of the name Lautrec.

Page 8

The catalogue raisonné for Steinlen's prints, posters and illustrations is E. de Crauzat's *L'Oeuvre gravé et lithographié de Steinlen,* Paris, 1913. For more on the relationship of prints to social concern in France see: Gabriel Weisberg, *Social Concern and the Worker: French Prints from 1830-1910,* exhibition catalogue, Utah Museum of Fine Arts, University of Utah, 1973.

The critic Philippe Burty, the artist Félix Bracquemond, and the conservative Society of French Artists looked upon photo-mechanical printing with great disdain and, in fact, represented the general opinion of the old guard no matter how enlightened they may have been in respect to other questions of art.

From 1894 to 1900 the journal *La Plume* published forty-three posters by forty artists for its Salon des cent exhibitions. Eighteen of the forty-three were printed by a photo relief process on a letter press with colors applied by stencil. This is just one indication of the numerous work in this medium. See: Phillip Dennis Cate, "*La Plume* and its Salon des cent — Promoters of posters and prints in the 1890s," *Print Review,* Spring, 1978.

Page 9

The pervasive influence of Japanese art, particularly prints, on the aesthetics, technique and subject matter of French painting, prints and decorative arts has been well documented in recent years. For the most comprehensive and recent study on this topic see: Gabriel Weisberg et al., *Japonisme: Japanese Influence on French Art, 1854-1910,* exhibition catalogue, published jointly by the Cleveland Museum of Art, the Rutgers University Art Gallery and the Walters Art Gallery, 1975. Section II of the catalogue by Phillip Dennis Cate discusses in detail the Japanese influence on French prints from 1883 to 1910 and is the basis for this topic in the present essay.

The color illustrations of Japanese prints and objects d'art for Louis Gonse's *L'Art japonais,* 2 vols, Paris, 1883, were printed photo-mechanically by Charles Gillot. Gillot was also a major collector of Japanese prints; see collection Charles Gillot, *Estampes japonaises et livres illustrés* (Sale catalogue, l'Hôtel Drouot, April, 1904).

Lotz-Brissoneau, who compiled the catalogue raisonné of Lepère's prints, places *La Convalescente's* (L-B 240) date of execution at 1892. However, the impression owned by the Boston Museum of Fine Arts has the year 1889 inscribed by Lepère in the margin. This leaves some doubt as to the precise date of execution. Lepère also produced another color woodcut in 1889, *Marchandes au panier* (L-B 187) stylistically not under the influence of the Japanese print.

Page 10

The full wording of the 1881 law is found in "Loi sur la liberté de la presse (XII, 13.DCXXXVII, N.10,850)," *Collection complète des lois, décrets, ordonnances, règlements et avis du conseil d'Etat,* v.81, J. Duvergier, Paris, 1881, pp. 290-324.

For a discussion on the *afficheurs* see Gustave Fustier, "La Litterature murale," *Le Livre,* November 10, 1884, p. 356.

Maindron discusses the poster industry in *Les Affiches illustrées* (1886-1895), G. Boudet, Paris, 1896, p. 19.

The earliest critical evaluations of French posters are Gustave Fustier's "La Litterature murale," *Le Livre,* November 10, 1884, pp. 337-356 and Ernest Maindron's "Les Affiches illustrées," *Gazette des Beaux-Arts,* 2d ser., v.30, November, 1884, pp. 419-433 and December, 1884, pp. 535-47.
by Fustier in "La Litterature murale," p. 353, and Charles Levy, Edward Ancourt (who becomes important as a printer of posters of Lautrec, et al in the 1890s), H. Castelli, Ferdinandus, Gerlier, H. Meyer and Willette mentioned by Maindron in "Les Affiches illustrées."

Besides Chéret, other poster artists of the 1880s were Castelli, Demare, Ferdinandus, Hope (pseudonym for Léon Choubrac), Kauffman, Michele, Quesnel, Tinavre and Alfred Choubrac mentioned

fiches illustrées," 1884, p. 540.

Maindron (1884), p. 544 suggests the enormity of Chéret's poster output. In his *Les Affiches illustrées* of 1896 he catalogues 882 posters by Chéret.

The quotation is from "Le carnaval des murs," *Le Gaulois,* July 24, 1885.

Page 12

Ernest Maindron's first book on posters was *Les Affiches illustrées,* H. Launette and cie., Paris, 1886.

The quotation is from Maindron, *Les Affiches illustrées,* 1896, p. 3.

In 1884 Sagot moved his shop from the rue Argout to the Left Bank at 18 rue Guénégaud, and then in January 1894 the shop was located again on the Right Bank at 39 bis rue de Chateaudun. After his death in 1917 the shop, now called Sagot-le Garrec (the result of a family partnership), moved to 24 rue du Four where it exists today under the direction of Jean Claude Romand, the great grandson of Sagot. I am especially grateful to Monsieur Romand for making available to me the sale catalogues of his great-grandfather.

Sapin's rare book and autograph shop was located at 3 rue Bonaparte and Brunox's Librairie du bibliophile at 7 rue Guénégaud; L. Vanier was located at 19 quai Saint Michel.

The quotation is from an unpaginated, anonymous article in *Le Petit moniteur,* August 20, 1888.

Chéret's first one-man exhibition at the Gallery of the Théâtre d'Application, 18 rue Saint Lazare, Paris, December 1889-January 1890, is documented by the catalogue *Exposition Jules Chéret* with a preface by Roger Marx. In the late 1880s Charles Bodinière, at one time associated with the Comédie Française as a script reader, opened his experimental theatre in what was previously an art gallery. He continued to include art exhibitions in the large foyer. In the early 1890s Yvette Guilbert, who began performing at Bodinière's theater in February 1892, gave the theater the nick-name "La Bodinière." The name stuck and was soon used regularly by artists when they exhibited at the theater—see Steinlen's *A La Bodinière* (Fig. 46). Bettina Knapp and Myra Chipman, *That was Yvette, the Biography of a Great Diseuse,* Frederick Muller Limited, London, 1966, pp. 84-86.

Page 13

An anonymous notice in *L'Eclair,* December 24, 1889.

Maindron in the 1896 *Les Affiches illustrées* enumerates the various poster sizes:

¼ colombier	41 x 30 cms
½ colombier	60 x 41 cms
jesus	70 x 65 cms
colombier	61 x 82 cms
grand aigle	110 x 70 cms
double colombier	122 x 82 cms
double grand aigle	140 x 110 cms
quadruple colombier	164 x 122 cms
quadruple grand aigle	220 x 140 cms

The double and quadruple colombier were the sizes most often used.

The quotation is from Fustier, "Litterature murale," p. 354.

Lorilleux, p. 274, states that the printing press manufacturing company of Marinoni constructed in 1888 (for Champenois and Company, printers of prints and posters) a press able to receive stones of 1 meter 56 by 1 meter 13 and that it was the first of its kind.

Page 14

For information on the Society of French Lithographic Artists see "Société des artistes lithographes français, statutes," *Le Journal des arts,* March 26, 1886.

For a catalogue raisonné of Brown's lithographs see Germain Hédiard, *Les Maîtres de la lithographie—John Lewis Brown,* Paris, 1898.

For mention of the activities of Goupil and Armand Durand see *The Reproductive Arts . . .* Boston Museum Catalogue, 1892, p. 77; Goupil and Co. ceded its firm to Boussod and Valadon in 1888.

For a history of the society of French Lithographic Artists see E. Cousin and Dubois-Menant *La Société des artistes lithographes Français,* Paris, 1892, p. 7.

The history of *L'Estampe originale* is recorded in *L'Estampe originale, a Catalogue Raisonné,* The Museum of Graphic Art, New York, 1970, p. 7 by Donna M. Stein and Donald H. Karshan.

Page 15

The quotation is from *Exposition des peintres-graveurs,* Catalogue of the Exhibition at the Durand-Ruel Gallery, Paris, January 23-February 14, 1889, preface by Philippe Burty, p. 8. As was suggested above, the photomechanical processes often offered creative outlets and economical support to young artists; however, to many the processes were synonymous with reproductive print-making and with the reactionary values of the Salon. This is ironic since the Salon also excluded photo processes from its galleries. The three, photo processes, reproductive prints, and the Salon became, after the declarations of Burty, the constant

whipping boys of all subsequent societies and organizations advocating innovative printmaking.

In 1891 Bracquemond and Guérard with the third Exposition des peintres-graveurs organized the group into the Société des peintres-graveurs français. Previous participants such as Cassatt and Camille Pissarro were excluded from the 3rd exhibition because they lacked French citizenship. The 4th, 5th, and 6th annual exhibitions of the Society were held in 1892, 1893, and 1897, respectively; the 7th was not held until 1906.

The quotation is from *2ᵉ Exposition des peintres-graveurs,* Catalogue of the exhibition at the Durand-Ruel Gallery, Paris, March 6-26, 1890, preface by Philippe Burty, p. 8.

Page 17

Bonnard's influence on Lautrec is suggested by Claude Roger-Marx, *Bonnard Lithographe,* Monte Carlo, 1952, p. 11.

Lautrec's posters for 1892 are *Reine de joie* (Adhémar 5), *Bruant aux Ambassadeurs* (Adhémar 6), and *Bruant Eldorado* (Adhémar 7).

Page 18

For a discussion on the illustrated programs and literary and artistic activities of the Théâtre Libre and the Théâtre de l'Oeuvre, see *The Avant-Garde in Theatre and Art: French Playbills of the 1890s,* with an essay by Daryl R. Rubenstein (catalogue for an exhibition circulated by the Smithsonian Institution Traveling Exhibition Service), 1972.

Signac's 1888 Théâtre Libre program advertised Charles Henry's *The Chromatic Circle,* 1888-90; see John Rewald, *Post Impressionism from Van Gogh to Gauguin,* Museum of Modern Art, New York, 1956, p. 139.

The quotation is found in *The Avant-Garde in Theatre and Art,* p. 22.

Lautrec's Théâtre Libre programs are listed in Jean Adhémar's *Toulouse-Lautrec: His complete Lithographs and Drypoints,* New York, 1965, nos. 40, 72, 143.

Page 19

The twelve posters produced between April 1890 and April 1892 are: 1—*Le Théâtrophone,* 2—*Maquettes années,* 3—*Jardin de Paris,* 4—*Paris-Courses,* 5—*Alcazar d'éte,* 6—*Casino d'Enghien,* 7—*Paris-Courses,* 8—*La Diaphane,* 9—*Le Courrier Français,* 10—*Musée Grevin,* 11—*Bals de l'Opera,* 12—*Saxoleine.* Twenty-five copies of each at the special price of fifteen francs per poster were available only by subscription to the entire series. The remaining

proofs would be sold to non-subscribers at twenty francs each. See the notice in Edmond Sagot's Sale Catalogue #24, April 1890.

The quotation is from Sagot's Sale Catalogue #25, July 1890.

The quotation is from Sagot's Sale Catalogue #31, December 1891.

For a description of *Catalogue d'affiches illustrées anciennes et modernes,* Paris, Librarie Ed. Sagot, 18 rue Guénégaud, 1891 see Charles T. J. Hiatt, "The Collecting of Posters, A new Field for Connoisseurs," *The Studio,* v.1, May 1893, p. 62. Also in 1891 Chéret designed the large poster *Librairie Ed. Sagot.*

For Sagot's poster exhibition see Germain Hédiard, *L'Affiche illustrée, expostion E. Sagot,* Paris, 1892.

The quotation is from an anonymous press clipping in the Chéret 1890-91 file (yb31657) of the Cabinet des estampes, Bibliothèque Nationale.

Page 20

Sagot published the *Paris almanach* for 1895, 1896 and 1897; the one for 1896 is illustrated with color lithographs by Georges Meunier. Georges de Feure created a poster (Fig. 47) for the 1895 *Almanach* illustrated by Dillon.

For an account of Pellet's publication see *Archivés de la maison Gustave Pellet,* sale catalogue #106, Klipstein and Kornfeld, Berne, Sale May 24, 1962.

For Arnould's catalogue see *Catalogue d'affiches artistiques, Françaises étrangères estampes,* June 1896, A. Arnould, 7 rue Racine, Paris.

Some of the more important dealer/publishers of contemporary prints and posters in the 1890s were: Samuel Bing, Art Nouveau, 27 rue de Provence (from 1895); Pierre Duffau, Maison d'Art Moderne, 25 galerie Vivienne; L. Dumont, 27 rue Laffitte (from 1891); Charles Hessele, 13 rue Laffite (2nd half of decade); Molines, 20 rue Laffitte; other shops include: Desbois, 7 rue Lafitte; Librairie Dorbon, 47 rue Le Peletier; Pierre Lechanteux, 65 rue Richelieu; Hippolyte Prouté, 11 rue d'Ulm; Victor Prouté, 12 rue de Seine; and E. Rondeau, boulevard Montmartre.

Page 21

By 1888 Ancourt, the one time poster designer, set up his own printing shop at 83 rue du Faubourg Saint Denis. He was responsible for Bonnard's 1889 *France Champagne* and during the 1890s printed major posters by Bonnard, Lautrec and others. Auguste Clot and Henry Stern worked as printers for Ancourt; the former soon became independent, working out of his own studio. Stern became the

personal printer for Lautrec. The lithographic firm of Lemercier, 57 rue de Seine, was founded by Joseph Lemercier in 1827. By mid-century his nephew, Alfred, had become his partner. Throughout the Century the firm was responsible for many of the important developments in lithographic printing and was especially supportive of artistic endeavors in the medium. See Lemercier, *La Lithographie française*, 1896. From 1888 Eugène and Charles Verneau had set up separate lithographic print shops in Paris. Eugène at 108 rue de la Folie Mericourt, eventually became known for the printing and publication of work in color by Henri Riviére. Charles Verneau, 114 rue Oberkampf, printed and published the major posters of Steinlen.

Some other printers in the 1890s were: Champenois at 66 boulevard Saint Michel since 1878, best known for publishing and printing the works in the albums of *L'Estampe moderne;* Monrocq Frères, 3 rue Suger; Ducourtioux and Huillard, 57 rue de Seine, specialist in lithographic and photo mechanical posters; Belfond and Company; de Vaugirard, G. de Malherbe and company, printer and publisher of decorative posters by Grasset; Camis and Company, 172 quai de Jemmapes.

The quotation is from Octave Uzanne, "Quelques peintres lithographes contemporains," *L'Art et l'idée*, vol. 4, 1892, p. 324.

The quotation is from *La Lithographie*, catalogue for the exhibition at the Ecole des Beaux-Arts, April 2-May 24, 1891, au bénéfice de l'oeuvre de l'union française pour le sauvetage de l'enfance, preface by Henri Beraldi, Paris, 1891, pp. iv-vi. The Society of French Lithographic Artists was also the guiding force behind the Paris centennial exhibition of lithography in 1895.

Page 22

Seven albums of *Les Peintres-Lithographes* were published between 1892 and 1897; each contained ten lithographs. Album no. 2 (1892) contains a three color lithograph by Anderson while Album no. 3 (1893) has one in four colors by Lunois. In November 1897 the Société des peintres-lithographes held its first exhibition in Paris at the Galerie des Artistes Modernes, 19 rue Caumartin.

E. Duchatel, *Traité de lithographie artistique*, Paris, 1893. Godefrey Engelmann, *Traité théorique et pratique de lithographie*, Mulhouse 1835-40. Duchatel had been employed for twenty-two years at the print shop of Lemercier where he specialized in the printing of artistic lithography.

The artists represented in Duchatel's treatise by one lithograph each are: Félix Buhot, E. Bertrand, Dillon, Dulac, Fantin-Latour, Fauchon, Fuchs, Charles Lefèvre, Lunois, Maurou, E. Pirodon, Vogel. In 1907 Duchatel published a second edition of his manual, *Le Manuel de lithographie artistique*, with a preface by Léonce Bénédite.

See Stein and Karshan for a lucid history and discussion of *L'Estampe originale* and for a fully illustrated catalogue raissonné of its ninty-five prints.

The quotation by Donna Stein is from *L'Estampe originale*, p. 8.

Page 24

Etudes de femmes was comprised of twelve prints in four installments by Hermann-Paul, Toulouse-Lautrec, Willette, J. E. Blanche, Helleu, Moreau-Nélaton, Eugène Carriere, Puvis de Chavannes, Vallotton, Chéret, deFeure, and Steinlen. It was published by Le Livre Vert: L'Estampe originale and printed by Lemercier in 1896.

The quotation is from a subscription announcement for *L'Epreuve* by Jules Le Petit, 1894.

In 1895 Dumont published *La Suite des polichinelles*, seven prints in color and embossed presumably by the process of glyptotype. Volume one of *Pan*, 1895 includes *Sappho*, a glyptotype by Dumont printed in blue.

A discussion of Dumont's process was given by Jules Le Petit, *L'Epreuve*, no. 9, August, 1895, p. 2.

Pan was published between 1895 and 1900 in ten volumes by Meier Graefe and Otto Julius Bierbaum, Berlin.

Page 26

Le Centaure, "recueil trimestriel de litterature et d'art," was published in Paris in two volumes in 1896.

Delteil's *L'Estampe moderne*, "moniteur mensuel des amateurs et des artistes," was published in five issues from November 15, 1895 through March 31, 1896.

For Von Groschwitz's discussion on Clot see pages 258-59 of his 1954 article.

Page 27

The second edition of Una Johnson's *Ambroise Vollard, Éditeur* was published by The Museum of Modern Art, New York, in 1977.

It was announced in *L'Estampe et L'affiche*, vol. 1, March 15, 1897, p. 24, that *La Corrida* was to be a series of fourteen lithographs; it appears, however, to have stopped at eight.

L'Estampe moderne was comprised of 24 monthly

issues from May 1897 to April 1899, four prints per issue with one extra print gratis to subscribers each year; the total publication is ninety-eight prints in an edition of 150 published by Charles Masson and H. Piazza, Champenois printers. The majority of the work is in color lithography; however, thirty-two of the one hundred prints are collotypes.

Page 28
Germinal, a portfolio of twenty prints, was published in 1899 by La Maison Moderne, 82 Rue des Petits-Champs, in an edition of one hundred; preface by Gustave Geffroy.

Page 29
For a discussion on interior wall prints see Maindron, 1896, pages 178 and 179.

Mucha's large panels are listed in Jiri Mucha's *The Graphic Work of Alphonse Mucha,* Academy Editions, London, 1973, p. 10.

Eugène Grasset's ten "estampes decoratives" were published in 1896-97 in an edition of 500; two of each in the following dimensions: 76 x 43 cm., 37 x 90 cm., 110 x 28 cm., 54 x 54 cm., 67 cm. in diameter.

For a review of an exhibition of color prints at *Le Figaro* see "L'Estampe en couleurs salle du *Figaro,*" *L'Estampe et l'affiche,* June 15. 1897, p. 127.

The prints and posters published by *La Revue blanche* (1891-1903) are listed in Fritz Hermann's *Die Revue blanche und die Nabis,* 2 vols., microcopy G.M.b.H., Munchen, 1959, p. 570-579.

For more information on *La Revue blanche* see especially Hermann and A. B. Jackson, *La Revue blanche* (1889-1903), Lettres Modernes, Paris, 1960.

Page 30
La Plume was published semi-monthly, the first and fifteenth of each month from April 15, 1889, through December 15, 1899, with Léon Deschamps as editor. From 1900 through 1904, Karl Boès was editor, and from 1905 through 1914, Boès and Albert Trotrot were co-editors.

Throughout the ten years of Deschamps directorship of the journal, "special" issues were often dedicated to a variety of topics including literary, artistic and social movements such as Decadence, Symbolism, and Anarchism. An overview of the journal for this period suggests that Deschamps was politically to the left but not a radical, a staunch supporter of the avant-garde but a wise enough businessman and historian not to tip the balance of his journal in favor of the extreme and controversial.

By early 1892 Maillard was assisted in art criticism by Félix Féneon, Alphonse Germain, and Charles Saunier.

Whether the number of posters published by *La Plume* actually attained fifty is not known. In addition to the forty-three *Salon des cent* posters, *La Plume* also published Lautrec's *Chap Book* (1896), Louis John Rhead's two 1897 "decorative panels," *Swans* and *Peacocks,* as well as Fernand Fau's poster for the *Tabarin* and others. There may well be others with the distinctive margin identification, "Affiche artistique de *La Plume.*"

Page 31
La Plume featured Eugène Grasset in issues no. 122 and no. 261, Puvis de Chavannes in no. 138, Henri Boutet in no. 146, Andhré des Gachons in no. 159, Félicien Rops in no. 172, Alphonse Mucha in no. 197, Jules Baric in no. 207, and James Ensor in no. 232.

It is quite clear that it was Léon Deschamps who, perhaps with the assistance of fellow collector and art critic, Léon Maillard, directed *La Plume's* activities in favor of prints and posters and its Salon des cent. Deschamps died on December 28, 1899, at the age of thirty-seven. The remnants of his efforts continued at *La Plume* for the next half year. His death, however, was accompanied by the demise of the Salon des cent and its important series of posters.

Page 32
Les Maîtres de l'affiche was published in five volumes from 1895 through 1900 with an annual preface by Roger Marx.

André Mellerio wrote the article "Un Salon de la gravure" in *L'Estampe et l'affiche,* May 15, 1899, p. 105-06, and Roger Marx wrote "Un Museé de l'affiche moderne" in *L'Estampe et l'affiche,* December 15, 1898, p. 263.

Page 33
J. F. Raffaelli's announcement was made in a letter on the subject of "Un Salon de la gravure," in *L'Estampe et l'affiche,* July 15, 1899, p. 172.

theCOLOR REVOLUTION

Chevaliers. Alors il l'embrassa et dit à ses frères : Faites sonner la trompette pour préparer la sortie, pour montrer au Roi qui nous sommes; si Dieu vouloit que nous puissions prendre le Comte d'Estampes, j'en serois fort joyeux, car, de tous nos ennemis, c'est celui que je crains le plus : il ne pourra nous échapper, il est toujours à l'avant-garde. Alors les quatre frères, et tous ceux de leur compagnie, s'armèrent et sortirent tous par la fausse porte du Château sans faire de bruit; ils tombèrent avec précipitation sur l'armée du Roi avec tant de fureur qu'ils renversèrent soldats, tentes et pavillons. Il eût fallu voir Regnaut, monté sur Bayard, et les armes qu'il faisoit, car celui qu'il rencontroit pouvoit se regarder comme très malheureux : il n'atteignoit personne qu'il ne le renversât.

Quand les gens du Roi virent leurs ennemis, ils coururent aux armes, et vinrent contre les gens de Regnaut. Le vieux Aymon entendit le bruit, et monta à cheval, lui et ses gens, et se mit en bataille contre ses enfans. Regnaut, voyant son père, fut bien fâché, et dit à ses frères : Voici notre père, quittons-lui la place : je ne voudrois pas qu'aucun de nous le frappât. Ils se tournèrent d'autre part, mais leur père vint sur eux, et les maltraita cruellement. Regnaut, voyant que son père les atta- quoit si vivement,

lui dit : Mon père, vous faites mal : vous qui devriez nous secou- rir, vous nous faites pis que les autres; il me paroît bien que vous ne nous aimez pas; il vous déplaît que nous sommes si courageux contre le Roi, car vous nous avez déshérités. Nous avons fait faire ce petit Château pour notre retraite, et vous-

41

48. Eugène Samuel Grasset, illustration for *L'Histoire des quatre fils Aymon*, 1883, multicolor photo relief process. Mr. and Mrs. Phillip Dennis Cate.

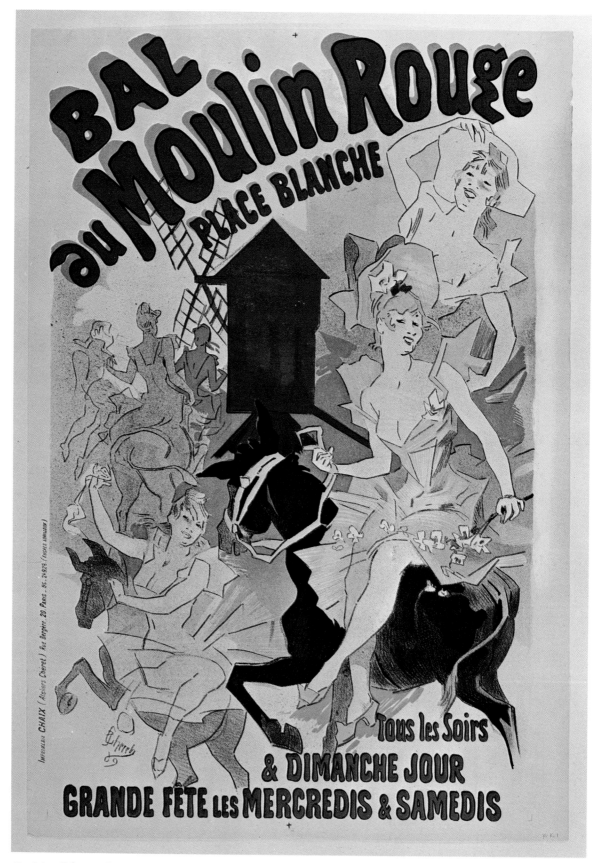

49. Jules Chéret, *Bal au Moulin Rouge,* 1889, four color lithograph, 23½ x 16½″. Rutgers University Fine Arts Collection.

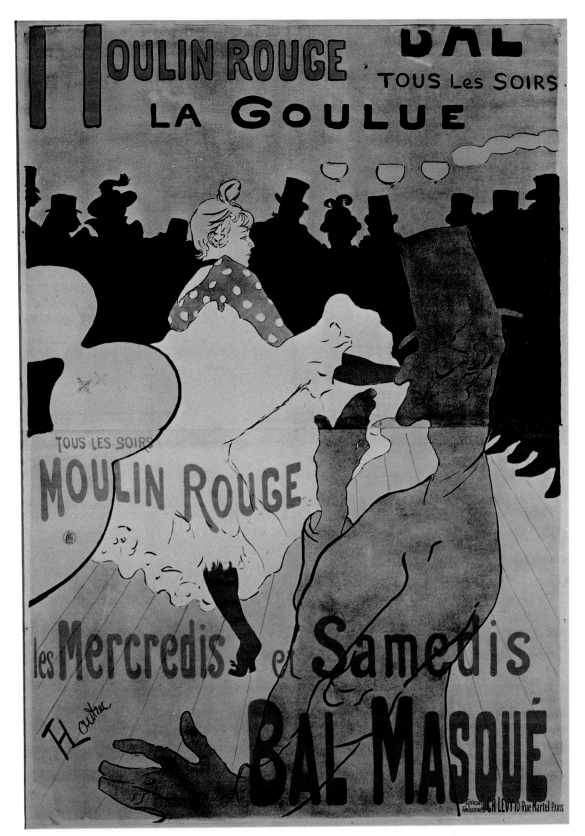

50. Henri de Toulouse-Lautrec, *La Goulue au Moulin Rouge,* 1891, four color lithograph, 65^{15}/$_{16}$ x 45^{3}/$_{8}$".
Merrill Chase Galleries.

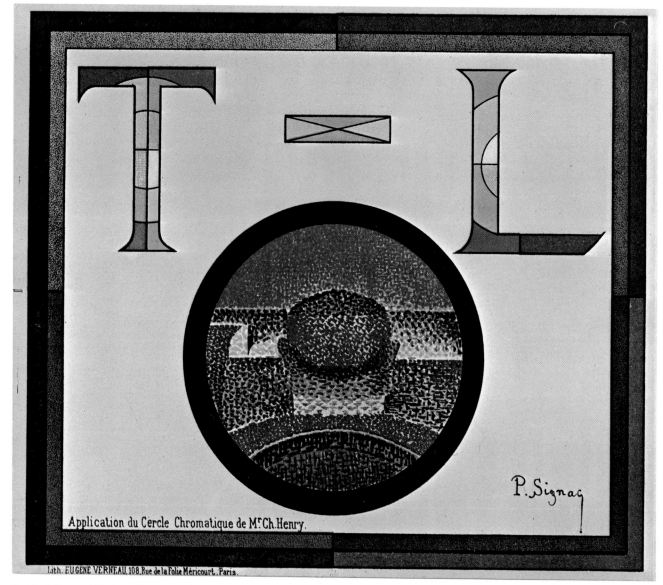

Within the image:
Application du Cercle Chromatique de Mᵣ Ch. Henry.

P. Signac

Lith. EUGENE VERNEAU, 108, Rue de la Folie Méricourt, Paris.

51. Paul Signac, Théâtre Libre program and ad for Charles Henry's *The Chromatic Circle,* 1888, nine color lithograph, 6½ x 7⁵/₁₆". Rutgers University Fine Arts Collection.

52. Henri-Gabriel Ibels, second program for the 1892-1893 Théâtre Libre season, 1892, five color lithograph, 9½ x 12½″. Rutgers University Fine Arts Collection.

53. Henri de Toulouse-Lautrec, *L'Anglais Warner au Moulin Rouge,* 1892, seven color lithograph, 18⅝ x 14¾". Boston Public Library, Gift of Albert H. Wiggin.

Maurice Denis, *Madeleine (two heads)* from *L'Estampe originale*, 1893, four color lithograph, 11¾ x 9⅞". The Brooklyn Museum, Smith Memorial Fund.

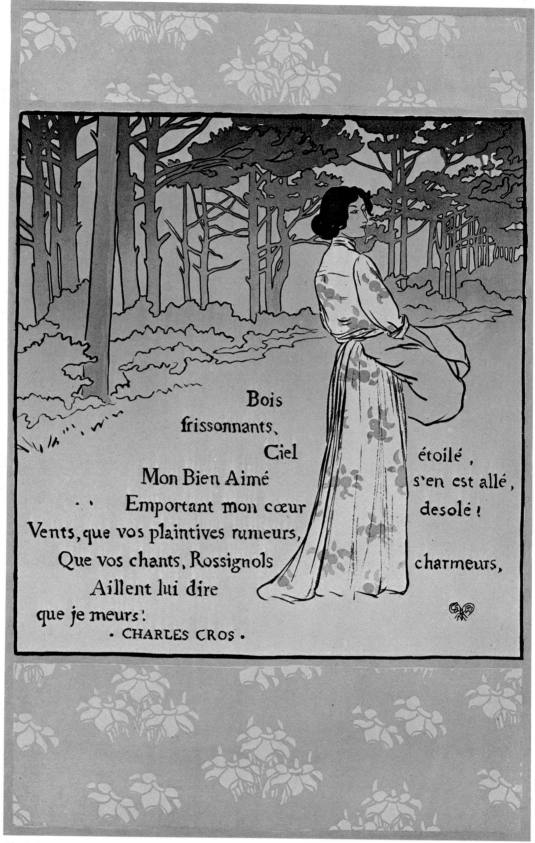

55. Georges Auriol, *Bois frissonnants* from *L'Estampe originale,* 1893, six color lithograph, 19½ x 12¾".
The Brooklyn Museum, Smith Memorial Fund.

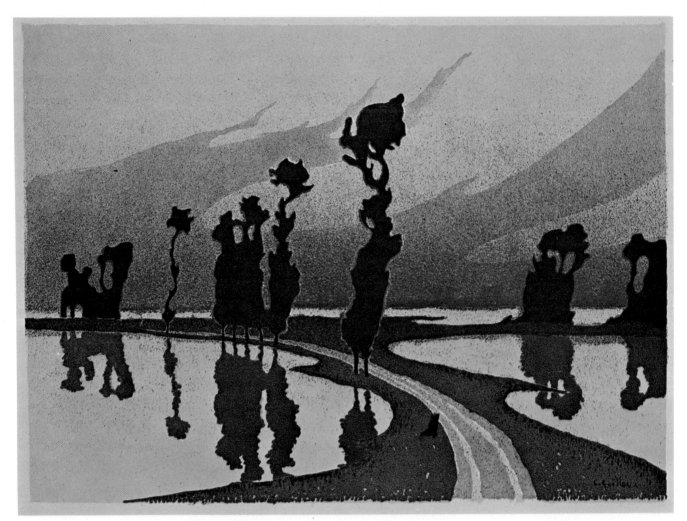

56. Charles Guilloux, *L'Inondation* from *L'Estampe originale*, 1893, four color lithograph, 8¼ x 11⅜". The Brooklyn Museum, Smith Memorial Fund.

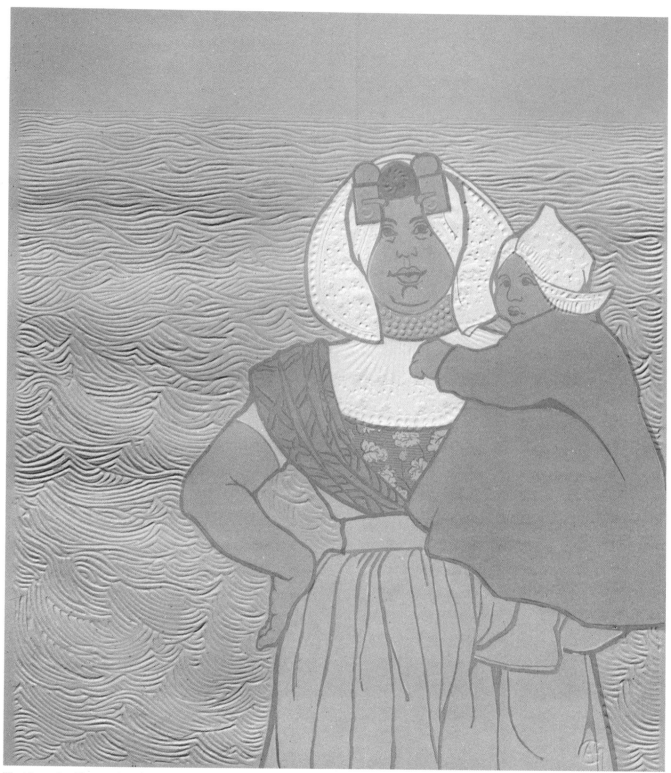

57. Alexandre Charpentier, *Mother and Child* from the series *En Zélande*, c. 1894, three color embossed lithograph, 13 x 11⅝".
François Meyer.

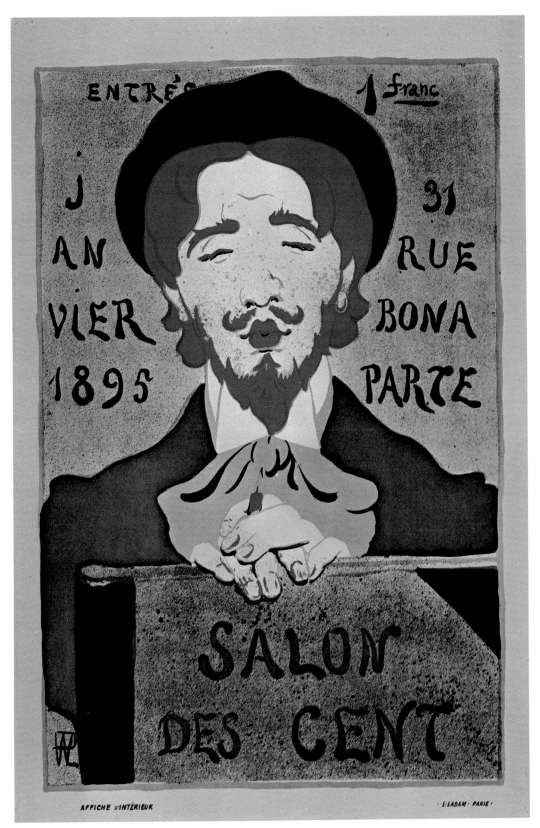

58. Hermann René Georges Paul (Hermann-Paul), poster for the fifth Salon des cent, 1895, five color lithograph, 24⅝ x 16⅝". The Museum of Modern Art, New York, Gift of Ludwig Charell.

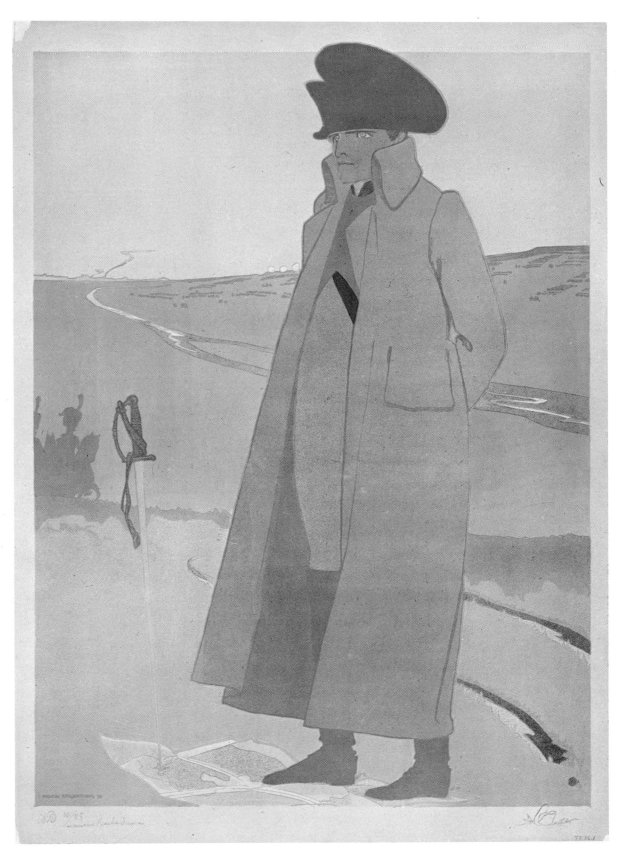

59. Maurice Réalier-Dumas, *Napoléon*, 1895, six color lithograph, 17½ x 22¾". Rutgers University Fine Arts Collection, Gift of the Class of 1958, twentieth reunion.

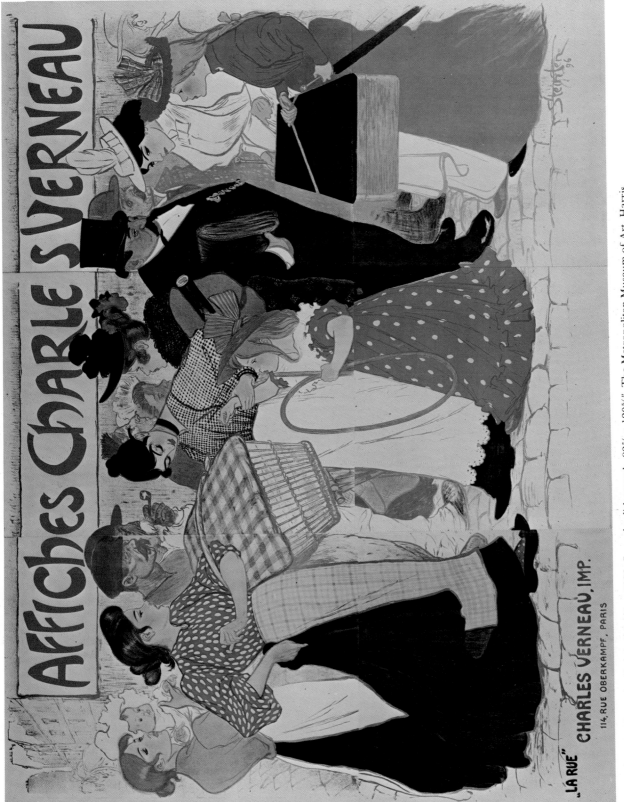

60. Théophile Alexandre Steinlen, *La Rue*, 1896, five color lithograph, 92⅝ x 120⅝". The Metropolitan Museum of Art, Harris Brisbane Dick Fund, 1932.

53

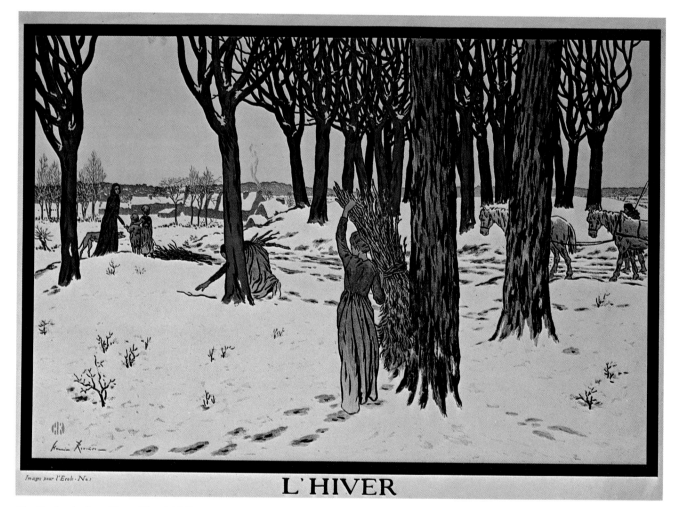

L'HIVER

61. Benjamin Jean Pierre Henri Rivière, *L'Hiver*, 1896, ten color lithograph, 22¾ x 33⅝". Rutgers University Fine Arts Collection.

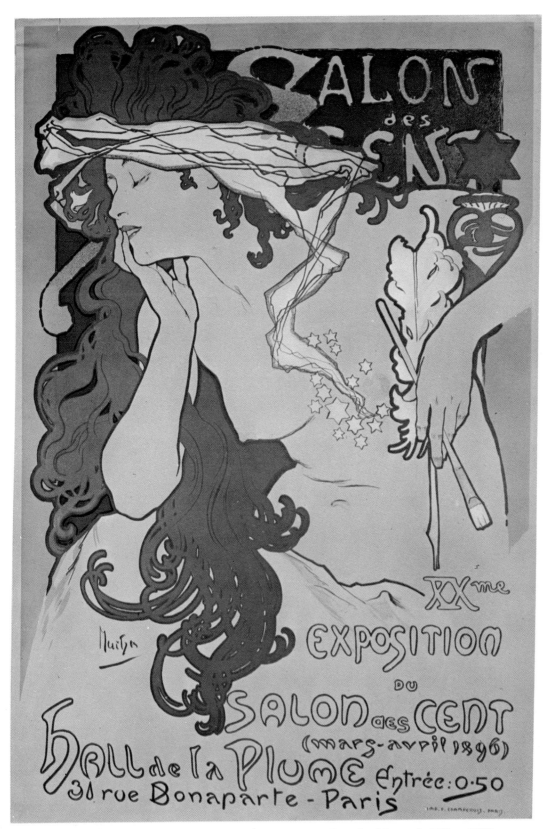

62. Alphonse Mucha, poster for the twentieth Salon des cent, 1896, five color lithograph, 24⁷/₁₆ x 16⅜".
Boston Public Library.

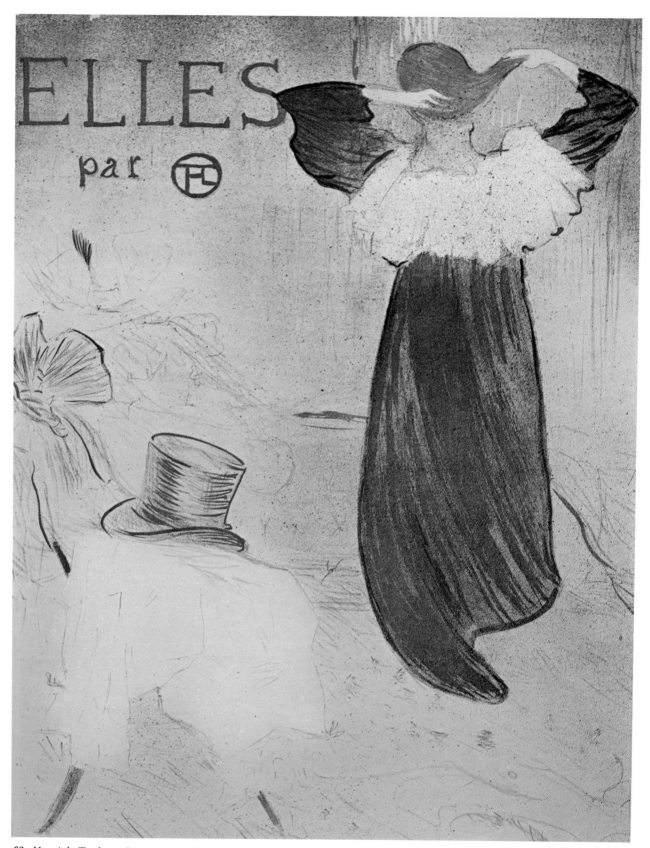

63. Henri de Toulouse-Lautrec, cover for the album *Elles*, 1896, four color lithograph, 20½ x 15¹³/₁₆″. Boston Public Library, Gift of Albert H. Wiggin.

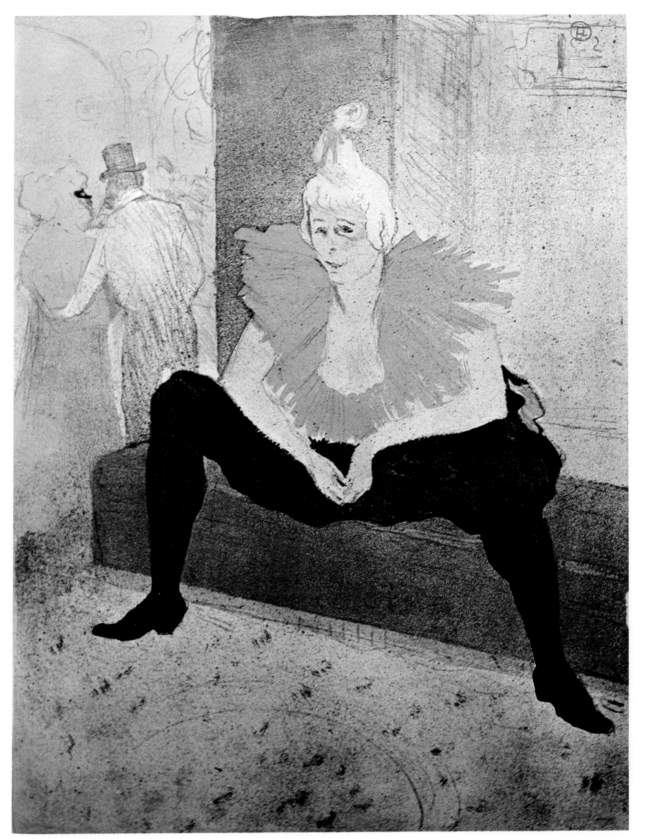

64. Henri de Toulouse-Lautrec, *La Clownesse assise* from the album *Elles,* 1896, four color lithograph, $20^{11}/_{16}$ x $15^{13}/_{16}''$. Boston Public Library, Gift of Albert H. Wiggin.

65. Paul Cézanne, *Les Baigneurs* (large plate) for the unpublished *L'Album d'estampes originales de la Galerie Vollard,* 1896-1897, Six color lithograph, 16 x 19⅞". The Baltimore Museum of Art, the Cone Collection, formed by Dr. Claribel Cone and Miss Etta Cone of Baltimore, Maryland.

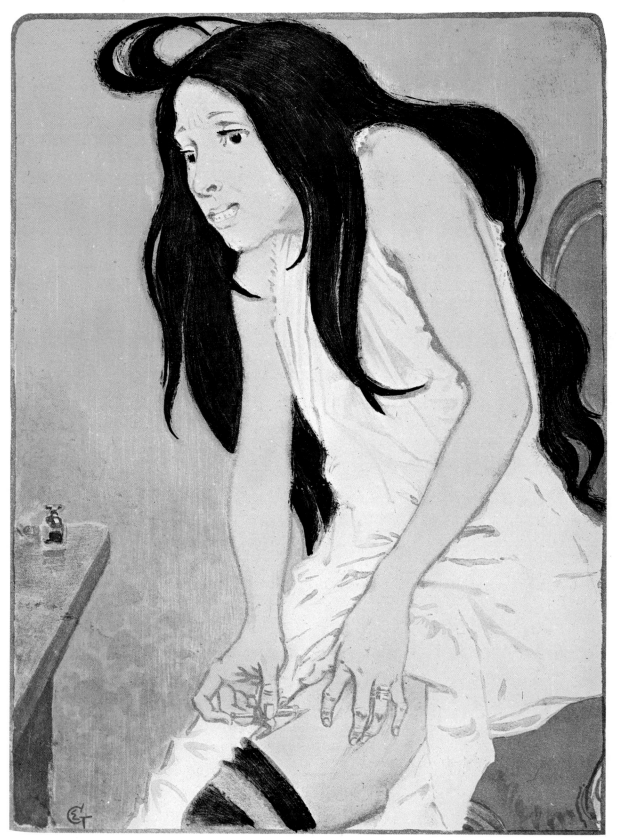

66. Eugène Samuel Grasset, *La Morphinomane* from *L'Album d'estampes originales de la Galerie Vollard*, 1897, seven color lithograph, 16¼ x 12¼″. Rutgers University Fine Arts Collection, "Friends" purchase.

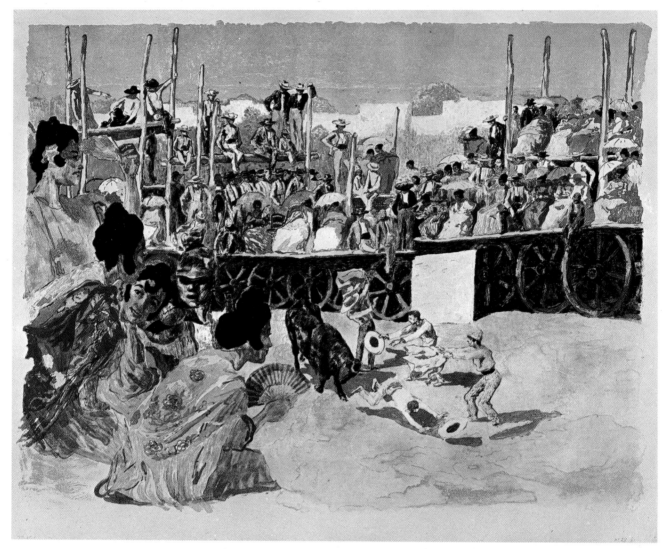

67. Alexandre Lunois, *Une Corrida à la campagne,* from the series *La Corrida,* 1897, six color lithograph, 17⅞ x 23¼". Rutgers University Fine Arts Collection, Gift of the Class of 1958, twentieth reunion.

68. Maximilien Luce, *Usines de Charleroi* from *Pan*, IV, 1898, five color lithograph, 10¼ x 8″. Rutgers University Fine Arts Collection.

69. Paul Signac, *Le Soir* from *Pan,* IV, 1898, five color lithograph, 7⅜ x 10″. Rutgers University Fine Arts Collection, Gift of the Class of 1958.

70. Jean Miscélas Peské, poster for *L'Estampe et l'affiche*, 1898, four color lithograph, 34 x 48¼". Mr. and Mrs. Herbert D. Schimmel.

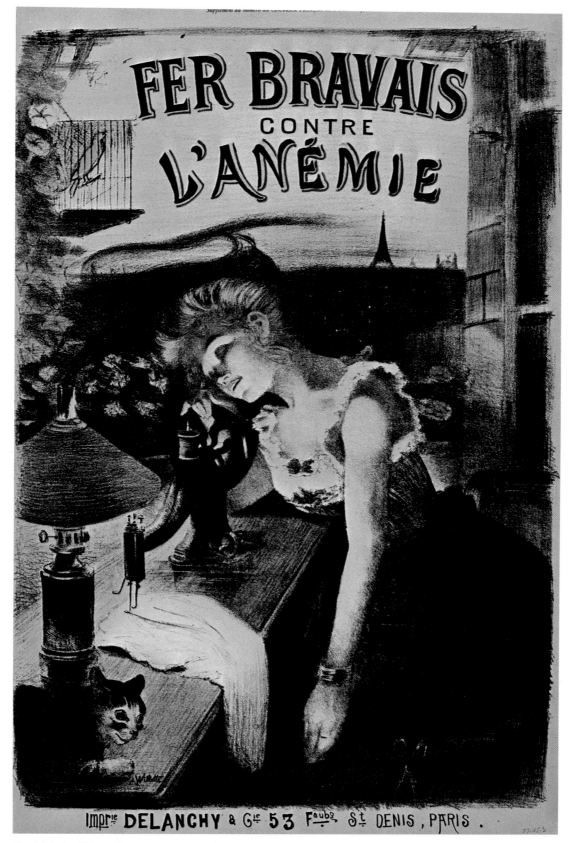

71. Adolphe Willette, *Fer Bravais contre l'anémie,* 1898, four color lithograph, 21½ x 14¾". Rutgers University
Fine arts Collection, Gift of the Class of 1958, twentieth reunion.

72. Pierre Bonnard, *Boulevard* from the album *Quelques Aspects de la vie de Paris,* 1899, four color lithograph, 6⅞ x 17³/₁₆″. Boston Public Library, Gift of Lee M. Friedman.

73. Pierre Bonnard, *Marchand des quatre-saisons* from the album *Quelques Aspects de la vie de Paris,* 1899, five color lithograph, 11⅛ x 13⅜″. Boston Public Library, Gift of Lee M. Friedman.

74. Pierre Bonnard, *Maison dans la cour* from the album *Quelques Aspects de la vie de Paris*, 1899, three color lithograph, 21 x 15¹⁵⁄₁₆". Boston Public Library, Gift of Lee M. Friedman.

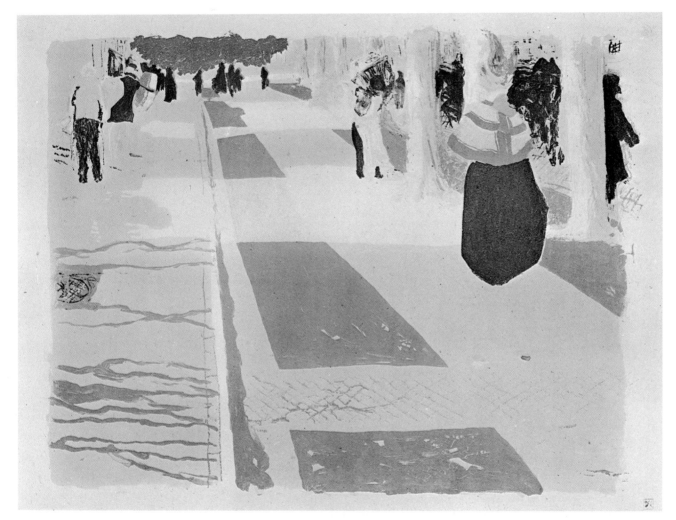

75. Edouard Vuillard, *L'Avenue* from the album *Paysages et intérieurs*, 1899, six color lithograph, 16$\frac{3}{16}$ x 12″. The Baltimore Museum of Art, Purchase fund.

76. Edouard Vuillard, *Intérieur aux tentures roses II* from the album *Paysages et intérieurs,* 1899, five color lithograph, 13⅝ x 10¹¹/₁₆″. Boston Public Library.

77. Maurice Denis, *Elle était plus belle que les rêves* from the album *Amour*, 1892-1899, four color lithograph, 16 x 11¾". The Museum of Fine Arts, Boston, Bequest of W. G. Russell Allen.

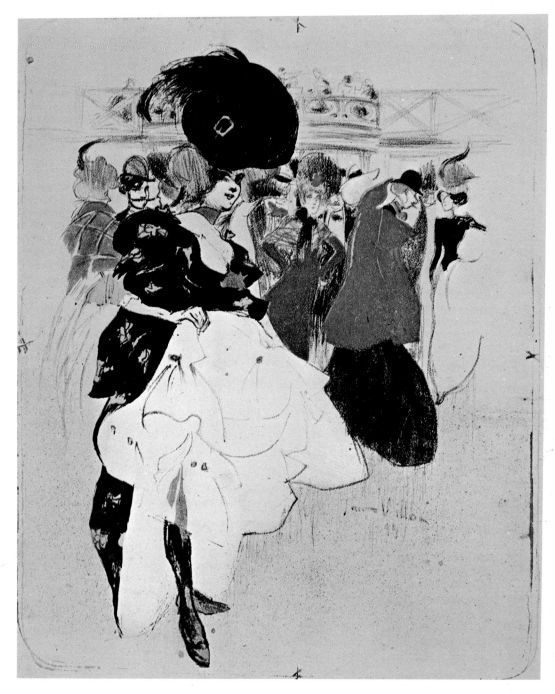

78. Jacques Villon, *La Danseuse au Moulin Rouge,* 1899, five color lithograph, 11¾ x 9¼″. Boston Public Library, Gift of Lee M. Friedman.

79. Paul Berthon, *View of Notre Dame,* n.d., six color lithograph, 22¼ x 16½". Rutgers University Fine Arts Collection, Gift of the Class of 1958, twentieth reunion.

80. Maurice Denis, *Homage à Cézanne*, 1900, oil, 70⅞ x 94½". Le Musée du Palais de Tokyo, Paris. From left to right: Redon, Vuillard, Roussel, Vollard, Denis, Serusier, Ranson, Mellerio, Bonnard, Madame Denis.

André Mellerio (1862-1943)

*L*ITTLE is known of André Mellerio's early years. As a young boy he attended the Lycée St. Louis in Paris and subsequently studied law for several years. In the 1880s and the early 1890s he was a published writer of poetry and short stories. The first evidence of his involvement with the visual arts was his preface to the catalogue of the November 1893 Mary Cassatt exhibition at the Durand-Ruel Gallery in Paris. Obviously receptive to Cassatt's art, he also endorsed the then common myopic European view of American art: "Miss Cassatt is perhaps, besides Whistler, the only artist of talent the United States has." Yet three years later, in his book *Le Movement Idealiste en peinture,* Mellerio's discussions on the Neo-impressionist, "Mystic," and Synthesist movements reveal him as an astute and sensitive observer of avant-garde French painting. He acquired a profound understanding of contemporary French art and was able, possibly more than any other critic of the time, to view the total scope of artistic activity, to analyse, to reflect, and finally to distill from the mass the unique and sustaining contributions of the period.

In May 1898, *L'Estampe et l'affiche* published Mellerio's book *La Lithographie originale en couleurs.* The journal, with Mellerio as editor, Clement Janin as director and Edward Pelletan as publisher, was in its second year of publication, carrying forth its declared program of propagating the taste for prints and posters. It was in the early issues of *L'Estampe et l'affiche* that Mellerio first defined and described the current renaissance of printmaking in France. In fact, in the journal's third month, May 1897, he first enunciated his views on the growing importance of color lithography and its special attraction to young artists as a means of personal expression. His January 1898 review of the exhibition of *L'Album d'estampes originales de la Galerie Vollard* anticipated his discussion in his forthcoming book on some of the same prints and many of the same artists—in particular Puvis de Chavannes, Redon, Guillaumin, Cottet, Bonnard, and Renoir. In reality then, *La Lithographie originale en couleurs* is the expansion and elaboration of concepts that Mellerio had developed earlier in *L'Estampe et l'affiche.* More precisely, it is the distillation of his perceptions into a unique analysis of the aesthetic activities of his time.

Mellerio's observation that color lithography is the special artistic form of his time appears today to be an obvious conclusion. However, it was not so evident to many of his colleagues. In the 1895 book, *La Lithographie,* by Henri Bouchot, the author applauded the courage but not the results of the young color lithographers whose works filled the albums of *L'Estampe originale* (Figs. 54, 55, 56). Bouchot found these prints "cruel, violent and daltonist." In his 1898 book, *Lithography and Lithographers,* Joseph Pennell, artist, critic and close observer of French printmaking, appreciated the creative use of flat tints by Toulouse-Lautrec and the unmuddied color of Lunois' *La Corrida* (Fig. 67) series. In final analysis, however, Pennell saw color

as an "amusing" part of the overall vitality of French lithography. The critic Roger Marx, who in his 1893 preface to *L'Estampe originale* was elated over the numerous color prints in that publication, came closest to Mellerio's views, but viewed the medium as just one of the various important aspects of avant-garde printmaking. Only Mellerio perceived color lithography as the most consistent common denominator of the avant-garde, regardless of philosophic or aesthetic bent — symbolist, pointillist or realist. His book systematically supported this view with critical analyses of the work of more than forty artists while documenting the publishers, the printers, and publications which promoted the medium.

Indeed, *La Lithographie originale en couleurs* set the tone for future aesthetic appraisals of 1890s print-making. Mellerio's choice of artists, his critical analysis of their work and his estimate of each artist's contribution to the color movement remain essentially valid today. In only a few cases has time controverted Mellerio's opinions. Ibels' accomplishments, for instance, seem overrated; the color work of Steinlen and Mucha deserves greater recognition, while that by Dulac is too harshly criticized. Yet these are minor problems, possibly realized only by hindsight, of an essentially accurate account of the color lithographic movement.

The book also proposed two rather radical concepts — one aesthetic and one social. The former is Mellerio's "axiom" that "any method or process which an artist develops to express himself is for that very reason legitimate." Today (after nearly a century of struggle) this has become the established dictum; yet in 1898 it threatened the normal relationship between student and mentor, a relationship which relied upon the transference of traditional techniques and know-how. In the social realm Mellerio suggests that color lithography is a democratizing force. It offers the general public access to quality original art at a low cost. This concept, radical in France, was a valid application to lithography of the social theory of the nineteenth century arts and crafts movement in England. In the 1890s one could purchase a color lithographic poster by Toulouse-Lautrec for the price of a meal at a good restaurant, or a color lithograph by Lautrec or by Redon for the price of a suit. Such equivalent values are, of course, impossible to find today.

Finally, Mellerio made a very practical assessment of the status of the color lithographic movement. Although he did not foresee the sudden end to the movement which occurred around 1900, he was aware of its potential weaknesses and such actual liabilities as the low quality paper and printing in the albums of *L'Estampe moderne*. He was convinced, however, that no matter what happened in the future the movement had already, by 1898, "created a high point in the history of prints, and consequently, in Art." *La Lithographie originale en couleurs* is essentially a record of almost a decade of avant-garde printmaking activity. In a broader sense it is also a forum for advanced aesthetic theories which challenged many reactionary academic values. As such it is an eloquent prelude to the aesthetic convulsions of the twentieth century.

P.D.C.

81. Pierre Bonnard, cover for *La Lithographie originale en couleurs* by André Mellerio, 1898, two color lithograph, 7½ x 8¹³/₁₆″. Boston Public Library.

82. Pierre Bonnard, *La Loge,* fronticepiece for *La Lithographie originale en couleurs* by André Mellerio, 1898, four color lithograph, 7½ x 8⁷/₁₆″. Boston Public Library.

ANDRÉ MELLERIO

LA

LITHOGRAPHIE ORIGINALE

EN COULEURS

COUVERTURE ET ESTAMPE

DE PIERRE BONNARD

PARIS

PUBLICATION DE *L'ESTAMPE ET L'AFFICHE*

50, RUE SAINTE-ANNE, 50

—

1898

ORjGjnAL cOLOR LjthOGRAphy

Color lithographic prints and the present.
—Their place in the history of lithography. —Their recent origins.
—Their legitimacy. —Their present importance.

For the last few years color lithography has developed to a point where it justly merits the attention of the public. It seems that now is the psychological moment to speak about it. On the one hand, a sufficient number of documents has been produced to constitute a movement, with its characteristic tendencies. On the other hand, the impetus is not finished and even, we believe, has not reached its climax. An absolute judgement cannot be made, as if this movement were something concluded; yet written considerations might be of some use in its development and might influence its final result.

It may be objected, why limit oneself here to original color lithography? First, our personal researches have led to a number of articles published during the past year[1], which in this brief study we will try to assemble, without claiming however to present a complete view of the subject. Secondly, we have a conviction derived from a study of the facts: it is in the present period of fermentation that the print is flourishing, is evolving and is being produced abundantly, and the color print is playing a striking role from a number of different points of view. It seems to us that color lithography has not existed before in the conditions in which we recently have seen it bloom and, consequently, is the distinctive artistic form of our time.

What has been the role of color in the history of lithography?[2] It must be said that it has existed almost since the origins of lithography, which go back only to the beginning of this century. The first efforts in color, still timid, were simply destined to serve as documents in the study of archaeology. It was only later, as improvements were made, that works of artists were reproduced. But it was necessary to reckon with the inking, the registering and the printing—all very complicated techniques. Furthermore, the work of the printer resulted in further modifications, which intervened between the sketch and the final work. These developments led to chromolithography, with all that that word implies of hard work and satisfactory technical successes, but also—it is necessary to add— mitigated by an indelibly inartistic quality. In reality, no matter how perfect it was, it was simply a method of reproduction by a more or less skillful technique, with a process more or less developed, of an original work, conceived often from an entirely different point of view.

Going back only a short time, two artists stand out as precursors. One of them, Manet, a revolutionary figure in prints as elsewhere, made his *Polichinelle* (Fig. 6) in lively and gay colors which were neither harsh nor heavy, auguring a new style. At the same time, at the end of his life, John-Lewis Brown was interested in color lithography (Fig. 21). His works are not numerous, the coloring in them is timid, the work in black is too visible; but the effect which is created by the tone and its nuances far outdistances ordinary reproduction. However, these early trials were not decisive.

Should we be asked, given the present movement, how chromolithography crossed the boundary line into the domain of original art, we would not hesitate to state that it was in the work of Chéret (Fig. 49). The renovator of the poster, or rather its true creator from the modern point of view, he not only achieved a personal statement, but he also exerted a large and resounding influence. The elegant variegated patterns, which brightened our city walls, led to the creation of original forms at the same time that they brought a sparkling and luminous range of gay colors. The print—in its ardent search for regeneration—was naturally affected. Chéret's posters opened up a new path—a path which the print happily followed.

Again, two influences seem to have determined the movement toward color. On the one hand the Impressionist school with its cleaning of the palette, its vision at once lighter and clearer, tied in certain of these artists (Renoir for example) with the tradition of our French 18th century. This brilliantly colored painting filtered down to the deepest and darkest levels of the official Salon, still so far behind the times. In addition, Japanese art, which had been recently introduced and was increasingly exhibited, could be more and more studied and deeply appreciated. From these sources, in a fully developed form, with varied and appealing characteristics, in its curious printings, the colored print triumphed.

How did the modern print differ from the old and ordinary chromolithograph to such a degree that it is necessary to look today for a name which clearly indicates this break? Precisely in the way Chéret freed his work and made it a creative form. The modern print was no longer a *facsimile* reproduction of just any original work in color, but a personal conception, something realized for its own sake. An artistic inspiration joined in advance with a technique expressed itself directly in the chosen process of execution. This principle, applied victoriously by Chéret to the poster, whose nature and function made it special, was to be applied by others to the print, whose characteristics differed in certain ways. And so original color lithography was born, and a simple sheet of paper for which mechanical means procured the advantage of unlimited copies, attained a real value as an art form.

But it is important to deal immediately with a previous question, the importance of which is evident, and upon which rests the matter of whether this effort will appear corrupt at its very base. We want to ask, what is the legitimacy of the color print? Should it be considered simply as an encroaching and diminishing incursion into the domain of painting? Or, on the contrary, does it have an intrinsic essence and its own particular range and scope?[3]

We lean resolutely toward the latter affirmation. And we leave to quibblers the task of distinguishing the more or less real preeminence of one genre over another. But the right of the color print to exist comes directly from the principle which we consider an axiom: any method or process which an artist develops to

express himself is, for that very reason, legitimate. Now, people cannot deny that this is so for color lithography. And for the present period we will go further: not only has it been happily used by a number of artists, but it seems that some of them can assert even more forcefully that it is their principle if not their unique mode of expression.

If, going from theory to fact, we examine the domain that the color print has created for itself, particularly in lithography, we see that, already vast, it is growing every day. We might almost repeat what we stated in the past about prints in general in our time: "There is no one who has not made them, who is not making them, or who will not make them."[4] Even artists who have reached an advanced age with a glorious career behind them are interested. As for the younger artists, color prints are for them a veritable weapon which they use extensively and well. Some threw themselves into printmaking early in their careers, and found a process suited to their incipient style, and their earliest attempts showed understanding. From day to day they improve and perfect the technique, each one in an aspect fitted to his temperament—and the group continually becomes stronger.

The subject has thus been laid out. Before envisaging the different aspects in more detail, and before approaching the general considerations, it is important to set out the information which will serve as a documentary base. This brief investigation will first examine the principle artists who are actively engaged in color lithography or those who are simply interested in it. A few words seem necessary concerning the dealers and publishers, as well as the printers. Finally, a listing of the principle publications which made their mark with this process. Then we will be able to go more deeply into the subject, basing our work on the different aspects which will help us understand it, at the same time that they will lead to our conclusions.

The Artists. —Publishers and dealers. —The Printers. Principle publications.

THE ARTISTS.

What is at first striking about the color lithography movement is both the number and diversity of the artists who have taken part in it. First, we will examine those who seem to have had a strong personal attraction to it, as well as those who have done the most work in this medium. Then we will take a look at the artists who are beginning to be involved in lithography, and those whose work in lithography has been only incidental.

TOULOUSE-LAUTREC

Toulouse-Lautrec demands to be considered first.[5] He has contributed in a powerful way to the creation of original color lithography, both from the point of view of conception and of craftsmanship. His personal taste and circumstances have pushed him to create numerous works.

The artist conceives simply and clearly—completely in terms of the print. He uses contrasting flat tones, vigorously composed and colored. Silhouettes also attract him—they stand out dramatically, but always form a compositional ensemble. *L'Intérieur d'une imprimerie* (Fig. 32) which Toulouse-Lautrec produced

for Marty's *L'Estampe originale* seems typical in all these respects. The large areas of color harmonize and respond to each other, while the white paper plays an important role. The main tones, outlined with light strokes, are never vulgar, and never loud in spite of their boldness. They are warmed by the savage red of the woman's hair, at the same time that the scarlet of her lips stands out, which, while never making a hole in the print, tones down the other colors. These same qualities are found in a scene at the Moulin Rouge, drawn with a very expressive line, where a woman throws herself backwards, while next to her the purplish silhouette of a man in a top hat stands in profile (Fig. 50).

This is no longer just a poster, and it is not yet quite a print; a work of a hybrid pungency deriving from the two, or rather, it *is* the modern color print. It is here expressed in its essential aspects and characteristics which we will find again with differences in temperament when we look at other artists. Toulouse-Lautrec's delicacies of accent—and he does not lack them—do not come from a too precious and confused mixture of superimposed nuances somehow or other melted together. The work here is energetic in one place and relaxed in another, always personal. Compare such a print to a chromolithograph; not only is there the evidence of artistic inspiration, but even the craftsmanship is a renovation—let's use the word—a creation. The general appearance, like the skillfulness of the detail, is due not only to a learned technique carefully executed. These are an artist's efforts and discoveries, an artist seeking to express himself directly and as completely as possible in a mode which is satisfying and sufficent to him.

Toulouse-Lautrec is certainly gifted for prints—we think especially for prints. We even prefer his prints to his painting, in which he doesn't seem as much at ease, in a medium which is more elaborate, less direct.[6] His remarkable inspiration and procedures, his knowledge that was slowly forged by a training which he evolved himself, have rightly given him a starring role in original color lithography.

BONNARD.

Bonnard, a fine painter, and an original draughtsman, is equally gifted from the standpoint of the print. He has an understanding of prints which is at once personal and distinctive. His free fantasy, his observation of life around him, the piquancy of his black and white illustrations, and also the matt effects which he often worked for in his painting have predisposed him to printmaking. And then again, he has, without being inclined to imitation, a bit of that Japanese love of checkered or floral designs which lend to the effects of the print.

The artist has worked very happily in this particular medium of color lithography. In it he shows a refined conception; his craftsmanship is straightforward, aiming for a delicate harmony of color, a concise and expressive line, achieving a grace of arabesque. Bonnard has continually achieved success since one of his earliest and most characteristic prints: *Une mère tenant son enfant* (Fig. 33). The checkered material of the clothing stands out soberly from a light green background. We see almost no modeling, flat areas of color, a delightful baby with an oversized head, as well as elegance in the inclined pose of the mother. Very skillful use is made of the white of the paper at the bottom of the child's dress. All of these diverse elements join together to create an inspired and beautifully made print.

Bonnard has continued to develop, diversifying his work, searching for a technique that would be his own. Next to his painting, he really loves the print for itself. An inventive artist, with a natural sensitivity, his continuing contribution to the color lithography movement has been a most important one.

IBELS (H.G.)

Ibels is more violent. He is not put off by the contrasts of raw color. He uses them boldly, almost brutally, at the same time that he retains a harmony. His figures are placed in a natural way, in vigorous silhouettes, sometimes drawn rather summarily. This is how we see the artist in his series of programs for the *Théâtre libre* (Fig. 52), his series, *l'Amour s'amuse,* and various title pages of songs, especially *Mévisto.* Equally memorable are the monochromatic lithographs made to illustrate *La Terre,* by Zola. Ibels' temperament, full of spontaneity, and very open, sometimes does not go deep enough. These qualities and faults of his personality are found in his color prints and in his paintings. To a direct and accurate observation he adds good humor and unfailing liveliness.

And sometimes we have thought this is what prints should be: color lithographs, well printed, in a large number of copies, very inexpensive, showing scenes in which common people can really see themselves. Everything that really amuses them, or makes them feel strong emotions: the circus, the fair, young soldiers, café-concerts, comic or sentimental scenes. And it seems to us that with his unsophisticated temperament, Ibels could accomplish this task which corresponds to his impulsive inspiration, to his naive and strongly colored art.

VUILLARD (Edouard). —DENIS (Maurice). —ROUSSEL (K.X.)

These are three artists who must be considered with the preceeding ones as their work has been shown together in many exhibitions.

Vuillard has a gifted mind which is both subtle and vigorous. A painter in the essential meaning of the word, he is endowed with an extreme sensitivity. He proves it both in his matt sketches on cardboard and in his recent more transparent oil paintings. An exact artistic sense makes him quickly understand his medium, both what one must and what one can get out of it. That is why in lithographic prints, after a few initial gropings, he managed to achieve results like the two works done for the Vollard albums. Crossing or parallel lines, finely drawn silhouettes, splashes of contrasted colors beautifully balanced, procure for Vuillard's prints their own recognizable character and an artistic value which puts them in a category different from his paintings (Figs. 76, 77).

Maurice Denis, in his first color lithographs, seems to have looked for nothing more than a rapid and relaxing escape from his painting. They are not *facsimiles,* but translations into a more muted color scale of certain of his paintings, such is the *Pèlerins d'Emmaüs.* This work and another, *Jeune fille à sa toilette,* are, unfortunately, from an edition which did not do justice to the artist. Maurice Denis' painting, which aims principally at decoration with only slight modeling, and his concern with the harmony of broad areas of color in almost flat tones seems more than any other propitious to the furthering of a rational conception of the print. In Vollard's latest album, the artist makes a special effort to adapt his work to the stone. We should mention his delicate illustrations, in very restrained tones with elegant lines, for Le *Voyage d'Urien*[7]. Maurice Denis'

decorative qualities, his artistic impulses, his intellectual and painterly development, promise much from him in this area where he seems very well equipped to express himself.

From K. X. Roussel, a single color lithograph—*Paysage*. In spite of a few hesitations, there is a real comprehension of prints—we see a delicate understanding of tones, a clear and very personal way of using a fresh range of colors applied in small strokes which mix with the white of the paper to give a great luminosity. He is only a beginner in the field which we are considering, but he is working assiduously at this time. He is an artist to be remembered and from whom we can certainly expect to see some very interesting works in the future.

LUNOIS.

Lunois is a practitioner who really knows the stone. Formerly he made reproductions, but he has since, by his numerous and varied works, earned himself an important place in original prints—particularly in color lithography.

We have to say that the craftsmanship that serves him impedes him at the same time. His professionalism hampers him in that he does not know when to relax his method. The drawing in black shows entirely too much beneath the color. Now it seems to us that one should not notice nor even suspect that there has been a time when the conception of the black and white print might have been complete in the mind of the artist, later to be dressed up as a new and different effort with an addition of color. If this is the case, we feel a disquieting element which is not part and parcel of the original inspiration—a lack of unity in the work.

However, Lunois has often found just the right tones, as in his *Danseuses espagnoles*, one of his best known works. Certain of his works, carefully done, but rather cold, come too close to chromolithographs. However, we must note that in his latest prints—those for the bullfighting series (Fig. 67) he is doing right now —the artist has achieved a lighter touch, he is using the paper itself in a more clear and distinct way, and shows concern for the relation of the main color areas and a simplification of the work in black.

Lunois' conscientious work, his technical knowledge, and his recent progress point to him as capable of exercising a strong influence on the color lithography movement, even more so because he produces so much.

RIVIÈRE (Henri).

Mr. Rivière used to make illustrations for albums of his shadow theater productions: *La Marche à l'Etoile*, *L'Enfant prodigue*. The dark tones of brown and blue silhouettes, standing out against their backgrounds, remind us of the shadow theater. On the other hand there is another group of his works where the artist seems to have created an interesting personal note. Here we are speaking about an exhibition which recently took place.[8]

Mr. Henri Rivière has produced a series of "decorative prints," justly named (Fig. 61). Their size, the intention of attaching them to walls and framing them for ornamentation of our interiors, makes them something other than a collector's item destined for the portfolio.

What is most striking about Mr. Rivière's work is the combination of a very real feeling for nature with a harmonic sense of the organization of line and color.

From this comes a mixed impression reminding us, when we add the use of flat tones, of the flavor of Japanese prints, but without any suggestion of a plagaristic copy. Mr. Rivière's colors, because of their more gentle scale, belong to a western eye. He is less preoccupied with pure arabesque, and his urge to simplification never gives way to the deformations of fantasy. It should be recognized that the artist always stresses the most strikingly decorative parts of the landscape, at the same time retaining all of its poetry.

The great care and the perfection of the printing should be mentioned. Mr. Rivière, it seems to us, has reconciled practical requirements and the demands of taste. Isn't this the tangible realization of the ideal of the arts and crafts movement we hear so much about? In practice, the latter often only brings together a lack of real originality and awkwardly achieved complications.

DULAC.

Mr. Dulac stands out from most of his contemporaries because he is less advanced than most of them. Did he look, as Toulouse-Lautrec, Bonnard, Vuillard did, for a new aspect of color prints? We must answer, no. What he did accomplish was to raise the level of the still rather crude chromolithographic process. He improved it with a personal, more refined approach. His lithographs (Figs. 34, 35) look like color drawings or washes; the drawing is sometimes rather hesitant. Nevertheless, the artist achieves a genuine effect. We experience the striving for feeling, the truly felt emotion in them. It is expressed gently, in harmony with the weak, rather faded color. The drawing in black is often too noticeable, the number of different colors overdone. What seems to prove this is that certain trial proofs, which do not yet have all the colors, are at times superior to the final ones.

Dulac, besides having shown that he has an individual sensitivity in his color choice, and having done original work with an everyday process, has also shown merit in producing careful printings.

DE FEURE. —HERMANN PAUL. —WEBER. —JEANNIOT.

De Feure has done a considerable amount of color lithography. He has experimented and worked in different styles (Fig. 47). The style that seems most personal to him and to characterize him is found in the series entitled: *L'Amour Libre*. Flat tones, but in heightened color, are enclosed in extremely sensuous lines, and together they produce a unified arrangement.

Hermann Paul has also adroitly used the multiple effects of color lithography (Fig. 58). He is familiar with all the tricks of the trade: spatter, flat colors, softened outlines, and large areas of color. Besides his consistent gift for observation and his feeling for caricature, there are personal developments which show that he is at home in the medium he has chosen. Some of his stones show effects that are rather crude in color, but nevertheless true.

Weber too shows diversity in his prints: some light, others more somber. The latter seem more typical of him. His work is very elaborately drawn, though set off here and there by a few colors.

One can say almost the same thing of Jeanniot. He produces many carefully drawn lithographs—copies of his paintings, with nuances added. For us, these are operations which do little to facilitate the direct expression of an emotion, and

which give an overworked character to his prints. Jeanniot, a serious artist who is a bit heavy and dark on his canvases, shows the same tendencies in color lithography.

CHÉRET. —STEINLEN. —GRASSET.

These three artists are known for their posters, Steinlen also for his drawings, and Grasset for his decorative art. From the special point of view of color lithography which concerns us now, we have little to glean from among their works.

Chéret, the indisputable renovator of the art of the poster, never, correctly speaking, made prints. But some book covers, some brochure illustrations, some small posters come close (Figs. 3, 20). Again, one finds here the spirited qualities and the fresh colors of his murals, of which these are in some way "reductions." As for the real and very wide influence which we think Chéret has on the color print movement, we pointed that out right at the beginning of this study.

From Steinlen as well—even though his black and white lithographs are numerous and interesting—the contribution is slight (Fig. 60). We will not consider his production for daily papers, which is materially defective and is not able to have a suitable printing. The artist has confined himself here and there in his work to light tints, as in the small poster for Delmet's songs, touched up with bistre. But Steinlen is a very able spirit, his inspiration varied and his production plentiful. It is probable, in the future, that he will devote a good portion of his time to color lithography, which seems to be well suited to his temperament.

Grasset has made a certain number of small sized posters which come close to prints. A real color lithograph by him, *La Morphinomane* (Fig. 66), appears in Vollard's album. It lacks a little lightness on tone as well as in subject. However, because of his instinct and his decorative knowledge, his repeated success with multi-colored printing in posters as well as in illustrations, Grasset seems destined to become more involved in color lithography.

LUCE. —SIGNAC. —CROSS.

The Pointillists have tried their hand at the print and one may say that they have succeeded to a certain degree. Without reopening the debate on their extremist style which has been exhausted many times elsewhere,[9] we may observe that in color lithography as well as in painting the style allows for an overall harmony as well as a particular lightness of coloring. Furthermore, in a print the white of the paper shows through the dots of color and seems to circulate the air, giving lightness.

One could not really say that Luce is a true Pointillist. Rather, he uses a broad division of colors (Fig. 68). Unfortunately, there is an unpleasing heaviness in this artist who is well-endowed to create a more luminous vision. This defect is not being remedied and is even more shocking in the print. Furthermore, he tries to make an exact copy of his painting which, already heavy on the canvas, crushes the paper. This is unfortunate because there is in Luce conscientious effort and a true artistic temperament. Signac appears just as personal, but more refined. His division of color is more accentuated, but the tonalities remain subtle and their placement harmonious (Fig. 69). *En Hollande,* a canal view in misty weather, has a

delicate vaporous quality at the same time that it is very print-like. The impression of nature remains real and the whole has a charming effect.

Cross is the most categorically and formally Pointillist, with a round, distinct dot which hits you in the eye (Fig. 36). That is how his print in Vollard's album strikes one, although the simplicity of the colors and the arrangement of the lines are also notable.

WILLETTE. —FORAIN. —PUVIS DE CHAVANNES. —RODIN. —SISLEY. —GUILLAUMIN.

By Willette—*Le Petit Chaperon rouge*. This is less a real attempt in color than a touched-up lithograph, but it has a delicacy one might expect from such a charming artist.

We must also consider the lithographs in black and red chalk in which Forain shows that he continues to be a sensitive and incisive draughtsman—a result of an interest in the color print.

And we will point out as a matter of curiosity an attempt made by Puvis de Chavannes: a monochromatic lithograph which is a copy of his *Pauvre pêcheur*, for Vollard's second series.

In the same album is a Rodin lithograph or, to be more exact, a copy of a Rodin. It is a triumph of a *facsimile*. From the standpoint of the print, less an original work than an extremely skillful chromolithographic reproduction due to the printer Clot. Rodin's sketch was a diluted sepia in which the master sculptor enclosed a striking and precise nude of a woman in an encircling line. All the interest, indivisible in a true color print, is divided here between the original work of the artist on the one hand and the technical perfection of the work of reproduction on the other.

In the same category belongs a color lithograph, a real tour de force of craftsmanship, executed again by Clot, after a light and luminous Sisley pastel.

Guillaumin's *La Falaise* erupts in a clumsy but convincing brutality more appropriate to the print. *Une tête d'enfant* by him reminds us of his painting, but in broader divisions of color and aiming for a print-like quality.

None of these efforts constitutes a real document in the progress of original color lithography. But they are a precious indication of the appeal of this movement. It must be very strong and very widespread in order that such busy artists, masters in other areas, deign even secondarily or indirectly to be interested in it. This is more a proof of its vogue than a meaningful contribution to its direction.

In any case we strongly doubt, for our part, that it is incumbent on these masters, of a ripe age and whose careers have already been accomplished, some who have even achieved great fame, to create true color lithography. They will indulge in it as a popular form of the day, seeing it as a simple pastime. On the contrary, what will be necessary is a group of completely convinced young artists with a new spirit, who will find in lithography a form which fits their inspiration. For them, color lithography will not be an amusing pastime but a serious and necessary occupation. As a means of self-expression it will coincide with the intensity of their feeling, while it will occupy a most important place in the total number of their works. In a word, it will be for them not a fugitive foray of the moment, but the complete conquest of a virgin territory — they will create in it

their personal domain. They will find in color lithography both artistic discovery and a process that will seem to them amply sufficient, and they will make it greater by perfecting it with use.

ODILON REDON.

In the case of Odilon Redon we must make an exception to what we have said about established artists. It seems that this extraordinary lithographer who has handled black and white with such intensity again occupies a special place in the framework that we have set up. Until now Odilon Redon has produced only two color prints. One, his *Béatrice,* in softened, almost misty, colors, with its delicate charm remains almost hesitant. But the other, *La Sulamite,* freshly conceived and boldly harmonious in color, is a find—a new and personal quality is here given to color lithography. This is not a copy, but the equivalent of a pastel, in which the formerly severe wielder of the black crayon now seeks limpid tones and beautiful nuances.

In the realm of color, where he seems to be happy in many different mediums, we can, full of anticipation, reserve a place for an artist of the first order like Odilon Redon.

AURIOL. —LEGRAND. —MOREAU NÉLATON. —MUCHA. —MARCEL LENOIR. —AMAN-JEAN. —RÉALIER-DUMAS. —GUILLOUX. —ELIOT. —CHARPENTIER. —DILLON. —CÉZANNE. —LEHEUTRE. —BLANCHE (J. E.)

A few more names can be pointed out as having awakened curiosity for different reasons.

Auriol is without doubt the French artist who is presently doing the most original and decorative work in typography. His decorations for the *Revue encyclopédique,* his cover for *L'Image,* published by Floury, and especially the one for *L'Estampe et l'affiche* are extremely successful. Auriol has also tried color lithography (Fig. 55). Like Rivière, he is fond of flat colors. He often outlines them and imprints them with a decorative aspect.

What can be said about the two attempts made by Albert Bertrand to copy Louis Legrand's pastels? Only that they are prints of polychromatic reproduction, just as it exists in black and white. One of them, light, and a bit fuzzy, has an unusual effect and is worth examining closely. Legrand's personal spirit seems to be more at ease with the black and white of the etching, of which he is a master, knowing his craft well and being careful to pull prints of high quality.

From Moreau-Nélaton, under the title "mural prints," some small posters. In them, the artist retains his austere drawing with a very concentrated effect, in extremely sober tones. Some, like *Ellas,* have pretensions to a greater vivacity of color.

Mucha, of whom it has been said that he is a "likeable poster maker," (Fig. 62) carried his style into some prints and calendars. These are no more than chromolithographs, easily produced in quantity but pale and affected.

Mr. Marcel Lenoir has also produced prints of a terribly complicated process, triumphs of chromolithography, with fifteen or eighteen trips through the press: gold, garnet-red, and all the colors of the rainbow. It is an effort rather than an achievement.

Aman-Jean has transposed the style of his painting into color lithography: contoured lines, the colors of faded tapestries, and a certain elegance.

Réalier-Dumas has used flat colors, reminiscent of the poster rather than the print—as in his *Napoléon* (Fig. 59).

Guilloux, in the manner of the summary effects of his first efforts, has made an interesting color lithograph for Marty's publication (Fig. 56).

Eliot has contributed some nuanced prints, but without finding a particular direction or a striking aspect.

Charpentier, whose tin objects are often remarkable, has, in his series of multi-colored lithographs, *En Zélande* (Fig. 57), combined flat, pale, colors with a relief design harmonizing to form a whole. These are the techniques of certain Japanese prints though used in a fashion unique to the artist.

Dillon has sometimes scattered touches of light colors in his lithographs which are very heavily worked in black (Fig. 38). From Cézanne and Leheutre, in Vollard's collection, prints which are copies of their works (Fig. 65). These, like those of Rodin and Sisley, already mentioned, can be regarded as technical achievements falling between truly original lithography and ordinary chromolithographs. As we have noted à propos of Legrand, they are in reality color reproductions.

Blanche made a bistre print with highlights in red in two or three places. Though not without interest and elegance, this is more of a fantasy drawing than a true color print. A subject in light colors in Vollard's first album could also be mentioned.

Let us note a few more artists who have been briefly interested in color lithographic prints: Cottet, Roedel, Lewisohn, Peské (Fig. 70), Wagner, Henri Martin, Rippl-Ronai, Malteste, Rassen-fosse, Bellery-Desfontaines, Berthon (Fig. 79), Fauché, etc., etc.

PUBLISHERS AND DEALERS.

We do not have to bother ourselves here with commercial considerations. What is interesting is the role played in the movement we are considering by a few publishers and dealers: the choice they made of certain artists, how they encouraged them, and trends in taste and opinion that they were able to encourage.

SAGOT.

He was perhaps the first. Formerly a book lover, he became interested in posters at a time when they were only placards scarely looked at on the walls, and he became an official dealer in them. He placed himself resolutely in the avant-garde and has stayed there since. Always avid about things that are modern, he has been interested in each new effort. He was one of the first to take an interest in Lunois, who is now sought after by many others. The color lithographic print finds itself in good company with him.

KLEINMANN.

Kleinmann has a very intimate little shop, stuffed to the corners with portfolios, drawings, prints, and even with tin objects and knick-knacks. Art lovers and artists like to come here to browse and chat, finding in Kleinmann an intelligent taste and a love for his merchandise. His temperment leads him to seek out young talent. It is one of his glories to have recognized and recommended Toulouse-Lautrec from the beginning. He also published Willette, Steinlen, de Feure . . .

PELLET.

Arriving later on the scene, Pellet rapidly made an important place for himself as a publisher. In his shop, a former coach-house fixed up at the bottom of a courtyard, color is spread out in a victorious manner. Lunois shows his important bullfight series which he is presently working on; Signac and Luce, landscapes and seascapes. Then there are Jeanniot's prints; a series by Lautrec entitled *Elles* (Figs. 63, 64) and Bertrand's copies of Legrand—the latter's work being intimately linked with Pellet's effort.

VOLLARD.

Vollard is certainly one of those most enthusiastically and actively involved in the publishing of prints, even though he has been and remains a dealer in paintings. In the area of color lithography, Vollard's recent endeavours are typical and important. His two albums, especially the most recent one, will last as valuable collections, extremely interesting and most complete.

A FEW OTHERS.

Let us add a few more names to this list. That of Arnould, a champion of Mucha, and especially of Marcel Lenoir, whose work he has printed very carefully. Then Moline [sic.], Pierrefort, Duffau, Hessèle, the latter having just established himself (Fig. 30). One can see that all together this is a veritable constellation offering the color print movement publishing help as well as numerous outlets.

THE PRINTERS[10].

We cannot be as pleased on the subject of printers. Not only is their number limited, but, in spite of the undeniable quality of some of them from a technical standpoint, they have not yet achieved the necessary artistic insight to bring the color lithographic print completely to fruition. Still, their importance is very real. There must exist between the artist and his printer an affinity, what Odilon Redon, an expert on the subject, characterized in a picturesque phrase: "It is a marriage." The role of the printer, without ever encroaching upon that of the artist, must be to support and help him, overcoming the hitches, making the right suggestion at the right time, based on his ability and his deep knowledge of the

craft. Finally he needs a whole range of physical and intellectual qualities. If the artist is not backed up in such a way, besides the question of the accuracy of the printings, there is risk of betrayal in the rendering of his work. His ideal is not expressed as he would like it and as it should be. Modifications and arbitrary changes are made without him, sometimes even against his expressed wishes. One must understand from this the capital importance of printers in the movement which concerns us.

We will mention the principle printers from the point of view of color, excepting Bellefond who is a specialist in black and white.

DUCHATEL.

Duchatel, from the artistic standpoint, is the pride and the support of the important commercial firm, Lemercier. We cannot speak here of his special and remarkable printings of the lithographic washes of Carrière. But we will say that he has also printed in color, notably Dulac and Weber. He is both expert and enamoured of his art, and has published a simple and very lucid treatise about it[11] (Fig. 31). We can expect a great deal from this practitioner possessing such an enquiring and intelligent spirit.

STERN.

At Ancourts he was preceeded by an old printmaker, Cotelle, now dead, who worked on Marty's *L'Estampe originale*. Since then Stern has become Toulouse-Lautrec's appointed printer. He is by that fact alone more than qualified to cooperate in future color printings, for he has proved himself many times and in good artistic company.

CLOT.

The color printer in the forefront now is certainly Clot. Almost the entire second Vollard album comes from his shop. And so do a number of important sheets by Lunois, Signac, and Luce for Pellet. Clot is intelligent and obviously knows his craft very well. He is not hostile to new things, and numerous young artists can be found at his shop. His fault would be not a lack of skill, but rather a tendency to substitute his judgement for that of the artists when their personality is not strong or assertive.

The great importance that we have attributed to the printer makes us hope that he would be as follows: at the same time knowledgeable and gentle; knowing perfectly the resources of his craft, but not imposing himself on the artist. Loving the new, he should, in the company of young enthusiastic artists, extend his knowledge. In comparison with the big printing factories, which impose themselves in an overwhelming fashion, his more modest shop, not however hidden in too eccentric a quarter, would become a haven. It would be a friendly place for meetings where the color lithography movement—still recent, diffuse, and finding its way—could concentrate and elaborate its different elements. This close and much needed collaboration between the artist and the printer would be reached by suggestion and agreement. They would thus overcome the difficulties of the craft at the same time that the liberated inspiration would assert itself more directly and intensely.

THE PUBLICATIONS.

Of course we have had occasion to mention them many times during the course of this review. Nevertheless, it might be useful to talk about them all together in order to better appreciate their importance and evolution

L'Estampe originale was chronologically the first and it lasted three years (1893, 1894, 1895). This publication was privileged to begin the renewal and to give the impetus to the contemporary print movement. But from the particular point of view of original color lithography, we can say that it was a revelation, a first bringing together that has led to numerous and excellent consequences.

Prefaced by Roger Marx with a veritable manifesto, it introduced a fine collection of varied and independent artists. We must give André Marty, its creator, double credit—that he knew how to make a success from the material point of view of a difficult enterprise at the same time that his intelligent direction achieved a precious artistic result. Without prejudices he brought together contrasting talents, leaving to them the free expression of their own originality. It is a publication which from this time forward will have its important place in the history of the modern print.[12]

Vollard's two albums of *Les Peinteres-Graveurs* and *Les Peintres-Lithographes* [sic.] came a few years later, put together on the same logical principles as *L'Estampe originale*. Some of the artists from the latter are found here again, and it must be said that most of them have made great progress. Joining this original nucleus is a numerous constellation. The more recent of these albums, from the standpoint of color lithography, is a real encyclopedia. Of course, as in any publication of this type, the talents are not equal; but one may say that almost all the well-known printmakers of today are represented, permitting an instructive comparison.

The publisher, Pellet, is presently working on and has almost finished the important publication of *Courses de taureaux* by Lunois (Fig. 67). He also published *Elles*, a series by Toulouse-Lautrec, dedicated to the contemporary woman.

We will pass over *L'Estampe moderne* (Figs. 38, 39). Its banal and monotonous appearance prevents its having any artistic character, putting it on the level of commercial chromolithography.

Such is the present balance sheet—we hope that intelligent publishers, and artists who love their art, will fatten the next inventory. At the present time, the ever active Vollard, besides two publications in black and white by Odilon Redon and Fantin-Latour, is preparing four series, each of twelve color prints, by Bonnard, Vuillard, Denis and Roussel.

Successes of Color. —Two different currents. —*Facsimile* and its causes. —Tendencies we approve. —The social role of prints, especially of original lithography. —Decoration and hygiene. —Conclusions.

The scattered elements that we have just brought together in this brief study contain certain essential points which it is important to bring out. We will thus better grasp the characteristics and the meaning of the color print movement. After having analyzed and explained them—if that is possible—in both their apparent and hidden causes, we will try to state conclusions valid for the future.

First, we must make the obvious comment that we have already indicated at the beginning of this work. In the middle of this general renewal of the print

which is still expanding[13], color lithography conquers a more and more important place every day. It spread like wildfire from one generation to another of painters. Don't we see it actively involving the young painters— Toulouse-Lautrec, Bonnard, Vuillard, Rivière, Lunois, etc.—at the same time that it interests the Puvis de Chavannes, the Rodins, the Guillaumins. Its diffusion has been as widespread as it has been rapid, and we must even admit that it goes as far as being an infatuation. On the other hand, can one say that originality has equaled quantity, that the use of the technique has always been intelligent and inventive? Even if the production has sometimes been really outstanding, it is necessary to be prudent and, in the interest of the movement which we are advocating, to moderate exaggerated or impetuous praise.

In our time, in lithography, as in all colored prints, there is a bifurcation of tendencies representing two opposing principles. The first—retrogressive in our opinion, let's say that right away—we will define in one word: the *Facsimile*. It is virtuosity, easy mastery, and a mania to imitate not nature, but an artistic creation which has already been achieved. It is the eternal resort of crafts people, which is useless and repugnant to true and original artists, who have something else better to express and do not wish to make a process render with a relative exactitude, and often with an added difficulty, that which actually belongs to someone else. A part of the color lithography movement tends to pursue as much as possible the appearance of paintings. We would like to indicate the various determining causes which lead publishers, artists and printers into this fundamental error.

Essentially, the dealer and the publisher, with rare exceptions, stay closely in touch with public taste, they study it and they flatter it. Unfortunately, at present a good part of the public thinks that in a reproduction they are being given something of almost as much value as the original, and that they are paying infinitely less for it. As for examining the relationship, and seeing if the reproduction does not appear inferior to the original, conceived with another purpose, and executed with different techniques, this public does not seem to care or to be educated enough to understand the difference. That is why there is this infatuation with *facsimiles* of pastels, watercolors and even oil paintings.

With a number of artists—setting aside those who submit for commercial reason to the demands of the crowd—and considering only the serious ones, here is what seems to happen. On the one hand, their customary activities have given them a vision that they are used to realizing with certain materials. They have been painters, they will always be painters, and it seems to them that the new technique that they have taken up has no other aim then to render more or less the vision and the values of their usual work. Moreover, they are often ignorant of the limits of the field they are entering as well as of the resources that it contains. Sometimes they have thrown themselves abruptly into it without having investigated it carefully, or having really been attracted to it. The craftsmanship quickly discourages them, or they let themselves get caught in the net of a printer experienced in the technique. Then laziness sets in: it is so easy to hand over a bit of a study of a figure or a landscape, or a sketchy canvas which the workman will reproduce, as exactly—though never precisely—as he can.

For there lies the real crux of the question. It is that printers lean toward *facsimile* for two natural and easily explained reasons. First, certain of them have done chromolithography for a long time. The original color print was born only yesterday. Now, a skill having been acquired, it affects the method of executing the work, as well as its appearance. The printer thereby possesses a superiority

over the artist, an undeniable material means of emphasizing his own impor-
tance. The more he complicates the printing procedure, the more he points up
the importance of his help. Thus he is happy to show off his great technical skill,
and he is still more impatient to use the tricks he has learned or discovered. He
takes advantage of them to impose his dogmatic knowledge acquired from simple
chromolithography, either by paralysing the artist with fear at the material
obstacles standing in the way of his inspiration—or, on the contrary, by dazzling
him with his completed feats. No matter what happens, the result is the same—
the artist hands over to the printer his work which is ill conceived from the
standpoint of this special genre, a work sometimes contrary to the nature of the
print which the printer adapts and interprets more or less faithfully.

The other principle appears to be completely opposite. It is the one chosen, for
logical reasons, by the really interesting and original artists. It consists of
conceiving the subject directly as a print, and as a color print. We hope that
people will understand that original color lithography, by the nature of its
techniques, possesses a range of possibilities which belong to it alone—both
resources and limits that are inherent to it. And so conceptually as well as
technically, the artist has to take into account the means at his disposition, to be
satisfied with them and to saturate himself in them. Let us outline if we can a
brief but general view of how we see this subject.

The color lithograph is a print, and so the general laws of the latter must be
applied to it. What are they? Logically and necessarily we find them in the essence
of the print itself: a simple piece of paper, on which by mechanical printing a
drawing is reproduced numerous times. The picture surface is neither as solid or
sturdy as that for oil painting, just as the process does not have the same deep
and bountiful richness. Neither does it have the texture or the brilliance of pastel,
the penetrating light of the watercolor. Nor can it claim to have the imperceptible
delicacies of an original drawing. It is a fact that mechanical printing, as perfect as
it may be, takes away the tiny refinements of the brush strokes or of the artist's
touch by which he transmits his sensation directly. It seems then that for these
reasons prints should avoid ambitious effects, and that a simplicity of means
demanding a less active part from the printer should work in its favor.

Moreover, we have to examine the special process of color lithography. It has
its own advantages and its own pitfalls. Color permits different approaches and
effects from simple black and white. However, successive printings do not mix
colors thoroughly, but rather superimpose them. It thus seems wise to avoid
excessive mixtures ending in the pretentious insipidities of chromolithographs. It
is to the advantage of the modern multi-color print to keep the color areas
separated, with a simplicity of tone, aiming more for the harmony of the whole
than for complicated shadings. If one can say that posters are prints in large
format, then original color lithography by its very origins remains still very close
to its big sister, the poster[14]. It has, however, a different goal and special points of
view: made to be held in the hand and looked at from close range, it naturally
involves a greater detail and a greater refinement. With these possibilities the
original print enjoys a harmonizing play of colors and of lines that might even be
described as decorative. The range of tones can be light, gay, very lively, but not,
however, the boisterous burst of color called for by the utilitarian goal of the
poster. We will be attracted to a varied play of color harmonies over which the
eye can travel easily. Lines that are too complicated, tangled composition, or
elusive delicacies of atmosphere do not seem to fall within its competence. It

would be vain, as we have said, for the original print to compete with the varied and flexible means which oil painting has to achieve perfect and delicate modeling, or with the sparkle of the pastel or the washes of the watercolor.

But, on the other hand, what holds a special charm is the way the mat impression inks the paper without seeming too heavy. We can really appreciate this when, like the Japanese, the artists delight our eyes with original tonal harmonies united with elegantly decorative lines. But it must be said that this simplicity of means requires true artists. Yet many different resources are available. For example, look at the way Lautrec uses a little of everything in his prints: flat tints, outlines, bright spots, spatter, fine strokes of the pen, etc. But however original the working, it always remains a true color print which we will define as follows: a piece of paper decorated with colors and lines which are part of it without hiding it or weighing it down. It is neither a *facsimile* of, nor a substitute for painting; it is another process, lacking certain elements, but with its own charm, of equal artistic value and the appreciable advantage of a printing with numerous copies.

Let us note in passing that among the modern color processes, lithography seems to have produced more varied results in the contemporary movement, and to have presented richer possibilities. Woodcuts and etchings have a rather similar appearance in some works; it seems sometimes that they can be used almost indifferently, without a marked character of their own, by using flat colors and outlines. Lithography, with less bite in the lines, is warmer, has more variety and depth, and lends itself perhaps better to nuances while remaining very much a print[15].

But here, just as in our earlier statements, we do not intend to set absolute limits. This is a broad overview, not an unchanging code designed to limit originality. Each artist, with his own feelings and his way of thinking, must choose and adapt a particular technique to his personality, just as he does with the particular effects which he wishes to produce. Furthermore, ingenuity, technical discoveries, all the advances, can and must continually modify the application of the processes.

But there is another question of a different order which we feel it is necessary to consider. What role can the color print, particularly the easier and more economical lithograph, aspire to play in our present social order with its new developments? We live in a time described as democratic. A very big word in which each person hears what he wants! If we look for equality at a common level, it is the very death of art, because while we can lower the highest, we will never raise the lowest to the highest level. It would be the triumph of mediocrity. But, there is another mode of democratization worthy of attracting reasonable and generous minds. It does not degrade the personality of the artist, thanks to means that science gives him, to be able to put for very modest prices true works of art within the reach of ever larger groups of people. That is, we think, all that can and should be done in our desire to further purify public taste. The continual improvement in the reproduction of museum masterpieces, which have now become accessible to all, is a beautiful and eternal means of instruction[16]—as long as we understand, however, that its essential teaching is to enlighten the mind and not to enslave it. Now it is not less true that we live in our own time, that we share its impulses, even its mistakes, if you will, and its preconceptions, but that is the very substance of our lives, not an artificial varnish made from the residue of dead civilizations. Antiquity lives in our modern times

only because of that part of humanity which is common to it and to us. And so it is that in comparison to the works of ancient art which, no matter what one says, require an introduction, the general public will find in the representation of its daily feelings a more direct nourishment, easier to digest, and which will lead it to the past.

Now it has happened that paintings, statues, and all works that have a value as unique objects by their rarity, have become costly collector's items, accessible only to a limited number. What remains? Prints and original prints. Their artistic value is indisputable. The number of prints that can be pulled, and the reasonableness of price, put them within reach of the general public. And it cannot be denied that besides the big collectors, who sometimes are lovers of art, but often are nothing more than wranglers over expensive objects, either because of vanity, or for hidden speculation, there exists here and now numerous representatives of the middle class who dedicate their leisure time, a portion of their intelligence and their money, to nosing about, to being interested in, and to buying. There is a potential enthusiasm, that could easily be triggered among ordinary people for this art, that is not yet perfect, but is already more refined. They are beginning to recognize the chromolithograph and to abhor it, preferring the original print. Now, while possession instructs, it also makes the interest more passionate and the search more active. Little by little, cultivated by efforts of artists, publishers, and magazines, and by the growing culture of a more educated public, this group will become numerous, with clearer ideas, asking only to see itself encouraged, enlightened, and helped.

But, it may be asked, why color prints rather than black and white? Can it be claimed that the former will kill the latter. Certainly not! And don't we see an old master, Fantin-Latour, a painter with such a gift for color, remaining obstinately faithful to the black and white print, in spite of all the enticements and direct entreaties. In our personal opinion, one black and white lithograph by Odilon Redon, just to take modern artists, achieves a summit of art. And if we look back to past masters, who can ever prevail over a Dürer or a Rembrandt? We will even say that there is in this kind of print where one can be a supreme colorist in the true sense of the word—just as in a pure drawing, a certain something which is more essential, more austere, which will always be a challenge for the strongest artists.

But there is a question of fact. From the standpoint of artistic diffusion, it is the general public, which turning to the print, finds in color a more accessible, more direct, and more engaging quality. We must understand that black and white involves an abstraction, relying only on certain qualities of the concrete. Thus the public's interest will contribute even more to the production of color prints, to which, culturally, artists have already been led by the various influences which we have indicated.

And even science itself, which in our day is concerned with improving public health, seems to encourage the print. After having opened up the wide boulevards and avenues, science wants light flooding into our homes, and it even advocates gaiety, that health of the soul, as a physical remedy. Now, isn't color the embodiment of light and gaiety? Furthermore, there is the everyday decoration of our interiors, which is pursued so rightly in its aim, but so erroneously and clumsily in its applications. Certainly, color lithography, without usurping anything from painting, holds its own in our decorative schemes, fitting in with simple furniture and natural woods from which gold leaf is excluded. One might

almost say of Chéret's posters (Fig. 49) and Rivière's prints (Fig. 61) that they are the frescos, if not of the poor man, at least of the crowd.

What will be the future of original lithography, tied moreover to the general movement of color prints? Materially, we can predict it will be productive. But what will be the artistic result? It may be assumed that the enthusiasm will increase and become a torrent. Abuses have already begun and will continue. What does that prove against the thing itself? Nothing, because abuses are everywhere in the human condition. But, on the other hand, the fine works already produced, the true artists involved, permit us to salute a distinguished flowering peculiar to our times, not to mention the future which they promise. May we have enlightened these artists concerning this subject, and warned them of some of the pitfalls. Only these true artists are and will remain interesting, their number is already large enough to have created a high point in the history of prints, and consequently, in Art.

A.M.

NOTES

Original Color Lithography

[1] We were especially concerned in 1897, in the magazine *l'Estampe et l'affiche,* with everything having to do with lithography and color printing.

[2] *La Lithographie,* by Henri Bouchot, librarian at the Cabinet des estampes at the Bibliothèque Nationale, Paris, Libraries-Imprimeries réunies.

This book, naturally brief, because it aims to be part of the Fine Arts Teaching Library, gives a clear view of the fluctuations of lithography from its birth to our day. In it one finds useful documentary information. As for the new movement, it is studied, if not with indulgent affect on, at least with a very keen curiosity.

[3] The debate is now taking place actively and passionately on all sides. Mr. Henri Lefort, president of the print and lithography section of the Society of French artists, presented to the Committee of 90, last January 24, a report stating the reason for the non-admissibility of color prints to the Salon. In it is stated that "by its essential principles, its origins and its traditions, the art of the print is, unquestionably, the art of *Black and White.* This is the traditional classification to which it is attributed."

Mr. Charles Maurin, painter-printmaker, counters by a virulent article in *Le Journal des artistes,* on March 20, 1898: "It is perhaps important to protest against Mr. Lefort's claims. In doing so, we are sure that we represent numerous printmakers, who for the last ten years have given a new scope to the original French print, which the new president classes under the disdainful and childish heading: 'colored pictures'."

Mr. Thiébault-Sisson seems to share Mr. Lefort's opinion: "The painter-lithographers in my humble opinion ... waste too much time searching for effects which are not in the domain of lithography; in particular, they are almost all struck by a manic desire to translate into color their elucubrations, and I find that mania deplorable ... it is impossible to make color lithography produce anything but very contrasting effects, which are marvelous in posters, but which bombard and irritate the eye in a carefully done print, made for a collector's portfolio or for an album" (*Le Temps,* November 5, 1897).

As a counter argument comes Mr. Roger Marx's article *"pour la gravure en coulers"* in the *Voltaire* of March 30, 1898: "the contemporary school contains too many eminent colorists to be fairly judged without them; furthermore this ostracism is in formal contradiction with the preferences so many times expressed by historians and collectors. . . .

The works of the masters teach that in the recent and in the distant past, wood, stone and metal have never refused to accept a multicolored inking; between the materials and the process no incompatibility exists."

[4] "La Rénovation de l'estampe" by André Mellerio. See copies of *L'Estampe et l'affiche* for March 15 and April 15 of 1897.

[5] On Toulouse-Lautrec, as on many of the artists who follow—Bonnard, Ibels, Vuillard, Denis, Roussel—more details can be found in a study we published previously: *Le Mouvement Idéaliste en peinture,* by André Mellerio, frontispiece by Odilon Redon, Paris, 1896, H. Floury, publisher—which is part of *La Petite Bibliothèque d'art moderne.*

[6] We made this remark in the past in an article in *La Revue artistique* (March 1896) dedicated to an important exhibition of the artist's lithographs, paintings and posters at Manzi's.

[7] *Le Voyage d'Urien,* by André Gide—Maurice Denis. Paris, Librarie de l'Art Indépendant, 1893. Three hundred numbered copies printed.

[8] Exhibition of decorative color prints by Henri Rivière (Imprimerie Eugène Verneau) at the Théâtre Antoine, January-February 1898.

[9] Especially in *Le Mouvement Idéaliste en peinture,* previously cited.

[10] Here we mean by printer what in the industry is designated by the more specialized technical term, essayeur. He is the expert to whom it falls to do the research and

experiments which lead to the printing, and when his work is finished, in the case of a large edition, the process is continued either by ordinary workers or by machine.

[11] *Traité de lithographie artistique,* by Mr. E. Duchatel, essayeur at the Lemercier Printing Company; Preface by Léonce Bénédite, Illustrations by Buhot, Bertrand, P. Dillon, Dulac, Fantin-Latour, Fauchon, Fuch, C. Lefèvre, Lunois, Maurou, Pirodon, Vogel. First edition of two hundred copies, for sale by the author, 8, rue Guy de la Brosse.

[12] *L'Estampe originale,* which has been out of print for a long time, is now at a premium. The complete collection which was 450 francs in the beginning, now easily costs 600 francs. There is even one copy which also contains proofs which reached the figure of 1,500 francs.

[13] This is what Louis Morin in his *Carnavals Parisiens* (Paris, Montgredien et Cie.) points out in a humorous fashion. ". . . In the past in the palaces of princes, the fresco unfurled, alone, along the walls. The age of the painting succeeded the age of the fresco; . . . the painting was made for apartments, apartments became too small for large scale decoration. . . . Today it is the age of the print and the small picture which is beginning."

We do not, however, share the following, perhaps rather paradoxical, opinion of the author: "And the painting will disappear, or at least will be no more than the original, the model for the victorious color engraving — the print." p. 178.

[14] It is to be noted, moreover, that many of the artists of whom we have spoken have attained success not just in color prints, but concurrently in posters. We should mention among others, Toulouse-Lautrec, with *Jeanne Avril, Le Divan Japonais,* his remarkable *Babylone d'Allemagne,* Bonnard: *France-Champagne* (Fig. 24), *La Revue blanche* (Fig. 43) *L'Estampe et l'affiche.* From Ibels, *Mévisto* (Fig. 25), *Irène Henry, Le Champ de foire,* etc. From Maurice Denis: *La Dépêche de Toulouse.*

[15] However, the objection can be raised, and we will raise it ourselves, praising the previously mentioned Japanese prints which are woodcuts. Furthermore, in our own time, Mary Cassatt has produced remarkable color etchings. Raffaelli is perhaps even more typical in that respect: his numerous plates for the same print are all cut by him and generally rest on the principle of different inks penetrating the incisions, which is the basis of all engraving, rather than using tints laid flat on copper.

Our colleague, Mr. George Lecomte, is now preparing a work on color printing: etching, dry point, etc., that will more completely elucidate these interesting points.

[16] Let us remember in reference to this the excellent article by Charles Saunier, *La Chalcographie du Louvre (L'Estampe et l'affiche,* November 15, 1897 issue). "Must one really be so rich to own works which do not clash with basic good taste, which divert the eyes and impose on the mind an idea of beauty. We are going to prove that it is not so. . . . People of taste and of modest means desiring to own beautiful things can have their attention called to a gallery of masterpieces of which it will be easy to take advantage.

Their purchase will sometimes cost less than a franc, more often from two to five francs, very rarely a little more. For a modest sum they will have extremely important works. . . ."

This treasure trove is in the Louvre's reproductive department.

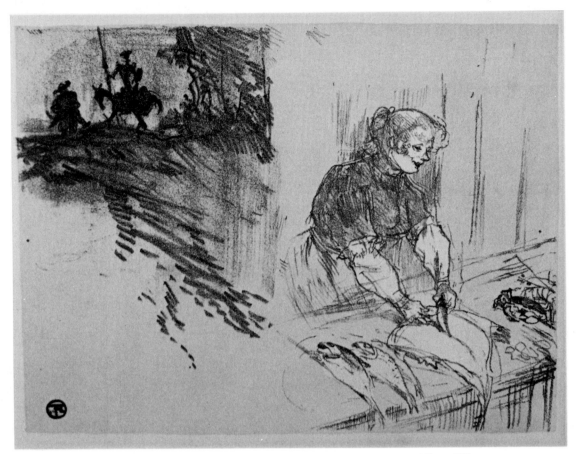

83. Henri de Toulouse-Lautrec, cover for *Les Courtes Joies,* 1897, two color lithograph, 7⁷/₁₆ x 9¾".
Boston Public Library.

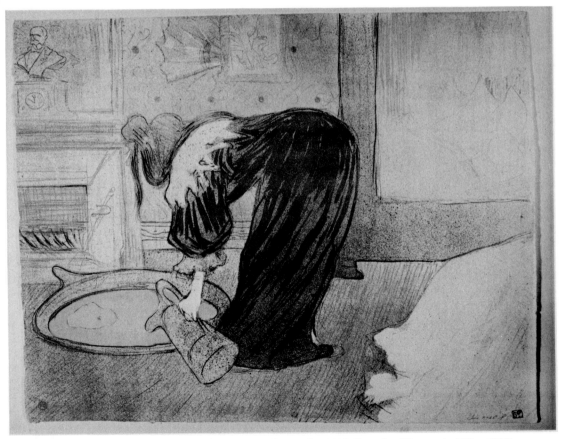

84. Henri de Toulouse-Lautrec, *Femme au tub* from the album *Elles,* 1896, five color lithograph, 15¾ x 20½".
Boston Public Library, Gift of Albert H. Wiggin.

SIMPLICITY OF MEANS

BY the time André Mellerio wrote his essay on original color lithography, arguments about style—so it seemed to him—meant little. The debate over pointillism, he notes, "has been exhausted many times elsewhere." Styles—many styles—were well established. They were facts, calling not for anguished denunciation or angry defense but for description, analysis and critical judgment.

Toulouse-Lautrec's book cover for Julien Sermet's Les Courtes Joies, *issued in paperback, is shown here before imprint of author, title and other information in red, and before folding; the fishseller is to adorn the front cover, the glimpse of Don Quixote and Sancho Panza the back cover, with the spine running down, between. Lautrec used a buff tint stone. On top of it are printed gray-black and white. With such sparing use of color, Lautrec makes his effect. In the print reproduced below,* Le Tub, Elles, *his colors are sometimes superimposed, sometimes alone, like the solid grey of water in the tub. With spatter textures and by showing one color through the open lines, masses or textures of another, as in the woman's dress, Lautrec achieves remarkable variety of color effect. He made the most of the fact that a color printed solid becomes a different color from the same ink printed in a textured or granular or spatter pattern.*

A new art form was emerging which welcomed different styles. Color lithography practiced by artists as a means of personal expression possessed its own characteristics and offered fresh opportunities. The intimacy and the direct personal quality of the drawing, the monumentality of the fresco or mural, the plastic quality and domestic scale of the oil placed brushstroke by brushstroke on the canvas, the sharp, scratched line of the engraving, the ease of drawing with the etching needle on the grounded plate and even smoother extension of the drawing process with greasy pencil or crayon on the surface of the lithographic stone, the strong black and white of woodcut and wood engraving—all of these were different worlds for the artist, and many an artist has welcomed changes of scale and of working tools. "Rembrandt expressed many of his finest artistic concepts in prints much as Beethoven expressed some of his profoundest ideas in string quartets," wrote Arthur Vershbow in his essay of 1969 on print collecting. So it was with Goya in varying modes of expression which included the aquatints of the *Caprichos;* so it was for Lautrec and Bonnard in ways of picture-making which included, to their pleasure and ours, color lithography. More than

(continued on Page 106)

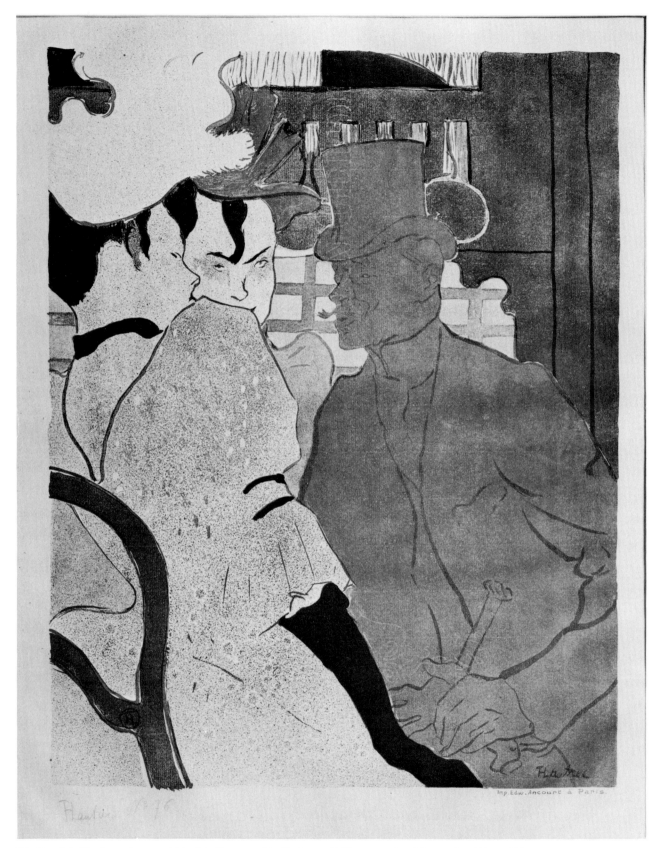

85. Henri de Toulouse-Lautrec, *L'Anglais Warner au Moulin Rouge,* 1892, seven color lithograph, 18⅝ x 14¾".
Boston Public Library, Gift of Albert H. Wiggin.

86. Henri de Toulouse-Lautrec, *9, Place Pigalle, P. Sescau,* 1894, five color lithograph, 23⅝ x 31½".
Boston Public Library.

87. Henri de Toulouse-Lautrec, cover for *Les Vieilles Histoires,* 1893, six color lithograph, 13⅜ x 20½".
Boston Public Library.

88. Henri de Toulouse-Lautrec, *Marcelle Lender, en buste* from *Pan,* I, 1895, eight color lithograph, 12¹³/₁₆ x 9¼″. Boston Public Library.

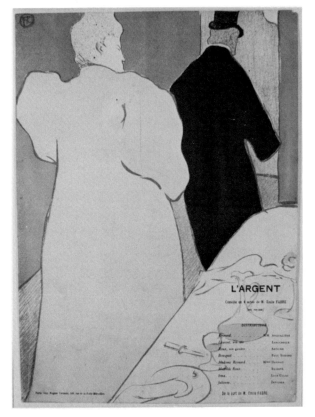

89. Henri de Toulouse-Lautrec, *Un Monsieur et une dame,* program for the Théâtre Libre, 1893, six color lithograph, 12½ x 9¼". Boston Public Library.

90. Henri de Toulouse-Lautrec, *Le Coiffeur,* program for the Théâtre Libre, 1893, three color lithograph, 12½ x 9¼". Boston Public Library.

Previous pages: L'Anglais au Moulin Rouge *makes its effect from bold outlines and luminous transparent colors contrasted with solid blacks in glove, hair, and smaller accents. On the page that follows,* P. Sescau, photographe *uses a ground of flat, vivid green, with bold silhouettes superimposed upon it and strong imprints of red, blue and yellow; below it, the soft clear areas of color of* Les Vielles Histoires, *apart from the black lettering and design (including the hat) are mauve (background city silhouette), green (the river), grey (Desiré Dihau's jacket and trousers) and tan (the bear). The full-page reproduction of* Mme. Marcel Lender en buste, *on the page opposite this note, may suggest even in black and white how subtle Lautrec's coloring can be. He creates the effect of glaring artificial stage light, then conveys even the nuances of Lender's eye make-up. Just above this note,* Un Monsieur et une dame *uses the flat patterns of Japanese prints with total success;* Le Coiffeur *(upper right) is effective with sparing but decisive colors (olive green for the figures and background, yellow for the hair, salmon for the lips of the woman in foreground and in accents by her ear and on the backdrop to the right of the hairdresser's head).* Jane Avril, *at right, fills the eye with a rainbow-effect achieved only with yellow shading into aquamarine, an effect made possible by strong masses of framing black and red.*

91. Henri de Toulouse-Lautrec, *Jane Avril,* 1899, four color lithograph, 22¹/₁₆ x 14³/₁₆". Boston Public Library.

At right: Bonnard used the paper masterfully in his four part screen (the upper section, third panel, is shown here, with cabs and a dog) (1899). By comparison, his much later Place Clichy (1923) shows faces gleaming out of a dense background of horizontal line-work in black, brown and blue.

any other artists, these two men established the medium as an art form, and so it has remained. Not a decade has passed since the nineties without new work of great visual interest and originality.

For artists, as Mellerio recognized, the challenge of the color lithograph was one of simplification. "I have learned a great deal about painting from doing colored lithographs," Bonnard declared. "You can discover a great many things by having to study tonal relationships when there are only four or five colors to play with, superimpose, or juxtapose." Toulouse-Lautrec, said Mellerio, had a special gift for printmaking: "We even prefer his prints to his painting, in which he doesn't seem as much at ease, in a medium which is more elaborate, less direct."

The new form came in a field which had engaged the keen interest of artists throughout the nineteenth century. While Gericault, Delacroix, and many others drew on the lithographic stone and treated black and white lithographs as a new art form, on a level with the drawing, watercolor, or etching, there had been a parallel exploration of color largely by printers for commercial purposes. For Mellerio, the term *chromo* signified the commercial, the cheap and the garish, just as it does today, when it is almost impossible to give the word a new definition in terms of the extraordinary craftsmanship we find as we look at the finest achievements of the chromolithographers.

To define original color lithography, Mellerio had to contrast it with the technical skills of chromolithography. Speaking of Lautrec's poster showing a dance at the Moulin Rouge, he says, "Compare such a print to a chromolithograph; not only is there the evidence of artistic inspiration, but even the craftsmanship is a renovation—let's use the word—a creation. The general appearance, like the skillfulness of the detail, is not due only to a learned technique carefully executed. These are artist's efforts and discoveries, an artist seeking to express himself directly and as completely as possible in a mode which is satisfying to him."

To Mellerio, the word *chromolithograph* was anathema; its skills had become so complicated that it was intimidating to anyone other than a professional lithographer. It was necessary for artists to re-invent color lithography in simpler terms and in situations in which the lithographic craftsmen were their servants, not their managers.

Artists had been intimately associated with chromolithography from its beginnings. Thomas Shotter Boys took pains to point out, in the preface to *Picturesque Architecture,* his pioneering series of color lithographs of 1839, that these were his own original works, from his hand and under his control and approval. Unfortunately, as a publishing venture, the project lost money, and when Boys undertook a second series, *Original Views of London As It Is* (1842), he made black and white lithographs which were hand-colored, a skill long available in the London print industry. Lithographic printers did not abandon printed color, but their efforts in chromolithography imply their feeling that direct intervention of the artist made an already complicated process altogether too time-consuming and expensive.

Of course, few artists who practiced original color lithography have carried out every step of the craftsmanship connected with it. Few have smoothed the surface of the stones; few have poured onto the stones the weak etching solution which helps to fix their greasy drawings; few have been their own printers. But they have made their own drawings on the stone or zinc or other lithographic surface, and on separate stones they have prepared their own color separations. This presence of the artist is very different from the situation of the painter who loaned an oil or watercolor to a chromolithographer and later was shown proofs of the chromo with all stones printed. The distinction extends to the present day, when the word "print," with its implications of originality, is often used in advertising photomechanical reproductions, using half-tone and four-color process printing. The starting point for these present day descendants of the chromo is a large photographic color negative of the original print, drawing, watercolor or oil being reproduced.

106

92. Pierre Bonnard, upper third panel of *Paravent à quatre feuilles,* 1897, five color lithograph, 10½ x 18½".
Boston Public Library.

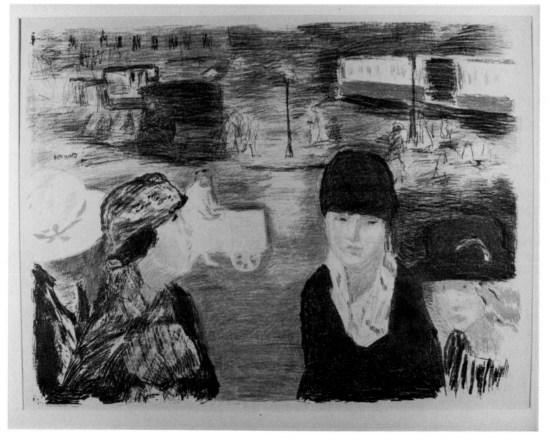

93. Pierre Bonnard, *Place Clichy,* 1923, five color lithograph, 18½ x 25". Boston Public Library.

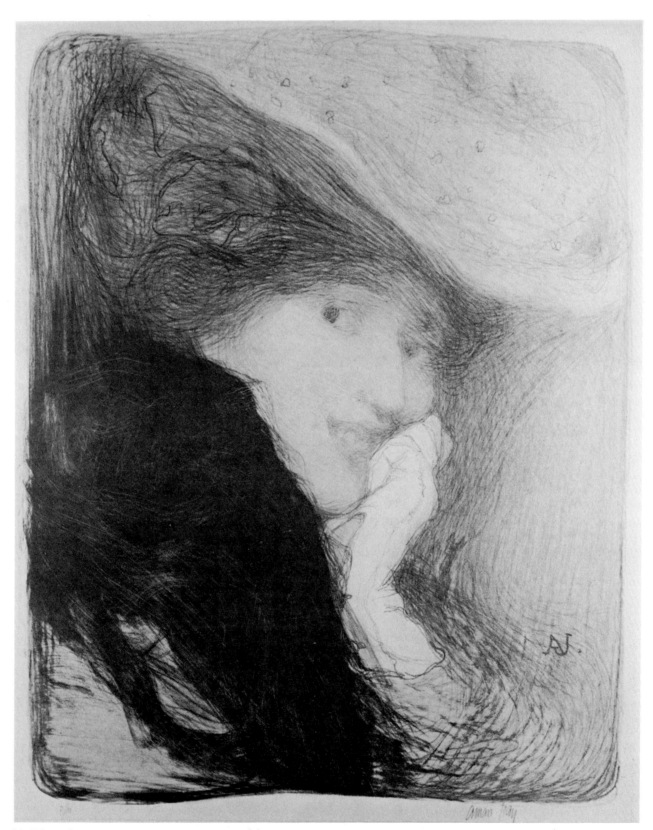

94. Edmund Francois Aman-Jean, *La Rieuse,* 1900, two color lithograph, 16⅞ x 13⅜″. Boston Public Library.

Aman-Jean's individual style uses vibrations of lines and gentle color to portray a face. At right, two of de Feure's prints from the series Bruges mystique et sensuelle *achieve their effect sometimes with black and only one other color.* Le Paysage nocturne, Bruges *employs black and a vivid tan.*

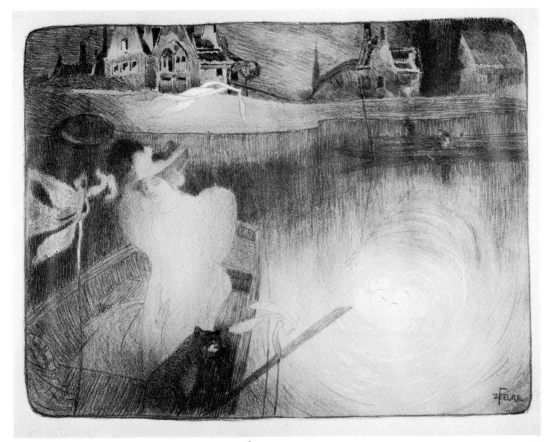

95. Georges de Feure, *Woman in a Boat* from the series *Bruges mystique et sensuelle,* n.d., two color lithograph, 10¾ x 14⅜". Boston Public Library.

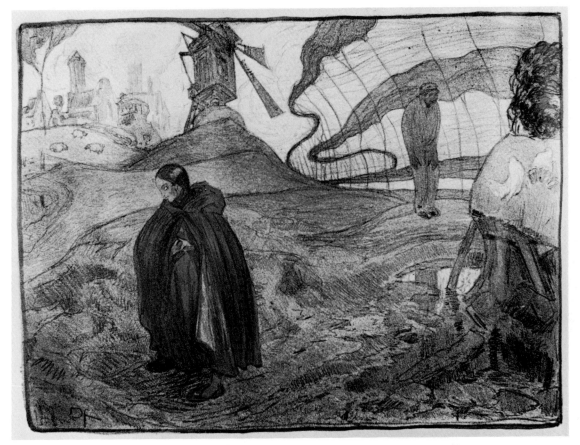

96. Georges de Feure, *Woman and Man Near Windmill,* n.d., three color lithograph, 10⁹/₁₆ x 14⅜". Boston Public Library.

Chromolithography was used to superb effect in books and portfolios of travels in search of the picturesque; in illustrations of costumes; in works on architecture, including interior furnishing; and in medical, botanical, archeological and ethnological treatises. The word itself was in use by 1838, and the process of building up effects in color by printing from stone after stone in (Mellerio's scornful words) "all the colors of the rainbow" was in full flower in the 1860s.

Mellerio believed the interest of prints lay in the artist's ability to impose his conception on the means of expression. If his conception was weak, then an established way of expression would fill the vacuum — the formulas of the chromolithographer, the interpretations of a craftsman putting someone else's design on stone. Of Marcel Lenoir's triumphs of "chromolithography with fifteen or eighteen trips through the press," he commented in an epigram wonderfully French in tone, "It is an effort rather than an achievement."

Mucha, in Mellerio's view in 1898 (still early in Mucha's activity as a poster designer) was weak, affected, and easy prey for the chromolithographer. Today, we do not think of Mucha's posters as chromolithographs but rather as masterpieces of Art Nouveau style in line and color. The greater masters—Lautrec, Bonnard, Vuillard, Denis—stand forth in their personalities in art, and style occupies us less in thinking about them than their own individuality. Mucha achieved a recognizably individual expression, too, but with him the style comes down to us as more important than his artistic personality. If ever an artist can be said to gild the lily, it is Mucha in his ornately framed posters of blond goddesses whose ecstasy sometimes is offered to us as nothing more than an advertisement for a cigarette. Lautrec's posters, by contrast, have a cutting edge of wit, character and memorable human observation. The people seen are diverse. Each design is a new undertaking requiring a fresh approach from one vivid mind. The Mucha posters sometimes achieve superb decoration, and they tell us that their maker labored over many small details and effects. His small poster for the twentieth Salon des cent, a masterpiece of design, is for him exceptional in using few colors and broader areas of color. Others quickly suggest the chromolithographers' bag of tricks. Mucha planned his posters with these tricks in mind, and only occasionally, as in the Salon des cent poster (which employs, incidentally, the chromo craftsmen's skill in printing gold) does he make a single, united, unforgettable image. Mellerio does not mention it, though it had appeared in 1896, nor does he concede a mention of the majestic *La Dame aux camelias: Sarah Bernhardt: Theatre de la Renaissance,* issued in the same year.

At intervals in his essay, Mellerio returned to the relationship of poster and print. It was as important to his theme as the relation between chromolithography and original color lithography, and it contained shadings of meaning that he as editor of the magazine *The Print and the Poster* (L'Estampe et l'affiche) could appreciate.

Chéret, he said, "never, correctly speaking, made prints." Of Lautrec's poster showing a dance at the Moulin Rouge, he said, however, "This is no longer just a poster, and it is not yet quite a print; a work of hybrid pungency deriving from the two, or rather, it is the modern color print." If there are minor inconsistencies in Mellerio's attempts to define, they nevertheless give us greater understanding: the print is intimate, "made to be held in the hand and looked at from close range," posters "are prints in large format" but requiring simpler, broader design and a "boisterous burst of color." Posters have a "utilitarian goal," an advertising mission to perform; prints can be subtler, more detailed, more refined.

Mellerio took note of Manet's one venture in color lithography, the *Polichinelle* of 1874, and of

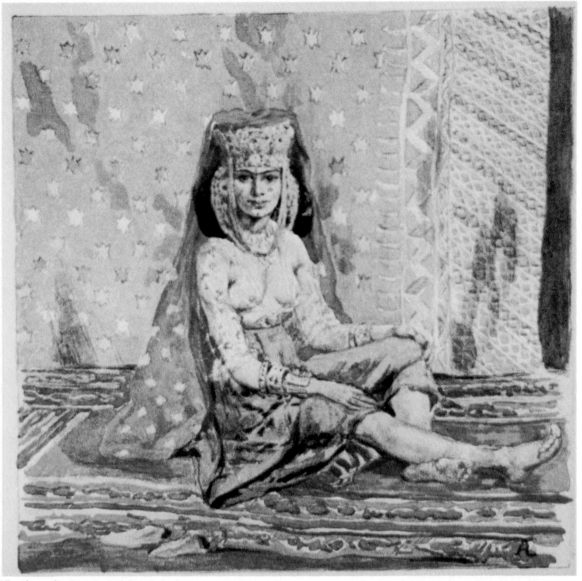

97. Alexandre Lunois, *Ouled Nail, Arab Woman,* 1900, six color lithograph, 7¹³/₁₆ x 8¹/₁₆″. Boston Public Library, Gift of Mr. and Mrs. John Holt.

Above: liquid tusche applied with a brush to the lithographic stone can establish a design which produces watercolor effects in the printed image. Lunois with his great technical knowledge used these effects to advantage in the stones for An Arab Woman *(above) and some of his other color lithographs. His appreciation of the clear, transparent brightness of watercolor washes interpreted in this way is one of his distinctive strengths in original color lithography.*

the early lithographs in color by John Lewis Brown; yet, as he pointed out, it was the poster which had opened the field of original color lithography, and Chéret who had shown the life, vivacity and variety of technique which could be brought to the creation of posters printed in colors from lithographic stones.

A key to Chéret's accomplishment was his desire to be close to the printing press. Clearly, he loved the process of drawing on the big stones from which his posters were printed, and his nearness to the printing process is symbolized by his ability, during many years of his career, to place the imprint of his own shop on his posters ("Imp. J. Chéret" from 1866; after 1881, "Imp. CHAIX (Succursale Chéret)" and "Imp. CHAIX (Ateliers Chéret)." He was both a lithographer and an artist. His career led him along the thin line between commercial art, in which the employer's desires may overrule those of the artist, and personal art expression, in which the artist insists on the power to approve or reject the final result. Chéret seems to have gone as far as his talents would take him, and with great success. He

offered images of gaiety, eye-catching advertising symbols; his customers were numerous, and his fellow artists looked with interest at his use of both solid and transparent color, his achievement of textures through spatter and parallel linework, and his bold, twisting silhouettes.

Mellerio repeatedly emphasized Chéret's role as "The renovator of the poster, or rather its true creator from the modern point of view," for this positive note represented most of the praise he could give an artist whose creations possessed comparatively little content. He avoided comment on the uneven quality of Chéret's designs, complimented him on establishing a personal style and exerting much influence, and let slip only one negative remark. Of Chéret, Steinlen and Grasset, he said: "These three artists are known for their posters, Steinlen also for his drawings, and Grasset for his decorative art. From the special point of view of color lithography which concerns us now, we have little to glean from among their works."

In defining original color lithography, Mellerio conveyed a remarkably clear sense of what gave this new species of print its character. He did not stop there, for his discussion of essentials constituted one of the most lucid realizations of what a print is.

Line as well as color was important in the unfolding of color lithography in its first decade. Mellerio noted Lautrec's effective use of silhouettes and his "expressive line"; later, in discussing the work of Lunois, he asserted the need for a unity of line and color: "We have to say that the craftsmanship that serves him impedes him at the same time. His professionalism hampers him in that he does not know when to relax his method. The drawing in black shows entirely too much beneath the color. Now it seems to us that one should not notice or even suspect that there has been a time when the conception of the black and white print might have been complete in the mind of the artist, later to be dressed up in a new and different effort with an addition of color. If this is the case, we feel a disquieting element which is not part and parcel of the original inspiration—a lack of unity in the work." Lunois' work drew from him a further definition of what an original color lithograph should be: the artist must have a sense of the relation of areas of color, and should be able to simplify "the work in black" including, presumably, the linear elements of the design.

The artist's starting point, before line and color take shape, is paper. Mellerio had an intense awareness of the thinness of the paper and the flatness of the colors printed on it from lithographic stones. Unquestionably these were limitations. The painter's canvas, in contrast, could carry a rich weight of color. As in other graphic processes, however, like the etching or black and white lithograph, this seemingly flimsy or ephemeral piece of paper possesses its own physical integrity and capacity for long life, and it gives the artist, as a starting point, a ground of white or cream that becomes light, gleaming through line and pattern, if the artist allows it to. Colors and lines should become part of the paper "without hiding it or weighing it down." With this in mind, Mellerio in his sections on Lautrec and Bonnard praised each of them for the use they made of the white of the paper. Of Ker Xavier Roussel's first color lithograph, *Paysage*, he says: "In spite of the few hesitations, there is a real comprehension of prints—we see a delicate understanding of tones, a clear and very personal way of using a fresh range of colors applied in small strokes which mix with the white of the paper, to give a

98. Alexandre Lunois, *Peintres orientalistes, diner du 17 Mars 1898,* 1898, seven color lithograph, 8⅞ x 7⅛".
Boston Public Library, Gift of Mr. and Mrs. John Holt.

great luminosity." The Pointillist style, especially as used by Signac, adapts well to color lithography: "in a print the white of the paper shows through the spots of color, and seems to circulate the air, giving lightness." His appreciation of what flat line, color and pattern can become on the surface of the paper is many times evident. He spoke of "matt effects" in Bonnard and "a bit of that Japanese love of checkered or floral designs." In Vuillard's prints "crossing or parallel lines, finely drawn silhouettes, splashes of contrasted colors beautifully balanced" give character; Lautrec "uses a little of everything in his prints: flat tints, outlines, bright spots, spatter, fine strokes of the pen, etc." The term "matt" appears several times in his essay, suggesting the appearance of a heavy, textured paper, with a grid of laid lines revealed on its surface, or even the interweavings at right angles of a rush or cord matt, or the texture of a painter's canvas, a pattern which is similar to crosshatching with pen or pencil, which can be exploited in painting and which can emerge in the color lithograph: "what holds a special charm is the way the rather matt impression joins the paper without seeming too heavy."

In the arts of the book, there is a saying that the printer has the last word. Even if he does all that is asked of him, the final step in the making of a color lithograph is a mechanical process, the passage of the inked stone, with the paper on top of it, through the press, a process repeated for the printing of each color. Mellerio knew this and accepted it—a limitation, to be sure, but further evidence that "simplicity of means" was best. "It is to the advantage of the modern multi-color print to keep the color areas separated, with a simplicity of tone, aiming more for the harmony of the whole than for complicated shadings." For those with the gift of "conceiving the subject directly as a print, and as a color print" the results would be of enduring originality and interest. Sound advice from a man who knew what he was talking about. Among his heroes were Toulouse-Lautrec, Bonnard, Vuillard, Denis, and Redon; like Mellerio, we prize their work for itself and as part of the outpouring of creative effort which established the artistic medium of original color lithography.

S.H.H.

114

EIGHTY YEARS OF AN ARTIST'S MEDIUM

NDRÉ MELLERIO's assertion of 1898 that color lithography was a new and lasting medium of artistic expression has been verified by new practitioners, new styles and new approaches. True, there has never been a chapter of color lithography to equal the blaze of creativity experienced in the nineties, but there have never ceased to be important contributions.

Mellerio wrote only of the French achievement in color lithography, an achievement which reached its peak in 1899, the year after his monograph was published. The great albums published by Vollard in 1899, Vuillard's *Paysages et Interieurs* and Denis' *Amour,* following so much else of importance — most notably, the two other preeminent series, Bonnard's *Quelque Aspects de la vie de Paris* (completed in 1895, published in 1899) and Toulouse-Lautrec's *Elles* (1896)—at first make twentieth century color lithography seem only an epilogue. From almost its beginning, however, the movement had been international, and so it has remained, leaving behind it, even in the nineties, a story a little larger than the one Mellerio put on paper, and in the decades since, a varied, innovative addition to our legacy of art, marked by personalities as strong as those of the founders.

Whistler made his first color lithograph in England in 1890, and produced six more in Paris in 1893 and 1894; he had a vivid understanding of what was possible, and his use of delicate tints was peculiarly his own. Edvard Munch's *Madonna* was printed in Paris by Clot in 1895; in 1901 he drew on stone his image of a nude woman with red hair. These, and his *The Sick Child* of 1896, are among the best-known of all color lithographs today. Like Whistler, he had seen the possibilities of the new medium in highly personal terms and found it readily available to him. He produced only about a dozen lithographs in color, but all are of great interest, and among them are some of the finest works made by this means. *Picking Apples,* 1916, is not as well known as those just mentioned, but in concept and expression it ranks as high.

Munch may be compared to Redon as one who produced a major body of black and white lithographs and made a few (but important) experimental lithographs in color. Of Kathe Kollwitz this also is true. She produced only two lithographs in color, yet her *Working Woman in a Blue Shawl* of 1903 is a masterpiece, achieving unforgettable intensity in its union of line and color and its extreme economy of means. Kollwitz employed only three stones, black, blue and buff.

A major work in the medium, too, is Franz Marc's *Horses in the Woods* of 1908. Writing of Alexandre Lunois' role in the emergence of original color lithography, Gustave Von Groschwitz noted his important contribution but said that "he did not understand fully that the unique quality in color lithography is derived from the varying textures of the stone"; Marc's print of 1908 shows that understanding, reflected in the artist's scraping across the surface of his design on the stone to lighten and

99. Käthe Kollwitz, *Working Woman in a Blue Wrap,* 1903, three color lithograph, $13^{11}/_{16}$ x $13^{5}/_{8}''$.
Boston Public Library.

vary the effects. The same sense of color lithography as a unique medium of expression can be found in Gustav Kampmann's *Herbstabend (Evening in the Fall)* of 1900, where masses of flat color are used in an eloquent and effective way in a style quite different from that of Kollwitz or Marc a few years later. Kampmann's handling of flat color goes beyond the obvious affinities to Japanese prints evident in the styles of many Paris artists of the nineties.

Mellerio, in his essay of 1898, had carefully defined the characteristics of the poster and the smaller, more intimate color lithograph, a relationship at first very close. The poster movement by 1895 was international; it possessed an irresistible attraction for artists, and between 1890 and 1910 France, England, Belgium, the United States, Holland, Germany, Scotland, Austria, Italy and Spain made contributions possessing distinctive national characteristics and an international stimulus, for action or reaction, in Art Nouveau style. A large amount of outstanding work was the result. The achievement in original color lithography in the same period was much more limited. Only Paris had a Vollard to commission original color lithographs in surprising quantity. Many poster designers elsewhere, including Heine in Berlin, Privat Livemont, Crespin and Combaz in Brussels, Beardsley in London, Penfield in New York, and Dudovich in Bologna, never made limited-edition *lithographies originales en couleurs*. A distinction increasingly appeared between the decorator-designer and the painter-printmaker. Ludwig Hohlwein was designing posters of surpassing merit as early as 1906, E. McKnight Kauffer by 1920, A. Mouron Cassandre by 1923; all had long careers and became famous as masters of poster art, but they did not venture into original color lithography. In Paris in the nineties they would have been sorely tempted.

The Expressionists left a notable achievement in color lithography. Their prints in this medium are not numerous, but to them they brought an intense spirit and artistic virtuosity. Munch and Kollwitz have been mentioned; Nolde, Kirchner and Beckmann also made color lithographs, and among the Austrians, Klimt and Kokoschka.

In England, few artists tried the medium, and their work contributed little to it. Johnson, Clausen, Dulac, Greiffenhagen, Nicholson, Ricketts, Shannon and Sullivan each made a color lithograph for the portfolio, *The Great War: Britain's Ideals and Efforts*, published in 1917; one or two added colors seem secondary to the designs in black, almost afterthoughts, and the impact of the color is in the realm of discreet decoration. Shannon was a master of lithography, however, and truly, in the Paris term of the nineties, a *peintre-lithographe;* Von Groschwitz notes that he "made only a few chiaroscuro lithographs, but they are among the better color lithographs of the period," and he goes on to say "Idyl (1905) is typical—blue (or green) and brown are printed on a grey paper which is used for highlights. The two colors are well integrated and drawn with the brush, so that they give movement to the composition." Shannon ranks with Denis and Toulouse-Lautrec, too, in his genius for the use of a single color—blue, green, brown, russet and pink being used by him at various times with great success. He had rare sensitivity to the texture of the stone, to the patterns and densities he created on its surface, and to the ways he could let the paper speak through the crossing lines of his brush or pencil.

John Copley, another English master of lithography, experimented briefly with color. His prints in the medium are little known. *A Lavatory*, 1909, using seven stones, produces an interesting effect, but the complicated effort of registering the colors

100. John Copley, *The Weisshorn,* 1911, three color lithograph, 15¾ x 21½". Boston Public Library, Gift of Albert H. Wiggin.

can be felt; the picture is labored and the colors call attention to themselves. *The Weisshorn,* 1911, shows a far greater understanding of how to use the medium not merely to make a picture, but to create a work of art. There are only three colors, blue, green, and black. Design is very strong and use of color is subtle and poetic in feeling. Also notable is *The Surgeon,* 1911. No black is used; pale green is the prevailing color, and there are sparing touches of red, orange and lavender. The antiseptic feeling of the operating room is conveyed with great success. So effectively is the white of the paper put to work that it becomes, appropriately, the dominant color in the recollection of a viewer. Copley turned away from color in the second and final state of the lithograph, which is in black with very slight color tone.

T. R. Way, the accomplished English lithographic printer, left us a description which makes even clearer the need, emphasized by Mellerio, for effects achieved by comparatively simple means.

Recalling his work for Whistler, he wrote in 1905 of the problems of precise positioning of each successive color printed from its own stone: "In such subjects as *The Red House, Paimpol,* where only three printings are used, the matter is not very difficult, but when such a subject as the *Draped Figure Reclining* is in hand, with six printings, the problem is extremely complicated. In printing, each color takes a considerable time to dry, and so, under the most favorable conditions, such a print will take some days before a complete proof can be seen; but each color, when added, modifies the effect of the whole, and may render some alteration of a previously printed color desirable." These are the words of a man who had suffered much on behalf of the art of Whistler.

In the United States, Joseph Pennell momentarily and skillfully tried his hand at color lithography in the manner of Whistler. With this minor exception, the American revival of lithography by Pennell, Hassam, Davies, George Bellows and others

118

was an achievement in black and white. Not until the 1950s were color lithographs made in the United States which might have met Mellerio's exacting definition. This more recent era will be discussed a little further on; first it is necessary to look at an art form which has proved hospitable to the color lithograph and which assumed its modern character in the same decade of the nineties, the *livre de peintre*. The "painter's book," like the poster and the original color lithograph, was a characteristic expression of Paris in the nineties; Denis, Toulouse-Lautrec and Bonnard were among its masters. Mellerios' essay on original color lithography was adorned, on the cover and as a frontispiece, with color lithographs by Bonnard, and represents one of the first *livres de peintres* to use this pictorial technique. The typography of the book is careful, readable, neat, but undistinguished; perhaps with this in mind, Bonnard contributed splashes of color. The frontispiece enlivens but is a bit out of place. A far more advanced piece of bookmaking is *Le Voyage d'Urien,* 1893, probably the first of the "painter's books" with color lithographs. Maurice Denis' lithographs (there are thirty, in black and yellow and in black and green) are triumphs of subtlety and restraint and are completely integrated into the design of the book. From this time until the present, some of the artist's books published in Europe and the United States have contained original lithographs in color. They can be said to be a continuous thread in the history of color lithography as an artist's medium. Another element, originally of prime importance, the relationship between poster and print, ceased to be important by the time of World War I. A third factor is the availability to painters of lithographic equipment and skills. Toulouse-Lautrec's willingness to be frequently with his printers and intimately connected with the technical processes of lithography helped him to make his lithographs works of art of fundamental importance, ranking in the art of the nineteenth century with paintings, sculpture and other art forms. He drew on the stone, sometimes inked the stone himself, and often was present during printing. Nevertheless, he did not wish to involve himself in the ownership of stones and presses or to encumber his career by trying to carry out, by himself, the preparation and printing of stones. Only in Paris have graphic arts workshops continuously enabled artists, since the nineties, to enlist the aid of highly skilled craftsmen in the special field of color lithography. This continuity of tradition, and the continuing interest of Ambroise Vollard in the *livre de peintre,* made Paris still the center for color lithography in the years from 1920 to 1940. Joan Miró makes his appearance in the realm of color lithography in Paris as early as 1928 in the pages of *Il etait une petite pie* by Lise Hirtz. Like color aquatint, color lithography was well suited to the style of Rouault, and his *Clowns* of 1925 might find a place in any showing of the work of painter-lithographers. Dufy's light touch and gift for watercolor could also find the medium sympathetic, and he ventured into it about 1930. Le Corbusier's lithographs of 1936, too, reflect the longstanding attraction of the medium for artists, an attraction which Mellerio describes.

Mellerio had also commented on the flexibility of the medium — more adaptable to different styles and to the participation of the artist than, for instance, color wood engraving. As the founders of original color lithography devoted their energies more exclusively to painting, others with different artistic visions came to the medium to make prints in color. Pierre Bonnard's last single-sheet color lithograph was the *Place Clichy* of 1923. Lautrec had died in 1901, and for the other great Parisian practitioners of the new form—Denis, Vuillard, and Signac — making color lithographs was a part of their past. (An exception is Denis' *Chariot* of 1939, a sincere effort but very much a distant afterthought to the experience of the nineties which stimulated his best work.) If *Place Clichy* represented the last major work in color lithography by its founders, it

had interesting company in works by others which opened new directions in the medium. The fourth Bauhaus portfolio of 1921 contained color lithographs by Nathalie Gontcharova and Michel Larionow; Kandinsky's portfolio *Kleine Welten (Small Worlds)* published in Berlin in 1922 included several now-famous lithographs in color; and in 1923 in Hanover, Germany, Lissitsky published his portfolio of eleven color lithographs, *The Plastic Realization of the Electro-Mechanical Spectacle, Victory Over the Sun,* begun in 1919. Of great importance were Klee's color lithographs *Rope Dancer, Hoffmanesque Scene,* and *Saintly Woman,* made in 1921-1923.

Kandinsky's view of color lithography ends on a note which Mellerio had also struck, but its tone is strikingly different: "Lithography offers the chance of throwing off an unlimited number of prints in quick succession by a purely mechanical method, and emulates paintings by the increasing use of colour, so creating a certain substitute for the painted picture. Through this, the democratic nature of lithography is clearly established."

In a sense, this has always been true, provided large editions were desired and the print was simple enough in the demands it made on the printer. It has also been true that the more the artist imparted subtle personal values to prints, the more necessary would be painstaking hand printing, and the more likely would be a limited edition. An example is Nolde's *Autumn Landscape (Inundation)* of 1926, a color lithograph of great subtlety printed in black and two shades of reddish-brown. Control of color and surface values in such a print cannot be maintained on a mechanical press during a run of thousands.

In Paris, *ateliers* specializing in lithography provided a link to the nineties; the link is unbroken today. Auguste Clot in 1888 had left the firm of Lemercier to set up his own shop, and in the next dozen years he became the best-known of the printers who served artists making black and white or color lithographs. His work continued through the First World War and the twenties and thirties. He died in 1962, and his work was carried on first by his son, André Clot, and from 1965 by Madame André Clot, by Dr. Guy Georges, a grandson of the founder, and by the Danish lithographer, Peter Bramsen. The name of the shop today is Imprimerie Clot, Bramsen et Georges.

With the thirties began the fame, in our own times, of the Atelier Mourlot. Jules Mourlot's atelier, which he had directed from 1880, began its modern life in 1914 when Mourlot purchased the atelier begun in 1852 by Honoré Bataille. His son Fernand carried on the business, and a third generation shares in it. While Mourlot offered artists the opportunity to draw on stone, the atelier also carried machine printing to a very high level in the production of artist's designs, perhaps most notably for the periodicals *Verve* and *Derrière Le Miroir.* The shop encouraged artists, to design posters, and the poster format again welcomed the work of many painters, combining picture and lettering to announce gallery exhibitions of their work. After World War II, Atelier Mourlot attracted Picasso, Braque, Chagall and other luminaries of the modern School of Paris. Their single-sheet color lithographs and color lithographs in *livres de peintres* had international impact, stirring a revival of color lithography and stimulating interest in the establishment of lithographic workshops abroad.

The technical skills available to these painters were remarkable. Their lithographs were made with the help of a variety of techniques. The authors of *The Artist and the Book* (1961) write of the association of the painter André Masson and the master printer Léo Marchutz during production of Masson's book, *Voyage à Venise* (Paris, Editions de la Galerie Louise Leiris, 1951-1952): "For these luminous lithographs Masson made color notes and sketches on the spot with a greasy crayon on paper,

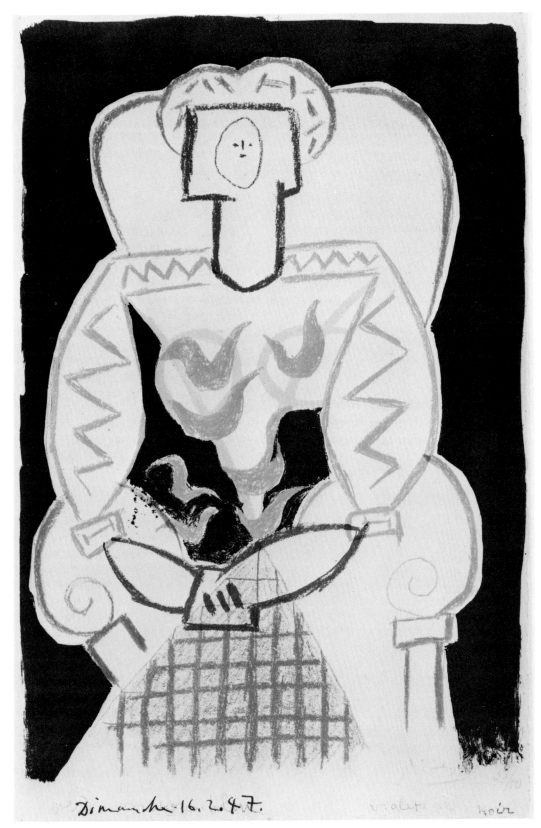

101. Pablo Picasso, *La Femme au fauteuil,* 1947, six color lithograph, 18⁵/₁₆ x 12½″. Fogg Art Museum, Harvard University.

which the master printer Marchutz transferred to the stone. Unlike most color lithographs, where a separate stone and printing are required for each color, all the colors were inked on a single stone and printed at once, achieving a remarkable spontaneity." For the 1953 edition of Jules Renard's *Histoires naturelles*, published by André Gonin in Lausanne, Hans Erni drew and painted directly on the stone, and the printer Armand Kratz, assisted by Emile Matthieu, worked with him to produce color lithographs which have freshness and immediacy. When Mourlot Frères printed Henry Moore's color lithographs for the 1950-1951 edition of Goethe's *Prométhée*, translated by André Gide, Moore was not present; from England he had sent plastics providing color separations and color instructions for his designs, and undoubtedly he received proofs for inspection before printing.

So exceptional were the available skills that publishers proposed and artists sometimes accepted ventures in reproduction which posed as original prints. "It is a pity," writes Felix Man in *Artists' Lithographs* (1970), "that Braque, like Picasso and Chagall, agreed that some sketches and gouaches should be reproduced by lithography in colour and numbered and signed in pencil by the artists." In a sense, these ventures, which stirred dismay and distrust among collectors, were a throwback to the reproductive intent of the masters of chromolithography. They occurred, however, as aberrations in the midst of a revival on a large scale of original color lithography. In Paris alone, there are many monuments from these postwar years — Fernand Léger's *Cirque,* for instance, of 1950, comprising black and white and color lithographs based on his observations of circuses in the United States during World War II — and the great French painters and designers who used color lithography

were numerous. One of the most distiguished contributors was Jean Lurçat, whose *Geographie animale*, with color lithographs printed by J.-E. Wolfensberger, was published by Gonin in Lausanne in 1948. Above all was Picasso's incredible outpouring of creative energy. "One may think that color lithography imitates the gouache, becomes a reproduction pure and simple," wrote Bernard Gheerbrant in *Artist's Proof,* Issue No. 6, Fall-Winter 1963-1964. "Well, then, Picasso, while playing casually with the register marks, discovers instinctively the powerful naiveté of the imagery of the past! His *Femme an fauteuil* (1948) reaffirms the power of full, flat colors and their somewhat casual superimpositions. Without dwelling on his discoveries, achieved with a little spit and glue, with old rags and a knife, by playing with the rejection of water by the stone, by overcoming difficulties of certain transfers, and by inventing new rules, he has given back to a medium destroyed by its own refinement all the expressiveness of the primitives. Upsetting the academic distinctions between the media, he scratched his airy shapes into the magnificent blacks of the lithographic stone and, at the same time, gave to wash drawings on stone a new quality of depth and sparkle."

Last of the great old men of painting in Paris to use lithography as a major means of expression was Jean Dubuffet, whose output in the 1950s and 1960s was prodigious, both in quantity and originality. A notable example, one of many, is his *Figure in Red* of 1961.

As leaders of the Abstract Expressionists and Op and Pop movements turned to lithography, Paris was still the center for color work in the medium, and *1¢ Life* (Berne, E. W. Kornfeld, 1964) is an exuberant display of new work. Artists young and old joined to add their lithographs to poems by

Walasse Ting. Alan Davie, Alfred Jensen, Sam Francis, Walasse Ting, James Rosenquist, Pierre Alechinsky, Kimber Smith, Alfred Leslie, Antonio Saura, Kiki O.K., Asger Jorn, Robert Indiana, Jean-Paul Riopelle, Karel Appel, Tom Wesselmann, Joan Mitchell, Allan Kaprow, Andy Warhol, Robert Rauschenberg, K.R.H. Sonderborg, Roy Lichtenstein, Oyvind Fahlstrom, Reinhoud, Claes Oldenburg, Jim Dine, Mel Ramos and Enrico Baj contributed. The lithographs were printed by Maurice Beaudet in Paris at a moment when still another chapter in color lithography was opening, this time in the United States.

Never has a venture in art patronage been more effective than the Ford Foundation grants made in response to proposals by June Wayne and administered by her to found and carry forward the Tamarind Lithography Workshop in Los Angeles. Under the direction of this remarkable artist-lithographer, Tamarind opened in 1960 and closed in 1970 after a decade of teaching and service which brought forth many prints of distinction and sowed the seeds of lithography workshops across the country. Its successor is the Tamarind Institute in Albuquerque, New Mexico, established in 1970 adjacent to the University of New Mexico.

The program at Tamarind in Los Angeles was well adapted to support by a charitable foundation. Fellowships were granted to printers, artists, and curators. As a result, the years from 1960 to the present have been immensely productive ones in lithography in the United States, and color lithography has flourished. Michael Knigin and Murray Zimiles in their book *The Contemporary Lithographic Workshop Around the World* (1974) describe eighteen workshops in America (United States, Canada and Mexico) and twenty in Europe.

The pioneer American graphic arts workshop, George E. Miller & Son, Inc., specialized in black and white lithography. Founded in 1917 but temporarily discontinued during World War I, it served many leading American artists in the twenties and thirties and continues its longstanding contribution today. Although it printed some lithographs in color, the real beginnings of color lithography in the great tradition begun in the nineties came in America in the 1950s. University workshops and art schools such as the Philadelphia College of Art and the School of the Museum of Fine Arts, Boston, provided lithographic facilities. Stuart Davis availed himself of equipment and skills at Pratt Contemporaries, the Pratt Institute, New York, to work in color lithography. In 1957 Tatyana Grossman founded Universal Limited Art Editions; her Long Island workshop has been a major force in interesting leading American painters in printmaking. In 1960 came Tamarind. Gemini Graphics Editions Limited in Los Angeles, Hollanders Workshop in Manhattan, Landfall Press in Chicago and Impressions Workshop (founded 1959) in Boston are among those with records of sustained service, opening the way to the association between artist and craftsman which has been possible in graphic workshops since the time of Dürer. Mellerio's prophecies have been abundantly fulfilled. The medium of color lithography, celebrated in museum collections such as Albert P. Strietmann Collection of Color Lithographs at the Cincinnati Art Museum, is very much alive and flourishing in the daily work of artists and craftsmen in (a partial listing) the United States, France, Italy, England, Holland, Denmark, Spain, Canada and Mexico.

S.H.H.

Biographies of Artists

The notes presented here follow Mellerio's example in concentrating on the contributions of the artists to original lithography in color; the sequence parallels that of his section on "The Artists." Toulouse-Lautrec and Bonnard are discussed first, then Ibels, then Vuillard, Denis and Roussel; then Lunois, Rivière, Dulac, de Feure, and Hermann-Paul. Weber (Veber) is briefly mentioned, but not Jeanniot, whose color lithographs have eluded our searches, or Chéret, who is discussed at length in the opening essay of this book. There are notes on Steinlen and Grasset, on Signac and Luce but not on Cross who is a minor though attractive contributor.

These nineteen are the principals in Mellerio's analysis, listed in what he considered their order of importance. He deals very briefly with twenty-one others, and at the end mentions the names of twelve more. Among the twenty-one is Mucha, dismissed with contempt by Mellerio, but immensely successful in his day and in our own times a cult figure.

A more balanced view is offered in Chapter five. The color lithographs of Forain (whose bicycle poster, incidentally, is one of the outstanding pieces of poster design of the nineties) are likely to attract more attention in the future; reddish-brown is the color most often used, with black, and occasionally buff or blue. Most date from the years 1900-1910. The attractive color lithographs of Aman-Jean deservedly receive increasing notice, as do the large prints of Paul Berthon. Most of the artists mentioned by Mellerio, however, in his final groupings, produced little in original color lithography. Jacques Villon, who is not mentioned, nevertheless, at the outset of his career attracted Mellerio's attention and received in 1899 a commission for a color lithograph (his second print in the medium) which was issued as part of *l'Estampe et l'affiche*. He produced a few more color lithographs in 1901, 1904, 1905 and 1907. Most notable of those whom Mellerio does not include, in writing of the nineties in

Paris, is Edvard Munch. In their book on Munch, Johan Langaard and Reidar Revold note of Munch in 1896:

> He also turned now to colour lithography, understandably, for this technique was ultra-modern, and Munch had a good opportunity to study it in the workshops of the lithographic printers, Clot and Lemercier, who worked for a number of masters.

At Munch's request, Clot changed colors in printing impressions of *The Sick Child,* and these differing and beautiful printings are a special moment in the color lithography of the nineties. Lautrec's work on the stones and at the press in making fifty impressions, each different, of *Miss Loie Fuller* (1893) is a more intimate moment, without an intermediary like Clot. Following Delteil's description, Gerstle Mack says that the design was printed in black and that Lautrec applied watercolor to the prints with wads of cotton wool, and then sprinkled each print with gold powder. Examination of several of the prints, however, shows that Lautrec did even more; a detailed description of impressions of the print would be an account of individualism and artistic virtuosity carried forward with intense enthusiasm and intimate familiarity with lithography. Several stones were used, and it would appear that in addition to conventional inking of the printed stones providing a base of printed design and color, Lautrec also applied color boldly to the key stone, making each print almost a monotype — and after this came the application of more color and of powdered gold to the prints, giving them a shimmering iridescence. Technically, *Miss Loie Fuller* is not a color lithograph in the sense of a uniform edition. In a larger sense, however, it holds a place in the story of color lithography of the nineties, as a successful attempt to transcend limitations of the medium without abandoning stones and press.

S.H.

HENRI DE TOULOUSE-LAUTREC (1864-1901)

As Mellerio remarked, Lautrec was "the star." His interest in lithography led him to make it a major part of his work, a commitment comparable to his commitment to drawing and painting. Among his thirty posters are designs which remain today among the best-known works in the history of printmaking. This is also true of his single-sheet lithographs, more than 300 of them; over thirty of them are color prints, and they include images of great familiarity and fascination, like *La Clownesse assise* in *Elles*. Richard Thomson in his book *Toulouse-Lautrec* (1976) writes, "The most imposing posters, like *Bruant aux Ambassadeurs,* use very strong light and dark contrasts to achieve their striking presence, and this increased effect by reduction of means was Lautrec's great gift to the poster." It is not always possible to distinguish sharply between the posters and the single-sheet prints; a small poster like *Jane Avril* (1898) has many qualities of the collector's print, as well. Lautrec's great sensitivity to the smoothed surface of the lithographic stone puts him in very select company; like Redon, he should be considered a master of the medium, and he possessed his own flair, instinct, and intense concentration, all brought to bear during the execution of designs which he often planned carefully through preliminary drawings. His color lithographs posed a difficult challenge to his printers; examination of impressions of *L'Anglais Warner au Moulin Rouge* (1892) shows that the print succeeds brilliantly in its areas of bright, flat color, broken color and transparent color despite the visible difficulties experienced by the printer in achieving evenness of color in the soft brown of the Englishman's figure. Impressions of *Femme sur le dos (Lassitude, Elles)* where Lautrec required an overall base tint of heavy green, giving the print a curtained dimness, show that again the printer had difficulty in printing the green evenly. In the poster *Jane Avril* (1899), mentioned earlier, Lautrec apparently specified what printers call a "rainbow roller," in which several different colors are used on the ink stone and kept as bands on the roller by rolling it across the stone in exactly the same way at each new inking. The *Elles* series, comments Richard Thomson, is almost a catalogue of Lautrec's different lithographic styles. He uses flowing line, spatter, strong outlining, color sometimes bright, sometimes soft; some prints are multi-color, some single color, and some employ two tones. *Femme qui se lave* in *Elles* with tender drawing of the figure shows a standing woman washing herself; two tones are used, a soft brown and blue, and the subtle result is one of Lautrec's greatest color prints. No artist was closer to his printers or found his way into a deeper knowledge of lithographic techniques. In lithography, both black-and-white and color, Lautrec exercised to the fullest a special gift. S.H.

PIERRE BONNARD (1867-1947)

Bonnard's color lithographs belong almost entirely to the excitement of the nineties, though his great *Place Clichy* (1923) is an isolated monument made much later. To color lithography, Bonnard, who was called the most Japanese of the Nabis, brought striking individuality; his sense of pattern, his solid masses of color in silhouetted figures, his love of color, too, with matt texture, his genius for the successful incorporation into some designs of broad areas of paper, all are applied in his own way. In his prints of the nineties he was a great colorist, as he always was throughout his long career as a painter, but he adapted his color to lithography and showed himself highly responsive to the medium. He designed a handful of posters and made, as well, fewer than thirty single-sheet lithographs in color. All are highly prized today. The love of Paris as a city has long since become a cult in the West, and the material from which uncounted romances have been fashioned; Bonnard's *Quelques Aspects de la vie de Paris* is not sentimental, but no work better expresses the character of the city as seen by one who cared greatly for it.

For the purposes of the present book, Bonnard's last original lithograph in color is considered to be his *Place Clichy* of 1923. In the early 1940s he signed a number of color lithographs, but in none of them did he work directly on stone. Jacques Villon, with Bonnard's color drawings before him, transferred them to stone. The resulting prints are of great interest and completely characteristic of Bonnard's painting style of the period, but they represent brilliant reproductive work rather than the direct, immediate presence of the artist, making the most of original lithography as a medium with its own characteristics. Incidentally, to go back to the nineties, among the mementoes of friendships with Mellerio which are scattered through the work of the Nabis are Bonnard's little lithograph, printed in red, announcing the birth of the Mellerios' daughter Marie Louise, as well as his two color lithographs which decorate Mellerio's book of 1898. S.H.

HENRI-GABRIEL IBELS (1867-1936)

Ibels was one of the first of the emerging young artists of the 1890s to produce significant work in color lithography. He studied at the Académie Julien with Bonnard, Vuillard, Denis and Serusier and joined with them in the early 1890s, under Serusier's leadership, to form the group called the Nabis which followed the aesthetic tenets of Paul Gauguin. The large poster, *Mévisto,* of 1892 and the series of eight Théâtre Libre programs for the 1892-93 season were his earliest and most important works in color lithography. The journal *La Plume* featured Ibels in the January 15, 1893, issue — reproducing *Mévisto* in color. In January 1894 Ibels

created the poster for *La Plume's* Salon des cent inaugural exhibition. He also produced color lithographs for *L'Estampe originale* (1893) and *L'Estampe moderne* (1897). Ibels was an energetic force in the printmaking renaissance of the 1890s. He collaborated with Toulouse-Lautrec on the lithographic album, *Café-Concert* (1893) and a lithography by him was included in the July 1894 *La Revue blanche*. He produced illustrations for the satiric journal *L'Escarmouche* and in 1898 founded the pro-Dreyfus illustrated journal *Le Sifflet*.

P.D.C.

EDOUARD VUILLARD (1868-1940)

Vuillard's color lithographs are few in number, but their impact has been immense. Though small in size, they have long been treated as major works. Moreover, in any discussion of the great pictorial achievements of artists in the nineteenth century, the chief sets of color lithographs—Lautrec's *Elles*, Bonnard's *Quelque Aspects de la vie de Paris*, Vuillard's *Paysages et intérieurs* and Denis' *Amour*—exist at a level of importance equal to that of the greatest paintings of the century. *La Sieste ou la convalescence*, made for *L'Estampe originale*, the extraordinary venture in print publishing directed by Roger Marx and André Marty, was published in 1893; *La Table au grand abat-jour*, about 1895, was a second venture into lithography in color, followed by *La Couturière* and *Le Déjeuner*. From 1896, after these few ventures in color lithography, Vuillard's style in the medium is well established and his works are major achievements: *Le Jardin des Tuileries* for Vollard's first *Album des peintres-graveurs* and *Maternité* for publication in the deluxe edition of *Pan;* in 1897, *Jeux d'enfants*, for Vollard's second *Album des peintres-graveurs;* and in 1899, again with Vollard as publisher, *Paysages et intérieurs*, thirteen color lithographs, including the cover of the set. Five lithographs in color, each a study in the possibilities of the medium, complete his work: *La Naissance d'Annette* (about 1899); *La Petite Fille au volant* (about 1899); a cover for an album of original prints projected by Vollard about 1899 (the album was never realized); *Un Galerie au gymnase*, for the album *Insel*, published in Leipzig in 1900; and *Le Jardin devant l'atelier*, published in the album *Germinal* in 1900. Mellerio wrote with insight: "An exact artistic sense makes him quickly appreciate his medium, both what one must and what one can get out of it," and Mellerio also appreciated Vuillard's clear stamp of individuality. In his biography of Vuillard, Claude Roger-Marx, who liked to refer to artists' original lithographs in color as "chamber music," said of the *Paysages et intérieurs:* "the colored inks—yellow-green, lemon-yellow, and reds, light as strawberry-juice—upon the white background describe, matt as in a fresco, a succession of interiors peopled with white or bluish stoves, hanging-lamps, crowded mantelpieces, and silhouettes of children and old people. Or we see little girls coming out of school and strollers in the country and avenues checkered blue and white by sun and shadow. Each of these lithographs is a tiny fresco. Not since Whistler, had the colored print achieved such wonders. Nowhere has Vuillard's drawing shown itself more expressive or more completely emancipated from any system."

S.H.

MAURICE DENIS (1870-1943)

Denis was a brilliant contributor to color lithography in the nineties. Mellerio, with his emphasis on the collector's print, the single-sheet lithograph to be held in the hand, mentions the lithographs for *Le Voyage d'Urien* with appreciation but almost as an afterthought. However, this small, squarish book of 1893 with André Gide's prose and Denis' prints is a landmark of original lithography in color. Denis contributes subtlety of tone and more than equals Toulouse-Lautrec, Bonnard and Vuillard in economy of means—he uses two colors, black on buff, and skillfully employs the heavy cream-colored paper as a third color; later in the book he uses black and a pale olive green, along with the paper. A single landmark which precedes this series is Denis' lithograph in three colors of 1892 conceived and issued as frontispiece of *La Demoiselle Elue* by Dante Rossetti and Claude Debussy. That one small picture could draw the viewer into the blue, star-pierced reaches of night is a miracle. In *Amour*, his series of 1899 for Vollard (twelve color lithographs, with an additional lithograph in color as cover), Denis shows himself to be one of the great masters of original color lithography; he lets the whites of the paper come up between the strokes of his lithographic crayon, he achieves radiance of gold and pink, he creates a halation around his figures; he knows how to make colors work together, and he knows how to make a single color vibrate by the way he draws on the stone. He has a strong sense of texture as it can be superimposed on areas of color—pressed-on cloth texture, for instance, the matt pattern which fascinated Bonnard and Vuillard, as well. In his painting and drawing, Denis had a particular penchant for portraits of his friends, including Verkade, Serusier, Paul and France Ranson, Vuillard, Maillol and Renoir. His *Hommage à Cézanne*, mentioned earlier in this volume, shows the Nabis gathered in Vollard's gallery, where a still-life by Cézanne is on an easel; Redon, Vuillard, Mellerio, Vollard, Denis, Serusier, Ranson, Roussel, Bonnard and Marthe Denis are shown. About 1904 he painted *Degas et son modèle;* in 1906, *Visite à Cézanne*. A portrait with great charm is *La Famille Mellerio* of 1897. Mellerio, an intense man, trim, bearded and moustached, sits at left, holding a book. In front of him is his oldest daughter, a little girl of about six. The middle child, a girl of about four, stands at center. Madame Mellerio, holding the baby in her lap, sits at right, and it was to her that Denis dedicated the picture.

S.H.

KER-XAVIER ROUSSEL (1867-1944)

When Mellerio wrote his essay on original lithography in colors, he noted that Roussel "is only a beginner in the field which we are considering, but he is working assiduously at this time." Roussel's contribution was brief and intense, taking place almost entirely in the years 1897 through 1900. It was his bad fortune that Vollard, who in 1898 gave him a commission for a portfolio of color lithographs, *Paysages*, later had to back off from the project because earlier albums and portfolios which he had commissioned were not selling well. As a result, Roussel's set was never published and did not become a public possession and known landmark like the four great published sets of color lithographs by Toulouse-Lautrec, Bonnard, Vuillard and Denis. De Feure's series, *L'Amour libre* and *Bruges mystique et sensuelle*, though published, suffered the same obscurity. Of the prints in Roussel's set, 100 impressions were printed of seven subjects, but few proofs were taken of the other five. Roussel's landscapes achieve subtle, shimmering light and a sense of space and air. His contribution was important, not only in its strong individuality, but because, as Mellerio commented, he possessed "a real comprehension of prints" — how to use printed color and the white of the paper.

S.H.

ALEXANDRE LUNOIS (1863-1916)

In the 1880s Lunois was a reproductive lithographer and an early member of the Société des artistes lithographes français. In 1888 he began producing his first original lithographs; the next year the dealer Sagot began selling his prints. In 1890 he was included in the second exhibition of Peintres-Graveurs. Early in the 1890s he is said to have introduced to Vuillard and Bonnard the delicate technique of wash lithography. Beginning in 1893 Lunois became a prolific color lithographer. He designed the only color lithograph in Duchatel's 1893 *Traité de lithographie artistique;* color lithographs by him are included in the 1893 album of *Les Peintres-Lithographes,* in *L'Estampe originale*, in Delteil's 1896 *L'Estampe moderne*, and in both Vollard's 1896 and 1897 albums. Gustave Pellet published more than sixty color lithographs by Lunois—most important is *La Corrida* (1897), a series of eight lithographs dealing with the theme of the bullfight. Lunois' travels to Spain and to North Africa are often reflected in the subject matter of his prints.

P.D.C.

BENJAMIN JEAN PIERRE HENRI RIVIÈRE (1864-1951)

Rivière, along with Adolphe Willette, Caran d'ache and Théophile Steinlen, was associated early with the Chat Noir café and journal founded in Montmartre by Rodolphe Salis in 1881-82. As secretary and one of the illustrators of the journal and as inventor of the café's shadow theatre, Rivière exercised a great deal of influence on the artistic environment of the Chat Noir. His first color prints were woodcuts done in 1888. The next year he produced his first color lithograph, a program for the Théâtre Libre printed by Eugène Verneau who was consistently Rivière's printer throughout the 1890s. *L'Estampe original* (1893) includes *La Vague* — an eight color lithograph. In 1896, Verneau published *L'Hiver*, the first of many color lithographic murals (les estampes décoratives) printed in a large edition of 1000 specifically for public consumption. This was followed by various albums of lithographys, such as *La Marche à l'étoile* (1898), designed by Rivière after his shadow theatre performance. In 1902, after studies begun in 1888, the color lithographic album *Les Trente-Six Vues de la Tour Eiffel* was published; it serves as a stylistic and thematic summation of Rivière's printmaking activities of the previous decade. His color lithographic oeuvre through 1902 is comprised of over forty prints and numerous albums.

P.D.C.

CHARLES-MARIE DULAC (1865-1898)

Dulac was a symbolist—admired by Huysmans, influenced by Puvis de Chavannes and Eugène Carrière—who specialized in landscapes. In 1893 he produced *Suite de paysages* (Suite of landscapes), a series of eight color lithographs. In 1894 visionary landscapes by him were included in the album of *Les Peintres-Lithographes* and *L'Estampe originale*. *Le Cantique des créatures* (1894) (The Canticle of Creatures), based on the thirteenth-century poem by St. Francis of Assisi, is a strongly symbolic series of nine color lithographic landscapes. It is a hallmark in symbolist art. Dulac's works are examples of the use of color lithography for nuances of muted colors and, as such, reveal the subtle qualities of the color revolution.

P.D.C.

GEORGES DE FEURE (1868-1943)

Writing in *The Studio* in 1898, Octave Uzanne commented that de Feure "only began to produce his work in 1890, and already he has achieved a great deal in oils, in lithography and in engraving. His lithochromes number a hundred; his pictures displayed in the past two years at the Champs de Mars are now hanging in several private galleries, while his posters which have appeared on the street walls in Paris and Brussels are already as much sought after as those of the young Chicago artist, Will H. Bradley, to whose work that of de Feure bears some resemblance." Later, Uzanne notes that de Feure's poster work "bears little resemblance to that of any other artist," a more accurate judgment than his interesting comparison to Bradley, and calls attention to four of the posters: *La Loie Fuller, Salomé, the Palais Indien,* and *Izita.* He goes on: "In lithography he has done innumerable pleasing little things—menus, invitation-cards, book covers, and many curious plates, such as *Les Trois Mendiants dans la forêt, Entrée des Vices dans la ville, La Voix du mal, L'Infini, Le Dernier Amant, Fleur de la grève, L'Amour sanglant,* and *L'Amour aveugle;* and a few lithographs in black, like *La Princesse Maleine....*" Uzanne's statement that by 1898 de Feure had made a hundred "lithochromes" establishes him as a prolific contributor to original lithography in color. His impact on printmaking in the nineties was small, however, compared to the attention given by his contemporaries to his designs for furniture and porcelain under the patronage of Samuel Bing at L'Art Nouveau. His posters attracted far more attention than his single-sheet prints, which have never been catalogued and remain, today, little known compared to those of Toulouse-Lautrec, Bonnard, Vuillard, Denis, Signac and others. The better-known artist-lithographers of the decade made their impact through continuity of style, but Mellerio wrote of de Feure that "He has experimented and worked in different styles" — perhaps a disadvantage as far as impact on the public was concerned. In addition to his single prints, he produced two series which are important in the Art Nouveau movement and in the phenomenon of artists' color lithography. *L'Amour libre,* which Mellerio mentions, has sharp, astringent colors. One of the lithographs in the series is listed as newly published in *L'Estampe et l'affiche,* the journal which Mellerio edited, in April 1897. William Weston, the London gallery-owner, in his Catalogue No. 10, 1976, reproduces and describes a lithograph from the series; its colors are chrome yellow, lemon yellow, grey, red, sage green, and purple. "Flat tones, but in heightened color, are enclosed in lines where the arabesque counts, and together they produce a unified arrangement," comments Mellerio. The other important set of single-sheet lithographs in color, *Bruges mystique et sensuelle,* often achieves strong effects with a single

color in addition to black—purple, a tan which has sharpness rather than blandness, or green. Like *L'Amour libre,* the series employs Art Nouveau patterns as well as symbolist iconography. De Feure was the son of a Dutch architect, apprenticed himself to Chéret in 1890, exhibited extensively in Paris beginning in 1892, and enjoyed his greatest fame through the furniture, poreclain, stained glass, fabrics and room interiors designed for Bing in the years from 1898 through 1903. The studies of Gabriel Weisberg have opened the door to research on de Feure's obscure later career. See his articles in the *Gazette des Beaux-Arts,* October 1974, as well as the assessment of de Feure in *Art Nouveau Belgium France* (Rice University, 1976), p. 472. The titles of eighteen of de Feure's posters are listed in *Art et décoration,* Vol. III, January-June 1898, p. 121.

S.H.

HERMANN RENÉ GEORGES PAUL (HERMANN-PAUL) (1864-1940)

Paul studied at the Académie Julien. Beginning in 1893 he created numerous illustrations for such journals as *L'Escarmouche, Courrier français* and *Le Cri de Paris.* In 1895 he produced a series of ten black and white lithographs entitled *La Vie de Monsieur Quelconque* (The Life of Mr. Whatever), followed by *La Vie de Madame Quelconque* and also produced a program for the *Théâtre de l'oeuvre.* The print department of the Bibliothèque Nationale, Paris, has a color lithograph by him entitled *Femme au chapeau et à la cape noir* which is attributed to c. 1890; however, the earliest documented work in color by Hermann-Paul is the brilliantly colored poster for the January, 1894 Salon des cent. This was followed that same year by the *Modiste* in the sixth album of *L'Estampe originale.* He continued producing color lithographic work up through 1900.

P.D.C.

JEAN VEBER (1844-1928)

Near the middle of Mellerio's discussion on specific color lithographers he includes the name "Weber." We are unable to find any information on or work by a "Weber" working in Paris in the 1890s. However, the names "Weber" and "Veber" were often used interchangeably during this period, and in the 1890s Jean Veber produced numerous macabre lithographic prints in muted colors and washes which seem to fit Mellerio's general description.

P.D.C.

THÉOPHILE ALEXANDRE STEINLEN (1859-1923)

Aspects of Steinlen's life and work are discussed in detail in the preceding essays. He is an important figure for the color revolution—not only for developing an audience for color printing in general,

but also for producing some of the strongest color lithographic posters and prints of the period. He designed his first color lithographic poster *Trouville sur-mer Hotel de Paris* in 1885; however it is in the 1890s with such posters as *Mothu et Doria* (1893), *À La Bodinère* (1894), *Yvette Guilbert aux ambassadeurs* (1894), *Tournée du Chat Noir* (1896), and *La Rue* (1896) that his real contributions to color lithography occur. His numerous lithographic book covers are generally in one or two subtle colors; his cover for *Ache* (1895) is an exciting, colorful exception to the rule. In 1898 Steinlen began producing color etchings and this medium dominated his work for the next several years; however, in 1909, he created two major color lithographs, *Eté Chat sur la balustrade* and *L'Hiver chat sur un coussin*, which are a tribute to the brillance of his work in the 1890s rather than an indication of future performance.

P.D.C.

EUGÈNE-SAMUEL GRASSET (1841-1917)

Born in Lausanne, Switzerland, Grasset arrived in Paris in 1871 and twenty years later became a naturalized citizen of France. He was strongly affected by the exotic decorative designs of Middle and Far East countries and played an important role in the development of French art nouveau with his designs for typefaces, furniture, book bindings, etc. In the 1880s he designed furniture for the photo printer Charles Gillot as well as the metal cat lantern for the entrance of the Chat Noir café plus other interior decoration for the same cabaret. In 1882-83 Gillot and Grasset collaborated in the publication of the book *L'Histoire des quatre fils Aymon*. Its multicolor photo relief illustrations dramatically integrated with the text make this book a major work in the history of French illustrated books and an important incunabulum of the color photo printing process. He began creating color lithographic posters in the mid-1880s with *Les Fêtes de Paris* (1886) and *Libraire romantique* (1887). These were followed in the 1890s with such distinctive posters as *Encre Marquet* (1892) and *L'Exposition internationale de Madrid* (1893). His series of ten decorative prints ("estampes decoratives") of 1896 was produced photomechanically and colored by stencil as was also his 1894 *Salon des cent* poster. Grasset produced single color lithographs for *L'Estampe originale*, Vollard's 1897 album, and *L'Estampe moderne*. The color lithographs *Vitriol-thrower* and the *Morphine Addict* from the first two of these print publications are hardly typical of the depiction of women in the 1890s. Grasset's two prints are dynamic designs, strongly individualistic and highly provocative in their social commentary. From March 8—April 25, 1894, the Salon des cent held two exhibitions covering all aspects of Grasset's art. The catalogue of his work in the May 15, 1894, special issue of *La Plume* was the first major study produced on the artist.

P.D.C.

PAUL SIGNAC (1863-1935)

Although Signac's lithographs in color number only twelve, they are among the key prints for an understanding of the birth of original lithography as an artist's medium. The color lithograph made by Signac and printed by Eugène Verneau on the program for the Théâtre Libre, season of 1888-1889, is the opening shot of *The Color Revolution*. It precedes the first efforts in color lithography by Bonnard and Lautrec, but it is also more complicated in its use of color. In this print of 1888, Signac emphasizes division of colors. Printed lettering identifies the lithograph as an application of the color circle of Charles Henry. The tradition of color circles, begun by Sir Isaac Newton, and used by a succession of theorists of color to show their personal analysis of the spectrum or primary and secondary colors would naturally appeal to the mind of a painter who was always, as well, a theorist, philosopher and writer. In order to apply the painting style of Divisionism to printmaking, Signac from the first had to make heavy demands on his printers. Verneau, faced with complicated registration of colors, did not do badly, but Auguste Clot was later to do better in prints such as *Le Soir, En Hollande,* and *Les Andelys.* Signac felt strongly about the importance of the white of the paper in his watercolors, and his prints use spots of radiant color which are lightened and enhanced by the whites around them. The printer achieved such registration and such colors only with the prod of extremely detailed corrections and instructions on proofs marked by the artist. Such detailed corrections and revisions must have pushed Auguste Clot to the limits of his endurance, but they also brought him to results which are a part of his fame. Signac's close working relationship with Clot recalls Redon's often-quoted remark that the relationship between artist and printer in the amking of lithographs is "a marriage."

S.H.

MAXIMILIEN LUCE (1858-1941)

In the late 1870s Luce was a wood engraver for the journals *L'Illustration* in Paris and the *Graphic* in London. By 1887 he had met the neo-impressionists (Seurat, Signac, Pissarro, et. al.) and began exhibiting with them at the Salon des independants. Luce was an anarchist-communist, as were many of the avant-garde artists of the time, and he created illustrations for such radical journals as *Le Chambard* and *Le Pere Peinard*. His color lithographs (e.g. *Usines de Charleroi*) generally depict industrilaized cities. In the first half of the 1890s he produced numerous black and white lithographs printed by Lemercier; and he is represented in *L'Estampe originale* with a black and white lithograph. In 1897 Gustave Pellet published seven color lithographs by Luce.

P.D.C.

Bibliography

La Lithographie originale en couleurs

Adhémar, Jean. *Toulouse-Lautrec: Elles.* Préface de Jean Vallery-Radot (Monte Carlo: André Sauret, 1952).

Adhémar, Jean. *Toulouse-Lautrec: His Complete Lithographs and Drypoints* (New York: Abrams, 1965).

André, Edouard. Alexandre Lunois, *Peintre, Graveur et Lithographe* (Paris: H. Floury, 1914).

Auberty, Jacqueline (Mme. Jean Gaudin) et Perusseaux, Charles. *Jacques Villon. Catalogue de Son Oeuvre Gravé* (Paris: Paul Prouté et ses Fils, 1950).

The Avant-Garde in Theatre and Art: French Playbills of the 1890s, Smithsonian Institution Traveling Exhibition Service, 1972.

Bland, David. *A History of Book Illustration* (London: Faber and Faber, Ltd., 1958).

Bouchot, Henri. *La Lithographie* (Paris: Librairies-Imprimeries Réunies, 1895).

Bremen, Kunsthalle. *Ker-Xavier Roussel,* 1867-1944 (exhibition catalogue, September 16 –November 21, 1965).

Cailler, Pierre. *Catalogue de l'oeuvre grave et lithographie de Maurice Denis* (Geneva, 1968).

La Centenaire de la lithographie, 1795-1895 (Catalogue of the exhibition at Le Palais des Beaux-Arts, Paris).

Charpentier, Galerie, Paris. *Collection M.L.* (Maurice Loncle sale catalogue) *Ensemble exceptionnel d'estampes originales, livres illustres...de Henri de Toulouse-Lautrec.* June 2, 1959.

Crauzat, E. de. *L'Oeuvre Gravé et Lithographié de Steinlen* (Paris: Société de Propagation des Livres d'Art, 1913).

[...]
Culturelles Reunion des Musées Nationaux).

Delteil, Löys. *H. de Toulouse-Lautrec* (Le Peintre-Graveur Illustre, xixe et xxe Siècles, Vols. 10-11. Paris: Chez l'Auteur, 1920).

Delteil, Loys. *Manuel de L'Amateur d'Estampes des xixe et xxe Sìècles* (1801–1924). (Paris: Dorbon-Ainé, 1925).

Druick, Douglas W. "Cézanne, Vollard and Lithography," *Bulletin 19* (Ottawa: National Gallery of Canada, 1972).

Duchatel, E. *Le Manuel de lithographie artistique* (Paris, 1907).

Duchatel, E. *Traité de lithographie artistique* (Paris, 1893).

Garvey, Eleanor, Hofer, Philip, and Wick, Peter. *The Artist and the Book 1860-1960* in Western Europe and the United States (Boston: Museum of Fine Arts, 1961).

Gautier, E. Paul. "Lithographs of the 'Revue Blanche,' 1893-95," *Magazine of Art.* (New York: The American Federation of Arts), October, 1952, Vol. 45, No. 6, pp. 273–278.

Geiger, R. *Hermann-Paul* (Paris, H. Babou, 1929).

Goriany, Jean, "Cézanne's Lithograph 'The Small Bathers,' " Gazette des Beaux-Arts, Sixth series, Vol. 23, 1943, pp. 123–124.

Groschwitz, Gustave von. *The Albert P. Strietman Collection of Color Lithographs.* (Exhibition catalogue, The Cincinnati Art Museum, October 1 to November 14, 1954).

Groschwitz, Gustave von. "The Signficance of XIX Century Color Lithography," *Gazette des Beaux-Arts,* 1954, pp. 243–266.

Harris, Jean C. *Edouard Manet, Graphic Works: A Definitive Catalogue Raisonné* (New York, 1970).

Hédiard, Germain, *Les Maîtres de la lithographie–John Lewis Brown* (Paris, 1898).

Ives, Colta Feller. *The Great Wave: The Influence of Japanese Woodcuts on French Prints* (New York, 1974).

Johnson, Una. *Ambroise Vollard, Editeur. Prints, Books, Bronzes* (New York: The Museum of Modern Art, 1977).

[...] Gustave [...]

Kornfeld, E. W., and Wick, P. A. *Catalogue raisonné de l'oeuvre grave et lithographie de Paul Signac* (Berne, 1974).

Kornfeld, E. W. *Estampes des Peintres de la "Revue Blanche."* Toulouse-Lautrec et les Nabis. Catalogue a prix marqués No. 50 (Berne: Klipstein & Co.).

Kovler, Marjorie B. *Forgotten Printmakers of the 19th Century.* Exhibition catalogue, December 1967–January 1968 (Chicago: Kovler Gallery, 1967).

Kovler Gallery, Chicago. *The Graphic Art of Vallotton & the Nabis,* 1970.

Lassaigne, Jacques. "Henri de Toulouse-Lautrec: His Complete Oeuvre of Posters," *Graphis,* Zurich, Vol. 6, No. 30, 1950, pp. 174–182.

Leymarie, Jean. *The Graphic Works of the Impressionists* (New York: Abrams, 1972).

Lotz-Brissoneau, A. *L'Oeuvre Gravé de Auguste Lepère* (Paris: Edmond Sagot, 1905). ("Lithographies," pp. 233–243).

Mack, Gerstle. *Toulouse-Lautrec* (New York: Alfred A. Knopf, 1942).

Man, Felix H. *Artist's Lithographs.* A world history from Senefelder to the present day (New York: G. P. Putnam's Sons, 1970).

Marguéry, Henri. *Les Lithographies de Vuillard* (Paris: L'Amateur d'Estampes, 1935).

Mauclair, Camille. *Jules Chéret,* (Paris: Maurice Le Garrec, 1930).

Mellerio, André. *Odilon Redon.* (Paris: Société pour l'Etude de la Gravure Francaise, 1913. New York: Da Capo Press, 1968).

Mellerio, André, editor. *L'Estampe et l'affiche,* March 1897–December 1899.

Melot, Michel. *L'Estampe impressioniste* (Paris: Bibliothèque Nationale, 1975).

Mucha, Jirí. *The Graphic Work of Alphonse Mucha* (London: Academy Editions. New York: St. Martin's Press, 1973).

Pennell, Joseph and Pennell, E. Robbins. *Lithography And Lithographers* (London: T. Fisher Unwin, 1898).

Rewald, John. "Diary of Paul Signac," *Gazette des Beaux-Arts,* No. 39, 1952, pp. 300 and 304.

Rewald, John. *Post Impressionism from Van Gogh to Gauguin* (New York: Museum of Modern Art, 1956).

Roger-Marx, Claude. *Bonnard Lithographe* (Monte Carlo: A. Sauret, 1952).

Roger-Marx, Claude. *French Original Engravings from Manet to the Present Time* (London, Paris, New York: The Hyperion Press, 1939).

Roger-Marx, Claude. *Graphic Art of the Nineteenth Century* (New York, Toronto, London: McGraw-Hill, 1962) (pp. 183–221) .

Roger-Marx, Claude. "La Lithographie en couleurs," *Arts et Metiers Graphiques,* March, 1931, pp. 193–200.

Roger-Marx, Claude. *Les Lithographies de Renoir* (Monte Carlo: A. Sauret, 1951).

Roger-Marx, Claude. *L'Oeuvre Gravé de Vuillard* (Monte-Carlo: André Sauret, 1952).

Salomon, Jacques. *Introduction à L'Oeuvre Gravé de Ker-Xavier Roussel par Alain* (Paris: Mercure de France, 1968).

Schaar, Eckhard and Hopp, Gisela. *Von Delacroix Bis Munch Kunstlergraphik im Jahrhundert* (Hamburg: Hans Christians Verlag, 1977).

Stein, Donna. *L'Estampe originale: a Catalogue Raisonné* (New York: Museum of Graphic Art, 1970).

Szabo, George. *Paul Signac (1863–1935). Paintings, Watercolors, Drawings and Prints. Robert Lehman Collection* (New York: The Metropolitan Museum of Art, 1977).

Terrasse, Antoine. *Bonnard Posters and Lithographs* (London: Methuen and Co. New York: Tudor Publishing Co., 1970).

Thomson, Richard. *Toulouse-Lautrec* (London: Oresko Books, Ltd., 1977).

Timm, Werner. *The Graphic Art of Edvard Munch* (Greenwich, Connecticut: New York Graphic Society Ltd., 1969).

Toudouze, Georges. *Henri Rivière* (Paris, 1907).

Uzanne, Octave. "Eugène Grasset," *The Studio,* IV, no. 20, November, 1894, pp. 37–47.

Uzanne, Octave. "On the Drawings of M. Georges de Feure," *The Studio,* Vol. XII, 1898, pp. 95–102.

Uzanne, Octave. "Quelques peintres lithographes contemporains," *L'Art et l'idée* v. 4, 1892, pp. 323–336.

Waldfogel, Melvin, "Bonnard and Vuillard as Lithographers," *The Minneapolis Institute of Art Bulletin,* September, 1963, Vol. LII, No. 3, pp. 66–81.

Way, T. R. *The Catalogue of Whistler's Lithographs.* New edition (New York: Kennedy and Co., 1916).

Weisberg, Gabriel, "Georges de Feure's Mysterious Women," *Gazette de Beaux-Arts,* Vol. LXXXII, October, 1974, pp. 223–230.

Weisberg, Gabriel, "Georges van Sluijters called 'de Feure': An Identity Unmasked," *Gazette des Beaux-Arts,* Vol. LXXXII, October, 1974, pp. 231–232.

Weisberg, Gabriel. *Images of Women: Printmakers in France from 1830 to 1930.* Exhibition catalogue, Utah Museum of Fine Arts, University of Utah, Salt Lake City, 1978.

Weisberg, Gabriel; Cate, Phillip; Needham, Gerald; Eidelberg, Martin; Johnston, William. *Japonisme. Japanese Influence on French Art, 1854–1910* (Cleveland Museum of Art, Rutgers University Art Gallery, Walters Art Gallery, 1975).

Weisberg, Gabriel. *Social Concern and the Worker: French Prints from 1830–1910* (exhibition catalogue, University of Utah: Utah Museum of Fine Arts, 1973).

Weisberg, Gabriel P. *The Etching Renaissance in France, 1850-1880* (Salt Lake City: Utah Museum of Fine Arts, 1971).

Weston, William. *Ninth Annual Exhibition of Selected Fine Prints by 19th and 20th Century European and British Masters* (London: William Weston Gallery, 1976).

Wick, Peter, "Some Drawings Related to Signac Prints," in *Prints,* thirteen illustrated essays on the art of the print, selected for the Print Council of America by Carl Zigrosser (New York: Holt, Rinehart and Winston, 1962).

Wick, Peter. *Toulouse-Lautrec Book Covers and Brochures* (Cambridge, Massachusetts: Department of Printing and Graphic Arts, Harvard College Library, 1972).

POSTERS

Abdy, Jane. *The French Poster.* Chéret to Capiello. (London: Studio Vista, 1969).

Barnicoat, John. *A Concise History of Posters* (London: Thames and Hudson, 1972).

Broido, Lucy. *French Opera Posters, 1868–1930* (New York: Dover Publications, Inc., 1976).

Catalogue d'affiches artistique françaises étrangères estampes (Paris: A. Arnould, June 1896).

Cate, Phillip Dennis. *"La Plume* and its Salon des cent Promoters of posters and prints in the 1890s," *Print Review 8,* Spring, 1978, pp. 61–68.

Cirker, Hayward and Blanche. *The Golden Age of the Poster*. Seventy European and American Posters of the 1890s in Color (New York: Dover Publications, Inc., 1971).

Constantine, Mildred, and Fern, Alan. *Word and Image*. Posters from the Collection of the Museum of Modern Art (New York: The Museum of Modern Art, 1968).

Fern, Alan. *Word and Image* (New York: Museum of Modern Art, 1968).

Flatau, Margot. *Posters of the Salon des Cent* (Los Angeles: Art Studio Margot Flatau, 1977).

Fustier, Gustave. "La Litterature murale," *Le Livre*, November 10, 1884, pp. 337–356.

Gallo, Max. *The Poster in History* (New York: American Heritage Publishing Co., 1974).

Goldwater, Robert. "L'Affiche moderne: A Revival of Poster Art After 1880," *Gazette des Beaux-Arts*, December, 1942, pp. 173–182.

Hédiard, Germain. *L'Affiche illustrée, Exposition E. Sagot* (Paris, 1892).

Hiatt, Charles T. J. "The Collecting of Posters, a new field for connoisseurs," *The Studio*, v. 1, May, 1893, pp. 61–64.

Hillier, Bevis. *Posters* (New York: Stein and Day, 1974).

Hutchison, Harold F. *The Poster*. An Illustrated History from 1860 (New York: The Viking Press, 1968).

Julien, Édouard. *Les Affiches de Toulouse-Lautrec* (Monte-Carlo: André Sauret, 1952).

Maindron, Ernest. "Les Affiches illustrées," *Gazette des Beaux-Arts*, 2d ser., v. 30, November, 1884, pp. 419–433 and December, 1884, p. 535–47.

Maindron, Ernest. *Les Affiches illustrées* (Paris: H. Launette & cie., 1886).

Maindron, Ernest. *Les Affiches illustrées* 1886–1895 (Paris: G. Boudet, 1896).

Metzl, Ervine. *The Poster. Its History and Its Art* (New York: Watson-Guptill Publications, 1963).

Oostens-Wittamer, Yolande. *La Belle Epoque*. Belgian posters, watercolors, and drawings from the collection of L. Wittamer-DeCamps (New York: Grossman Publishers Inc., 1970).

Rademacher, Hellmut. *Masters of German Poster Art* (New York: The Citadel Press, 1966).

Rickards, Maurice. *Posters at the Turn of the Century* (London: Evelyn, Adams, and Mackay Ltd., 1968).

Roger-Marx; Weill, Alain; Rennert, Jack. *Masters of the Poster 1896–1909*. "Les Maitres de L'Affiche" (New York: Images Graphiques, Inc., 1977).

Schardt, Hermann. *Paris 1900*. Masterworks of French Poster Art (New York: G. P. Putnam's Sons, 1970).

ART NOUVEAU

Battersby, Martin. *Art Nouveau*. (Feltham, Middlesex: Paul Hamlyn, 1969).

Berckenhagen, Ekhart. *Art Nouveau und Jugendstil* (Kiel: Kunsthalle, 1970).

Brunhammer, Yvonne, and others. *Art Nouveau Belgium, France*, Catalogue of an Exhibition Organized by the Institute for the Arts, Rice University, and the Art Institute of Chicago, 1976.

Champigneulle, Bernard. *Art Nouveau* (Woodbury, New York: Barron's Educational Series, Inc., 1976).

Cremona, Italo. *Il Tempo de l'Art Nouveau* Modern Style, Sezession, Jugendstil, Arts and Crafts, Floreale, Liberty (Firenze: Vallecchi Editore, 1964).

Gillon, Edmund V., Jr., *Art Nouveau. An Anthology of Design and Illustration from the Studio* (New York: Dover Publications, Inc., 1969).

Jullian, Philippe. *The Triumph of Art Nouveau* (New York: Larousse & Co., Inc., 1974).

Madsen, S. Tschudi. *Art Nouveau* (New York: McGraw-Hill, 1967).

Massobrio, Giovanna and Portoghesi, Paolo. *Album del Liberty* (Roma: Editori Lateza, 1975).

Melvin, Andrew, ed. *Art Nouveau Posters and Designs* (London: Academy Editions, 1971).

Mostra del Liberty Italiano, Palazzo della Permanente (Milano: Societa Per Le Belle Arti Ed Esposizione Permanente, 1973).

Mucha, Jiří. *Alphonse Mucha, The Master of Art Nouveau* (London: Hamlyn Publishing Group, Ltd., 1966).

Reade, Brian. *Art Nouveau and Alphonse Mucha* (London: Her Majesty's Stationery Office, 1967).

Schmutzler, Robert. *Art Nouveau* (New York: Harry N. Abrams, Inc., 1962).

Selz, Peter; Constantine, Mildred; Daniel, Greta; Fern, Alan; Hitchcock, Henry-Russell. *Art Nouveau*, Art and Design at the Turn of the Century. Revised Edition. (New York: The Museum of Modern Art, 1975).

Walters, Thomas, editor. *Art Nouveau Graphics* (London: Academy Editions — (New York: St. Martin's Press, 1972).

Wick, Peter; Garvey, Eleanor; Smith, Anne. *The Turn of a Century 1885-1910*. Art Nouveau-Jugendstil Books. (Cambridge, Massachusetts: The Houghton Library, Harvard University, 1970).

ADDITIONAL SOURCES

Adeline, Jules. *Les Arts de reproduction vulgarisés*, Paris: May and Motteroz, 1894.

Appignanesi, Lisa: *The Cabaret* (New York: Universe Books, 1976).

Broude, Norma. "New Light on Seurat's 'Dot': Its Relation to photo-mechanical color printing in France in the 1880s," *The Art Bulletin*, LVI, no. 4, December, 1974, pp. 581-589.

Burch, R. M. *Colour Printing and colour printers* (New York: Baker & Taylor, 1911).

Cachin, Francoise. *Paul Signac*. (Greenwich, Connecticut: New York Graphic Society Ltd., 1971).

Castleman, Riva. *Prints of the Twentieth Century: A History* (New York: Museum of Modern Art, 1976).

Cate, Phillip Dennis. "Empathy with the Humanity of the Streets," *Artnews*, v. 73, no. 3, March, 1977, pp. 56-59.

Chassé, Charles. *The Nabis and Their Period*. Translated by Michael Bullock. (New York: Frederick A. Praeger, Publishers, 1969) (For "Bibliographies and Exhibitions." pp. 125–130).

Dube, Annemarie & Wolf-Dieter. *E. L. Kirchner. Das Graphische Werk*. (Munich: Prestel-Verlag, 1967. 2 vols.).

Dubuffet, Jean, and McNulty, Kneeland. *The Lithographs of Jean Dubuffet*, November 18 to January 10, 1964–1965 (Department of Prints and Drawings, The Philadelphia Museum of Art).

Eichenberg, Fritz. "Lissitsky and the Russian Avant-Garde," *Artist's Proof,* Volume VII, 1967, pp. 68-71.

Engelmann, Godefrey. *Traité theorique et pratique de lithographie,* Mulhouse, 1835–40.

Exposition des peintres-graveurs, catalogue of the exhibi-lithographie, Mulhouse, 1835–40.

Esposition des peintres-graveurs, catalogue of the exhibition, January 23–February 14 (Paris: Durand-Ruel Gallery, 1889).

Feinblatt, Ebria. *Picasso. Sixty Years of Graphic Works.* (Los Angeles: Los Angeles County Museum of Art, 1966).

Field, Richard; Ely, Elizabeth; Campbell, Karen. *Oskar Kokoschka.* Literary and Graphic Works, 1906–1923. (Storrs, Connecticut: William Benton Museum of Art, University of Connecticut, 1977).

Frèrebeau, Mariel. "What is Montmartre? Nothing! What should it be? Everything!," *Artnews,* v. 73, no. 3, March, 1977, pp. 60–62.

Garvey, Eleanor, and Wick, Peter. *The Arts of the French Book, 1900–1965.* Illustrated Books of the School of Paris. (Dallas: Published for the Friends of the Dallas Public Library by Southern Methodist University Press, 1967.)

Geoffray, A. "Le Salon," *La Curiosité universelle,* no. 84, August 27, 1888, pp. 1–2.

Gheerbrant, Bernard, "The Print in Paris Today," *Artist's Proof,* Issue No. 6, Fall–Winter 1963–1964, pp. 8–13.

Goldschmidt, Lucien and Schimmel, Herbert, eds. *Unpublished Correspondence of Henri de Toulouse-Lautrec* (London, 1969).

Groschwitz, Gustave von. *One Hundred and Fifty Years of Lithography* (catalogue of an exhibition at The Cincinnati Art Museum, March 19–April 28, 1948).

Guicheteau, Marcel. *Paul Serusier.* Avec la collaboration de Paule Henriette Boutarie (Paris, 1976).

Hartrick, A. S. *Lithography As A Fine Art* (London: Oxford University Press, 1932).

Hermann, Fritz. *Die Revue blanche und die Nabis,* 2v., (Munchen, 1959).

"The House of Mourlot," *Lithopinion,* no. 10, 1968, pp. 28–48. Prepared by the editors of *Lithopinion.*

Jullian, Philippe. *Dreamers of Decadence* (New York: Praeger Publishers, 1971).

Jullian, Philippe. *Montmartre.* Translated by Anne Carter (Oxford: Phaidon Press Ltd.; New York: E. P. Dutton & Co., Inc., 1977).

Jullian, Philippe. *The Symbolists* (London: Phaidon Press Ltd., 1973).

Klipstein, August, and Sievers, Johannes. *Käthe Kollwitz.* Verzeichnis des Graphischen Werkes. (Berne: Klipstein & Co., 1955).

Knapp, Bettina, and Chipman Myra. *That was Yvette, the Biography of a Great Diseuse* (London: Frederick Muller Limited, 1966).

Knigin, Michael, and Zimiles, Murray. *The Contemporary Lithographic Workshop around the World* (New York: Van Nostrand Reinhold Co., 1974).

M. Knoedler & Co. *Ingres to Forain.* A Century of Lithographs (1815–1915). Exhibition catalogue, October, 1937.

La Lithographie, Paris: Ecole des Beaux-Arts, 1891. Catalogue for the exhibition at the Ecole des Beaux-Arts, April 2–May 24, 1891. Preface by Henri Beraldi.

Langard, Johan, and Reidar, Revold. *Edvard Munch. Masterpieces from the Artist's Collection in the Munch Museum in Oslo* (New York, Toronto: McGraw-Hill Book Company, 1964).

Lankheit, Klaus. *Franz Marc. Katalog der Werke.* (Cologne: M. DuMont Schauberg, 1970).

Lemercier, Alfred. *La Lithographie française de 1796 à 1896 et les arts qui s'y rattachent, manual pratique s'adressant aux artistes et aux imprimeurs* (Paris, 1896).

Lorilleux, Charles. *Traité de lithographie* (Paris, 1889).

Lostalot, de Alfred. *Les Procédés de la gravure* (Paris: A. Quantin, 1882).

Marty, A. *L'Imprimerie et les Procedes de Gravure au XX^e Siecle.*

Métenier, Oscar. *Aristide Bruant* (Paris, 1893).

Mourlot, Fernand. *Braque Lithographe.* (Monte-Carlo: Andre Sauret, 1963).

Mourlot, Fernand. *Picasso Lithographe.* (Paris: Andre Sauret, 1970).

Prasse, Leona, and Francis, Henry: *Catalogue of an Exhibition of the Art of Lithography* Commemorating the Sesquicentennial of its Invention 1798–1948 (Cleveland: The Cleveland Museum of Art, 1948).

Reproductive Arts from the XV century to the Present time, with Special Reference to the Photo Mechanical Processes (Exhibition Catalogue. Boston: Museum of Fine Arts, 1892).

Rewald, John. *Seurat and His Friends.* Catalogue of a loan exhibition, November 18 to December 26, 1953, at Wildenstein, 19 East 64th Street, New York.

Roethel, Hans Konrad. *Kandinsky. Das Graphische Werk.* (Cologne: M. DuMont Schauberg, 1970).

Rossiter, Henry, and Hoyt, Anna. *An Exhibition of Lithographs,* 527 Examples by 312 different Artists from 1799 to 1937. (Boston, Massachusetts: Museum of Fine Arts, 1937).

Schiefler, Gustav. *Emil Nolde: Das Graphische Werk.* Neu bearb. von Christel Mosel. 2v. (Cologne: DuMont Schauberg, 1966–67).

Singer, Hans W. "Recent German Lithographs In Colours," *The International Studio,* XXI, 1904, pp. 305–316.

Soby, James Thrall; Elliott, James; Wheeler, Monroe. *Bonnard and His Environment* (New York: The Museum of Modern Art in collaboration with The Los Angeles County Museum of Art and The Art Institute of Chicago, 1964).

Terrasse, Charles. *Bonnard* (Paris, 1927).

Ting, Wallasse, "Notes by Wallasse Ting on his 1¢ Life," *Artist's Proof,* Issue No. 8., 1965, Volume 5, no. 2, p. 2.

Twyman, Michael. *Lithography 1800–1850.* The techniques of drawing on stone in England and France and their application in works of topography (London: Oxford University Press, 1970).

Villon, A. *Manuel du dessinateur et de l'imprimeur lithographe* (Paris, 1891).

Wheeler, Monroe. *Modern French Painters and Sculptors as Illustrators* (New York: Museum of Modern Art, 1936).

Wheeler, Monroe. *The Prints of Georges Rouault* (New York, Museum of Modern Art, 1938).

OTHER BOOKS BY ANDRÉ MELLERIO

Works on art:

Exposition Mary Cassatt, preface to the catalogue for the exhibition at the Durand-Ruel Gallery, November-December, 1893.

Le Mouvement Idealiste en peinture, Paris: H. Floury, 1896.

L'Exposition de 1900 et l'Impressionisme, Paris: H. Floury, 1900.

Odilon Redon, Paris, 1913.

Odilon Redon, peintre, dessinateur et graveur, Paris: H. Floury, 1923.

Others:

La Cicatrice saynète pour Salon, Paris; Librairie Théâtrale, 1884.

Contes français: "Le Drapeau de la cathédrale," "La Porte du cimetière," "L'Espion," Paris: Librairie Théâtrale, 1885.

Jeunesse d'antan, poésies, Paris: L. Vanier, 1886.

Sonnets libres, Paris: L. Vanier, 1887.

L'Envoyé de Saint Louis, saynète, Paris: Librairie Théâtrale, 1888.

Etudes de femmes: Henriette Suger, Blanche Chaptal, Madame Aubierge, Claire Aubrey, Marcelle Levanneur, Paris: A. Lemerre, 1889.

Les Exploits de ragonnette, comic opera with couplets by Mellerio, Paris: A. Quinzard, 1892.

La Vie sterile, Paris: A. Lemerre, 1892.

La Vie intérieure, le crépuscule du siècle, Paris: A. Lemerre, 1896.

Index